P9-DVH-759

DATE DUE

GAYLORD			PRINTED IN U.S.A.

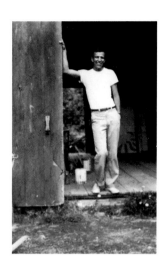

K

ALEX KATZ
A RETROSPECTIVE

by Irving Sandler

Harry N. Abrams, Inc., Publishers

Riverside Community College
Library
NOV '99
4800 Magnolia Avenue
Riverside, CA 92506

N 6537 .K32 S25 1998

Sandler, Irving, 1925–

Alex Katz

Editor:
Robert Morton

Editorial Assistant:
Nola Butler

Designer:
Samuel N. Antupit

Production Design:
Arlene Lee

Photo Editors:
Catherine Ruello
Jennifer Bright

*Library of Congress
Cataloging-in-Publication Data*
Sandler, Irving, 1925–
 Alex Katz : a retrospective /
 by Irving Sandler.
 p. cm.
 Includes bibliographical
 references and index.
 ISBN 0–8109–1231–7
 (clothbound)
 1. Katz, Alex, 1927–
 Criticism and interpretation.
 I. Title.
 N6537.K32S25 1998
 709'.2—dc21 97–29140

Illustrations copyright
© 1998 Alex Katz
Text copyright © 1998
Harry N. Abrams, Inc.

Published in 1998 by
Harry N. Abrams,
Incorporated, New York
All rights reserved
No part of the contents
of this book may be
reproduced without
the written permission
of the publisher

Printed and bound in
Japan

 Harry N. Abrams, Inc.
100 Fifth Avenue
New York, N.Y. 10011
www.abramsbooks.com

Page 1: Alex Katz, Maine, 1962.

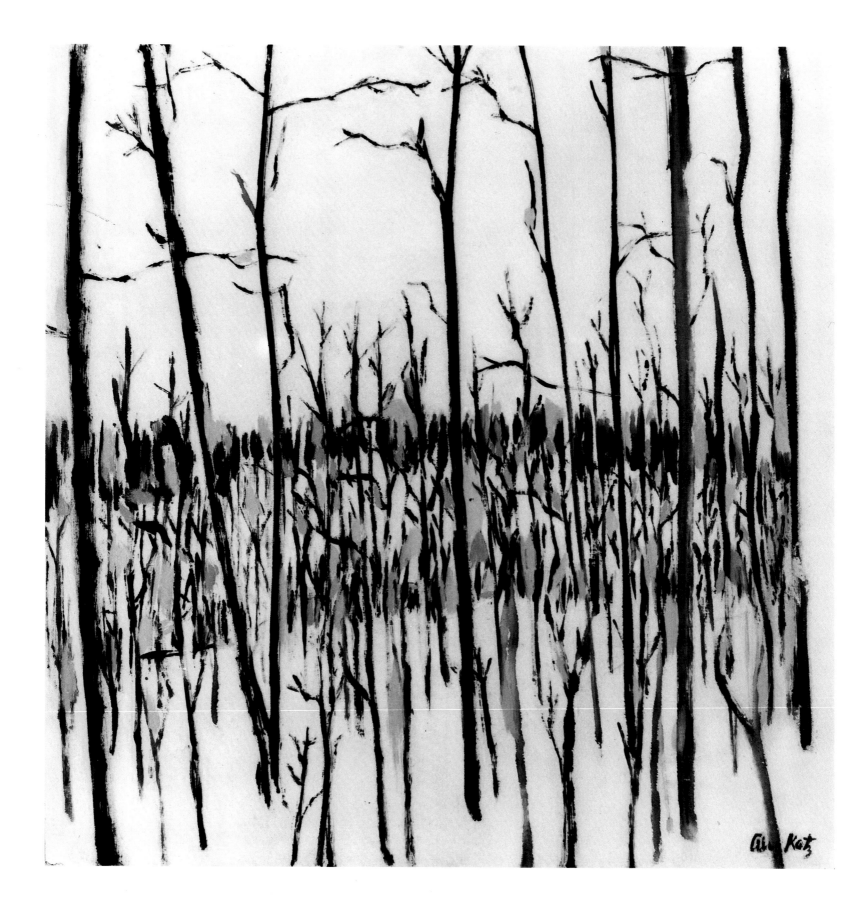

WINTER SCENE. 1951–52

Chapter 1:
NEW YORK
SCHOOLED
IN THE
FIFTIES

In the early 1960s, Alex Katz played a major role in the emergence of a new perceptual realism in painting. He was among the first of New York School painters to attempt specific representation and, in the process, to reduce the gestural or action brushwork common in avant-garde painting of the 1950s. And he was the first to adapt the size and scale associated with Abstract Expressionism and Hard-edge and Stained Color-field Abstraction to figurative painting.

Katz's parents were immigrants from Eastern Europe who settled in New York City. He was born in Brooklyn in 1927 but grew up in Queens. His mother had been an actress and his father was also interested in the arts. Katz started drawing as a child—with his father—and continued his art education in public school. His father was also fashion conscious and transmitted this interest to his son. Katz recalls: "In high school, I wore the zoot suit. I liked it because it had fluid lines. I liked it because it was free. It was socially free. I liked it because it was a romance suit. It was away from tradition, away from constraints, and I liked the music that went with it."[1]

Katz joined the navy in 1945. After his discharge, he was admitted to Cooper Union, where he studied from 1946 to 1949. There he became familiar with modernist approaches to figurative painting. At the time, the school's main orientation was toward late forms of Cubism with a heavy romanticist cast. Katz's first teacher, Robert Gwathmey, analyzed different styles and declared what was dead and alive in each. Katz found this approach stimulating; it would continue to be useful to him long after his student days. Other instructors who impressed him were Peter Busa, who,

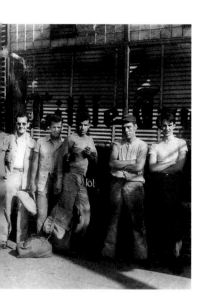

Alex Katz (third from right), 1945

in painting over student pictures, showed how pigment could come alive; Morris Kantor, who had the knack of demonstrating how a picture "worked"; and Carol Harrison, who taught Katz Cubist design. Also important to Katz's development were his interactions with fellow students, among them Tom Boutis, Jean Cohen, Lois Dodd, and William King, all of whom would go on to become professional artists. During his time at Cooper Union, Katz remembers being impressed by two shows, both in 1949, among all that he had seen: they were exhibitions of Henri Matisse and Arshile Gorky.[2]

Upon graduation in 1949, Katz was awarded a scholarship for summer study at the Skowhegan School of Painting and Sculpture in Maine, a grant that was renewed the following year. There, he worked with Henry Varnum Poor, who urged him to paint outdoors, an approach that had been ridiculed at Cooper Union but would prove germinal in Katz's development. Working directly from nature led Katz to painting directly—that is, spontaneously and naturally—and this, too, was crucial to his growth as an artist. The directness of Matisse and Marsden Hartley[3] also inspired him during this formative period, as did works by New York School artists, sixty-one of which he saw in 1951 in the Ninth Street Show, the first large exhibition of its kind. Above all, Katz was stunned by Jackson Pollock's poured painting; its quick image achieved by quick painting made the Cubism taught at Cooper Union look contrived, cramped, and enervated.[4]

At the same time, conventional figurative styles struck Katz as provincial and retrogressive. He had no sympathy for *Reality,* a magazine first published in 1953, which championed figurative artists, including his former teachers Gwathmey and Poor, and which derided Abstract Expressionism as formalist and antihumanist. Indeed, Katz entered the milieu of Abstract Expressionism in downtown New York City, frequenting the Cedar Street Tavern, The Club (formed by the first generation of the New York School), and other meeting places of the avant-garde, where he enjoyed the perpetual art talk and the camaraderie. This was Katz's period of apprenticeship and it was very exciting for him, even though he was earning little and living conditions were spartan.

Inspired by Pollock, Katz began to paint allover pictures of trees—branches and trunks against light. He aimed for an immediate sensation of nature—its energy, not its appearance. He based other works on photographs—*Four Children* (c. 1951) and *Family Album* (1953), for example—at a time when most artists considered working from photographs taboo. This made it even more of a challenge to Katz, and was an early sign of his artistic independence. Katz was not interested in the alleged realism of the snapshots or in their subjects: he had not taken the pictures himself—they were just around—and did not know the people in them. He responded to the nostaglia of the photographs but used them primarily as pretexts for painting, simplifying the figures and blurring their features. The painting in these works is flat, like his later pictures, but brushier. Although Katz abandoned (temporarily) the direct observation of nature in these photograph-derived paintings, his facture remained direct. Indeed, the straightforward physicality of his attack with the brush led him to paint on pressed wood board rather than canvas, for the resistance this surface gave him.

Snapshot of four children. Courtesy Jean Cohen, New York.

In 1953, Katz exhibited both the tree and the figure paintings in a two-person show with Lois Dodd at the Tanager Gallery on Tenth Street, the first and most prestigious of the artists' cooperatives in downtown New York City, which was then the geographic center of vanguard art.[5] Katz became a member of the Tanager in 1956, joining Dodd, Sally Hazelet, Philip Pearlstein, Angelo Ippolito, and Charles Cajori, among others.

Around this time, Katz's acquaintances in the New York School and their allies in the other arts grew in number. He got to know the more perceptual of figurative painterly painters: Jane Freilicher, Fairfield Porter, Nell Blaine, and Larry Rivers. Among his other friends were photographer-filmmaker-painter Rudolph Burckhardt (about whom Katz was later to write an article)[6] and poets John Ashbery, Kenneth Koch, James Schuyler, and Frank O'Hara, who purchased two works by Katz in 1960. In a letter to Ashbery the following year O'Hara wrote: "The great thing this year I think is Alex Katz. [His] figure things . . . were startling and original."[7] Burckhardt introduced Katz to dance critic and poet Edwin Denby, who impressed him greatly.[8] Denby was extraordinarily sensitive to the poetry in

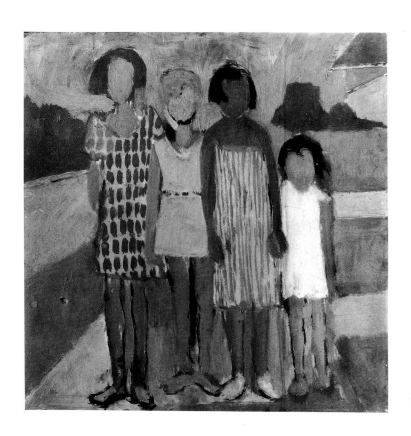

FOUR CHILDREN. c. 1951

painting, "the flash called beauty."[9] He also made intellectual and aesthetic ideas clearer than anyone Katz knew, stripping them of sentimentality at a time when art-world rhetoric was full of it. According to Denby, for example, his friend Willem de Kooning's aspiration was "meeting full force the professional standard set by the great Western painters. He wasn't naive, he was undesigning."[10]

In the works based on photographs of 1951–53, Katz first confronted the problem of painting a modernist figurative picture, that is, a picture of a recognizable subject in which the two-dimensionality of the canvas is strongly articulated. This led him to review the tradition of such painting. He was indebted to both modern and contemporary masters—Matisse, above all, but also Manet and Franz Kline, among others. In drawing, for example, Katz was stimulated both by Manet's contour drawing and by the nuanced edges of Franz Kline's energy-packed black and

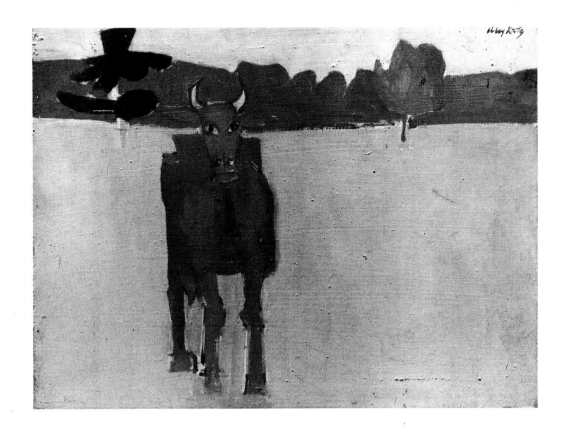

COW. 1955

white swaths. He was also influenced by premodern masters, notably Velázquez and Watteau, as well as the Japanese printmaker Utamaro. As a modernist, Katz aspired to be "brand new" and "responsive to the immediate," but he also wanted to be "traditional," because "all painting belongs to the paintings before them."[11] Indeed, he recognized that he looked to Manet just as Manet had looked to Giorgione and Velázquez.

After 1954, Katz relied increasingly on direct perception. His landscapes, interiors, and figures, however, are flatter and sparer than his earlier works. They are also higher key in color. It appears that the more closely Katz depicted observed reality, the more conscious of the picture plane he became. In the earlier of these pictures, expanses and lines of white gesso are allowed to show, simultaneously emphasizing the picture surface and acting as light. Later, Katz generally began with bright-colored grounds such as pink and yellow, on which he drew in vibrant colored out-

lines. He often juxtaposed a single planar volume on a single planar space to achieve a new assertiveness and openness of surface.

From 1955 to 1959, usually at the end of a day of painting, Katz made small collages of figures in landscapes, not from diverse materials as was common at the time, but from hand-colored, cleanly cut papers. These works were influenced by Matisse's collages and also by Conrad Marca-Relli's early figurative pasteups, which had been exhibited in 1954. Katz's collages, most no larger than twelve inches, challenged the Abstract Expressionist notion that in order to be major, pictures had to be big. What interested him more were problems of scale, making the minuscule look immense. In *Ada in the Water* (1958), for example, Katz reduced a panoramic beach scene with bather to an intimate five-by-eight-inch format. Katz's fascination with seemingly disjunctive and sudden jumps in scale continues to this day. In their flatness and seeming vastness, moreover, the collages anticipated his large-scale painting after 1962, indeed, becoming significant precursors.

Ada and Alex Katz, 1958. Photograph by Rudolph Burckhardt.

As the fifties progressed, Katz smoothed out painterly facture (which was never too brushy in his work to begin with). He wanted to emphasize and heighten color, and he found that heavy textures dulled color. At the same time, he wanted to provide more information about his subjects and their space, to describe them with greater accuracy, and he could not do so with overlapping and scumbled, open brushwork that obscured details such as an eye or a nostril. The specific, however, could be delineated by drawing on discrete, flat areas and adjusting colors to layer them in depth and to produce a particular, allover light. These newer pictures are almost as devoid of detail as Katz's earlier, more painterly canvases, but not quite, since the subjects are more clearly defined. This difference, or leap, was a qualitative one, anticipating the New Perceptual Realism of the 1960s.

Katz visualized his images from a single point of view because he wanted them contained and whole, not fragmented—again forecasting the New Perceptual Realism. His predilection for rendering definite images in believable space, and for painting thinly with vivid, little-modulated color,

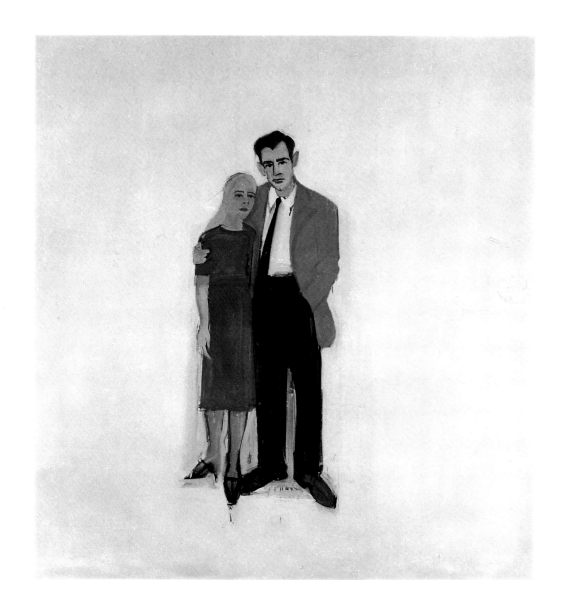

IRVING AND LUCY. 1958

opened a gap with the dominant avant-garde manner of the 1950s, namely
Gesture Painting. Katz's approach also struck figurative artists in the New
York School as backward looking. Most took as their model de Kooning's
Women, whose anatomies were segmented and in flux. Some were influ-
enced by Cézanne, whose realism was based on the experience of seeing in
a succession of glances, during which things seemed to shift and lose their
edges, to look "unfinished." And these artists equated modernism with an
ambiguous, dynamic, and continuous space.

 Katz was disposed neither to Cézanne's roving point of view nor to

de Kooning's painterly figuration. He did admire de Kooning's "quick light," that is, the immediate sensation of a single, pervading luminosity, and de Kooning's mastery, what Katz called his high style, but he was uncomfortable with his heavy and rough facture. He was even more uncomfortable with the excessively slapdash, fatty surface that characterized the work of most of de Kooning's followers, none of whom could equal the master in his own style.

Katz rejected frenetic Gesture Painting because it looked compulsive and seemed to be "about the passion of the artist [and] not about the perception and depiction of things."[12] Nor did Katz accept the heavy and heated rhetoric used by many of his fellow artists to justify Gesture Painting—the romantic notion that it was a metaphor for an artist's creative process, or the existentialist notion of painting as a leap into the unknown exemplified in the oft-repeated claim at the time: "I-don't-know-what-I-am-doing." Katz maintained that such rhetoric was spurious; he refused to sentimentalize chance in art, and he often spoofed it. In 1957, for example, while participating at The Club in a panel discussion on "The Accidental in Art," he said that "the only accidents were good and bad painting days." In his view, artists did not make unpremeditated stabs in the dark, but chose what and how to paint. They started with intentions and tried to achieve them. Intuition was vital as a source of inspiration, but an artist was ultimately in control. As he summed it up: "The whole process of working to me somehow is conscious—I mean in that if you want a drip, you overload the brush and if you want washes you don't start plastering. . . . And so somehow it seems that, although you might not know exactly what a picture will look like, you know what your technique is and that you control a controllable thing."[13]

As Katz moved toward the margins of gestural figuration, he ran the risk of not being taken seriously in his social milieu, the New York School, and, in fact, he was often dismissed or patronized. But he was convinced that as a style, Gesture Painting had become overworked and mannered, "reactionary," as he called it as early as 1957, when it was at the peak of its influence.[14] There was too much Gesture Painting, a veritable glut, and

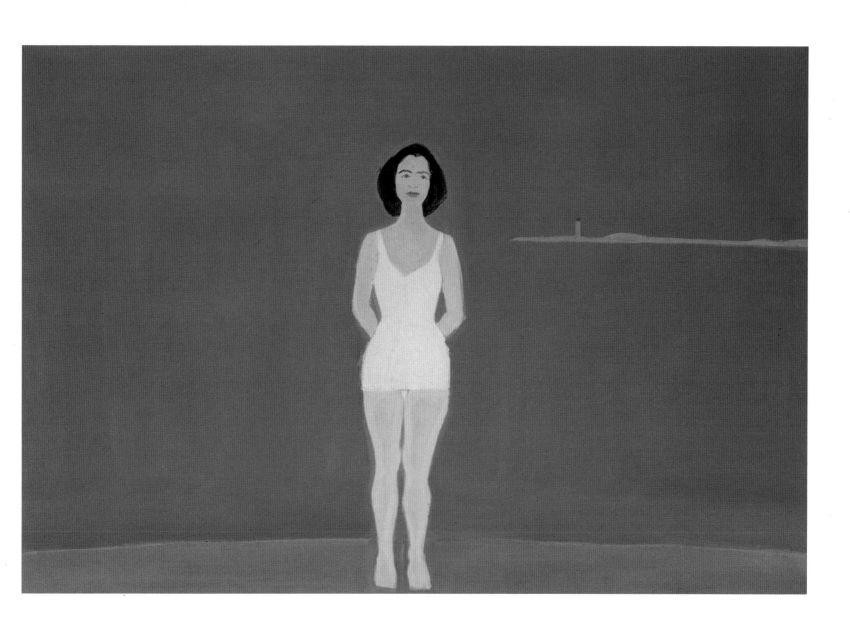

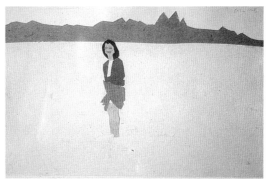

Top: BATHER. 1959

Above: ADA IN THE WATER. 1958

consequently it had ceased to be imaginable as avant-garde. Katz was among the first to recognize the crisis, as is clear from a statement he made in 1959: "The look of conventional bad paintings has changed. Many resemble the more traditional of advanced New York paintings. This has created a reaction against their ideas in general. . . . This paradoxical compliment of flattering imitation forces style to change. The general look shifts."[15]

OVAL ADA. 1958

As Katz was reacting against Gesture Painting, he was looking to the alternative and relatively neglected tendency in Abstract Expressionism, Color-field Abstraction, notably Rothko's and, to a lesser degree, Barnett Newman's. (Lawrence Alloway would trace Katz's single-color backdrops from Rothko back to Matisse, Manet, and Velázquez.[16]) Katz treated Color-field Abstraction seriously as early as 1956,[17] when only a few of his contemporaries were doing so, and he soon submitted to its influence, as in the atmospheric field of white behind *Irving and Lucy* (1958). Katz anticipated or paralleled some of the most challenging painting of the late fifties—the Hard-edge Abstraction of Al Held and Ellsworth Kelly, and the Stained Color-field painting of Morris Louis and Kenneth Noland— before it became fashionable.

Katz's own move away from painterly figuration was simultaneously toward greater realism and greater flatness. Aware that these two thrusts were antithetical, he thought, nevertheless, that both offered a way out of the crisis of Gesture Painting. In 1957, he began to concentrate on portraiture—representation at its most specific.[18] (Portraiture would constitute the bulk of his work for the next three decades.) To Katz the challenge was to paint *the portrait* by relying on perceptual information.[19] That was the point of painting portraits. "It's very hard for anyone who was brought up on the good manners of modern art to accept that. It's very easy to say, oh, it isn't the likeness, it's the abstract composition. But if I wanted to make an abstract composition, I would have."[20] Likeness took on additional significance for Katz. He believed that the *quality* of a portrait painting depended on it: "Strangely enough, if you don't have a good likeness, you don't have a good picture. That's up to a certain point. . . . You can wreck

BLACKIE WALKING. c. 1959

a painting very easily if you get obsessive about likeness."[21] Katz would repeatedly stress how important rendering appearances was to him. In 1984, for example, rebutting critics who "stressed the formal or social qualities" of his paintings, he said that they "actually have to do with seeing. It has to do not with what it means but how it appears."[22]

The difficult problem remained: Could Katz "make a valid painting that was a portrait—a modern painting, so to speak?"[23] Representation had long been spurned by the avant-garde because it seemed encrusted with conventions and overworked, too easy. But not the way Katz tackled it, for he wanted to synthesize two of the major, and seemingly irreconcilable, tendencies in modern art: truth to the perception of the real, three-dimensional world (the truth of a Courbet, for example), and truth to the medium—in painting, to the picture as a real, two-dimensional object (the truth of a Gauguin). Moreover, Katz aimed to deal with the competing demands of both conceptions of realism at their extremes, and venturing to extremes was a modernist aim—and a sign of his ambition.

The descendants of Gauguin argued that representation was obsolete because the camera could do it better. But Katz recognized that the camera lens does not record reality more perfectly or even in the same way as the human eye. Indeed, how could a simple, primitive mechanism have

vision finer than a complex, sophisticated organ? The eye is perpetually scanning, accumulating details and synthesizing them. In contrast, the camera shutter fixes subjects in an instant, freezing their movements, flattening them unnaturally, and, Katz thought, getting the color wrong. He most objected to photographs because they almost never captured the characteristic gesture of their subjects. He understood that our eyes interpret as they perceive, and that an objective realism is, therefore, unachievable. Nevertheless, he tried to record visual facts. On the color planes in his pictures, Katz drew the features of his sitters, which, though simplified, constituted a representation. It was as if he asked (as he continues to ask): "How much detail does a realist painting need to convey a convincing illusion?" And he has provided just that amount, an amount sufficient to capture a sitter's distinctive features, expression, and gesture, to render the texture and weight of a velvet ribbon or denim jacket, and above all, to specify the ambient light.

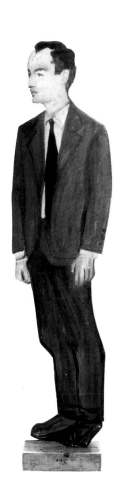

FRANK O'HARA. 1959

Thus, Katz continued the realist tradition of Courbet's *Stone Breakers* and Manet's *Olympia,* which had been considered anti-traditional or radical in their own time, particularly because the subjects were not idealized and sentimentalized. But the realist course set by Courbet and the early Manet had been diverted by Impressionism into paths that led toward abstraction, much as the Impressionists conceived of themselves as true realists. Realism in the mid-nineteenth century had been too short-lived to be fully developed. This left an opening for the New Perceptual Realists of the early 1960s to claim that an art that aspired to accuracy of appearances could still be viable, particularly since it offered alternatives to the outworn figuration of Picasso's and de Kooning's disciples. Specific representation without sentimentality became the goal of Katz and a few of the most provocative figurative painters in the 1960s.

Katz embraced flatness for a variety of reasons. For one, he wanted to use color for expression, and like Gauguin, he recognized that in order for color to be fully felt visually and emotionally, elements "alien" to color had to be reduced, above all, modeling, but also complicated drawing and textures. Suppressing modeling flattened the surface. Bringing the image

to the surface of a picture intensified its "frontal pressure," so as to make it project more strongly or aggressively and immediately.[24] Flatness also enabled Katz to distance his imagery, that is, "cool" it and call attention away from "deep" and "hot" readings, which he found pretentious. It also allowed imagery to take on multiple meanings. But most important, from the beginning of Katz's career, flatness was an essential component of his individual style, rooted in psychic urgencies and unavoidable in whatever he painted. (Wassily Kandinsky's conception of inner necessity comes to mind, although Kandinsky was thinking of Expressionist painting). And it was Katz's style that made his rendering of appearances *new*.

Gestural figurative painters and their advocates in the 1950s tended to identify flatness with abstract art—and attack it. In 1955, for example, Elaine de Kooning wrote: "Anyone who says 'the painting is flat' is saying the least interesting . . . thing about it."[25] Her comment aimed to rebut the the formalist ideology of Clement Greenberg, in which pictorial flatness was the central tenet, an ideology that would dominate art discourse in the 1960s. In the name of modernism, Greenberg rejected figuration. Katz was as panel-conscious as any of the nonobjective painters that Greenberg championed, but he refused to accept that pictorial flatness could be achieved only in abstract art. Although Katz provides enough detail for a convincing illusion, the flatness and slight distortion of his pictures have caused many critics to view them as "abstract" paintings or as abstract paintings *manqué*. Indeed, some have claimed that he has bridged figuration and abstraction and that such bridging has been his primary intention. This is not so. As Fairfield Porter summed it up: "Katz is a 'realist,' meaning that you recognize every detail in his painting, and the whole too, though the whole takes precedence and the detail may be only an area of color, in short, abstract."[26]

The flatness of Katz's painting separated him from both gestural figurative painters and, subsequently, his fellow initiators of the New Perceptual Realism, such as Philip Pearlstein, who worked with deep illusionistic space. But Katz's flatness anticipated Pop Art, which was based on copying two-dimensional preexisting images, such as comic strips and

soup-can labels, although his painting has rarely been labeled Pop Art.

In the portraits from the late 1950s on, Katz flattened his surfaces more than ever by smoothing out his formerly loose, uneven painting. Nevertheless, although he applied pigment thinly and flatly, he did not sacrifice painterliness. His brush-worked surfaces remained extraordinarily fluent, each nuance a plane contributing at one and the same time to the articulation of subject matter, two-dimensionality, and the sensuousness of the painting. His touch was, in a word, masterly. (After 1962, his artistry has been even more remarkable, since the flow of pigment has been checked repeatedly by hard contours.)

Katz could not achieve pictorial flatness *and* convincing representation by using traditional conventions of illusionism—the contrast of light and dark, for example, that is modeling, which bores into the surface.[27] He relied instead mainly on the interaction of color and contour drawing. Inspired by Matisse's and Mondrian's flat yet weighty surfaces,[28] and Rothko's thinly painted yet volumetric areas of color, Katz translated his subjects into flat planes of color, which he then adjusted so as to impart a convincing sense of mass or space. The colors suggested varying depths, and also created a uniform light in each picture. Katz's edges of forms, broken and painterly in the fifties, and subsequently, clean and flowing, also contribute to a believable sensation of volume, turning and twisting the planes in space (as Manet's do).

The contours are occasionally distorted and quirky looking, "clunky elegant," Katz called them. He elaborated: "I could refine [the drawing], but then I'd lose directness. I prefer directness to anything else."[29] A tug-of-war, moreover, between representation and two-dimensional surface pulls the images out of shape, even though they end up fitting pictorially. Roberta Smith, responding to Katz's competing intentions, wrote that he "finally succeeds in convincing us that he paints things as he sees them (and as we would see them too)." Then, "as soon as we believe that he sees things in a certain way, something . . . suggests that his real interest is in having them all conform to the picture plane—forget anatomy and depicted space."[30]

The willful quirkiness of Katz's edges resulted in a kind of jarring bad manners. Like Hartley and Milton Avery, Katz cultivated "wrong" drawing to make his shapes more physical and arresting. Distortions in drawing were also used to make the design stronger, the scale more perfect, and to enliven the line and the image—subtly, to be sure, so as not to overly call veracity into question.[31] His (mis)representation calls to mind a passage in "Self-Portrait in a Convex Mirror" by John Ashbery, who has been painted by Katz: "However its distortion does not create/A feeling of disharmony."[32] In later works, liberties with likeness enabled Katz to develop a unique style and to generalize his images, that is, to transform his portraits from *signs* of things seen to *symbols* with multiple meanings.

Katz compensates for lapses in truth to appearances by making his subjects appear "natural." He achieves this effect by painting from life. As his eyes scan the subjects, they record the flow of details, enabling him to keep his images fluid and thus alive-looking. Put another way, fluidity prevents the image from looking static or dead, and it simulates the manner in which the eye actually sees, contributing to a sense of animation. Manet's painting also has this quality, as Katz has remarked: "It appears to be natural because it's so fluid."[33] Finally, each of his pictures captures the light of a single moment, a light that one has experienced, "it could almost be said, that one has *inhabited*."[34] Katz has said that his kind of realism depends on getting the light right. To emphasize this, he occasionally incorporates the time of day into his picture titles, such as *Swamp Maple 4:30* (1968), to note the specific light.

The more natural Katz made his pictures, the freer he was to diverge from naturalism, to cultivate artifices such as flattening, distorting, and later magnifying images and dislocating scale. Indeed, his work is distinguished by the grace with which he bridges representation and artifice.

Since Katz desired realism without sentimentality, he spurned "humanist" expectations, refusing to illustrate philosophical or psychological ideas or serve social or other causes.[35] He reacted most strongly against psychological interpretation, which, as he viewed it, is the artist's imposition of known qualities on his subject. In contrast, "appearance is . . . most

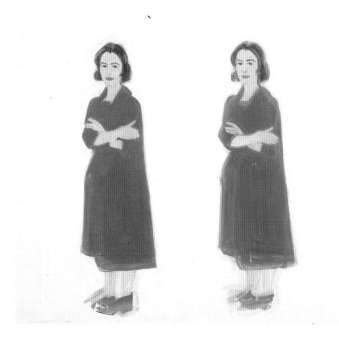

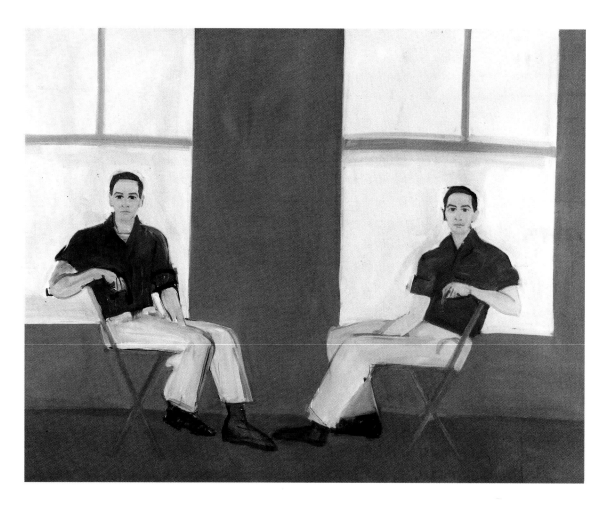

Top: ADA ADA. 1959

Above: ROBERT RAUSCHENBERG. 1959

Opposite: SWAMP MAPLE 4:30. 1968

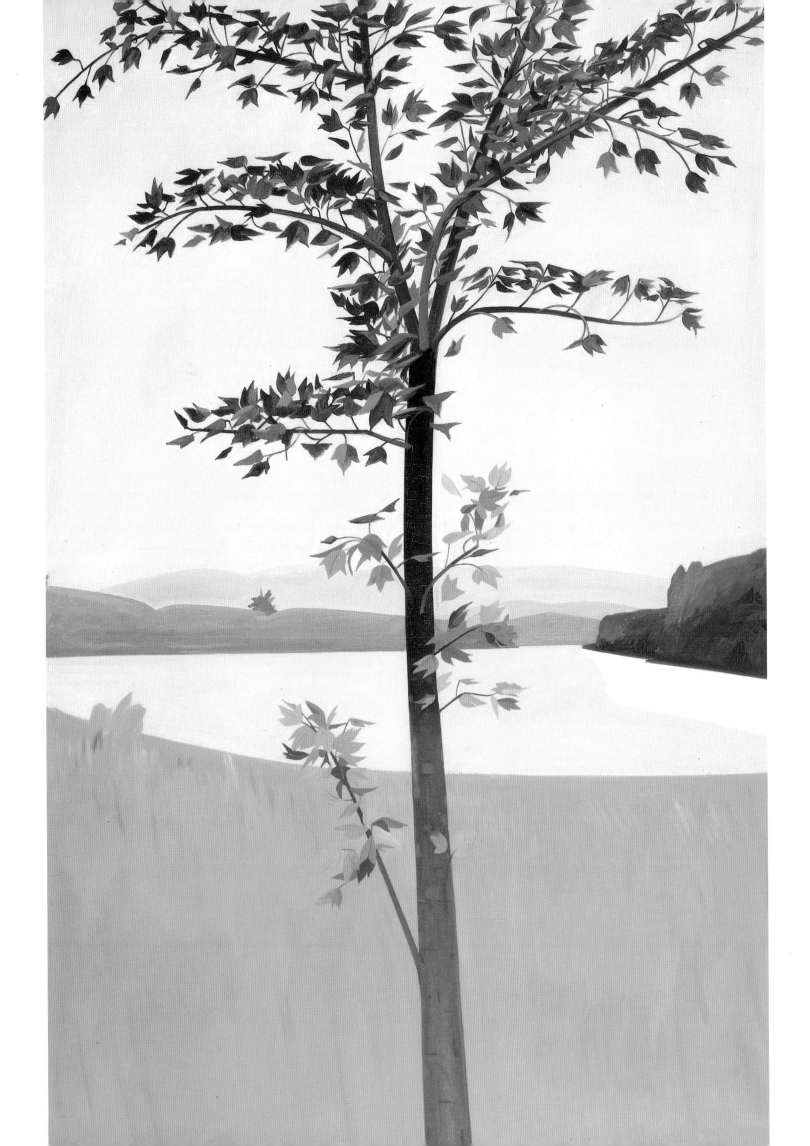

mysterious. . . . I can't think of anything more exciting than the surface of things. Just appearance."[36] Pictures with two or more interacting persons, such as Oskar Kokoschka's *Portrait of Dr. Tietze and His Wife* at the Museum of Modern Art, traditionally elicit an intense focus on the sitters' psychology. To avoid this, Katz painted double (or more) portraits—but of the same sitter, as in *Ada Ada,* the first of his "reduplicative" portraits, as Edwin Denby called them, and *Robert Rauschenberg,* both of 1959.

In *Robert Rauschenberg,* two facing seated images are equally or doubly impassive looking. In this they differ from an earlier picture by Katz's friend Larry Rivers, *Double Portrait of Berdie* (1955), in which the two versions of his then elderly mother-in-law augment each other's flesh-sagging and sad-faced aspects. The Katz painting is a negative gloss on Rivers's picture, but a positive homage to Rauschenberg's "action painting" *Factum I* and its near twin *Factum II,* both of 1957. An Abstract Expressionist painting is supposed to be *found* in the anxious struggle of painting, not *made.* By making the second *Factum* more or less indistinguishable from the first, Rauschenberg subverted the moral stance of Gesture Painting, an act of witty iconoclasm that delighted Katz.

Because of its lack of conventional "humanist" content, Katz's painting was often viewed as bland, even blank. Some art critics claimed that he rejected expressive content in order to call attention to formal or abstract qualities. But this is only one of several readings of his work. Indeed, his painting is anything but dehumanized or lacking in expression. Katz's representation is objective, but it is not unfeeling. This is particularly clear in his favorite subjects, portraits of friends in the arts and, above all, of his wife, Ada.

Katz chose these sitters because they were willing models, stimulating and sympathetic to him. But they were also interesting to him because they made up his milieu. His figures of the 1950s, generally painted against single-colored backdrops, are straightforward and plain. In depicting them, Katz also revealed the mood of the art world in America during the Eisenhower era (a mood far different from that of the following decades). The art world was small and poor then, its participants, responding to a

society hostile to their art, turned in on themselves and formed their own community. Of necessity, it was bohemian. The figures are also vulnerable, as in *Irving and Lucy,* in which a newly married couple huddle in the center of a vast expanse of white—for comfort, and also for mutual support. Katz's portraits convey a quality of homeyness and of the homemade (the antithesis of slickness). The pigment is a bit smudged, not unclean—or "dirty-ankle," as he called it[37]—like the rundown lofts artists could afford to live in and which they managed to make elegant. Katz also caught the pride of his sitters, soberly confident in their creative power. Indeed, he was able to document the down-at-the-heels condition of this artistic elite and make of it a high style.

A consideration of Katz's body of work in the 1950s would not be complete without dealing with his cutouts. He made the first of these in 1959, because, as Edwin Denby wrote, "among the figure paintings Katz was working on, one balked. The figure stayed live, the background dead, whatever he tried. Exasperated, he sliced the figure out of the canvas, and set it up with a wood backing to see what it needed. It didn't need anything."[38] Thus began a series of flat "sculptures" that he continues to this day—standing, seated, or reclining figures painted on sheets of wood or metal and sliced out with a power saw. The portraits exist in actual space, freestanding or as reliefs.

The cutouts raise provocative questions to which they never provide a single answer. Are they paintings (or shaped paintings, perhaps the first in contemporary art), sculptures, or, as representations in real space, effigies of some kind? Often they fool the eye, looking like real people momentarily, even though most are smaller than life-size. Indeed, they have the presence to be taken for real people. Lucy Lippard remarked: "Whenever I come into the Katz living room I turn toward the cutout thinking someone is there, even though I know no one is. It's a vital silhouette. I have to acknowledge its sharing of my space."[39] The cutouts were, in a word, immediate, and immediacy was a quality that Katz had begun to prize.

Because they were apprehended all at once, Katz's effigies functioned as gestalts. As such, they anticipated Minimal sculpture, which

would emerge in the early 1960s as the new avant-garde art. One of the main intentions of Minimal artists was to create a specific or primary *object* that emphasized its singular being while making viewers aware of themselves existing in the same space as the work.[40] That is precisely the effect of Katz's freestanding cutouts.

The references of Katz's cutouts to sculpture notwithstanding, they relate even more to paintings. Frequently body parts—hair, a chin—are lopped off. The slices are made both vertically and horizontally, implying the artifice of a picture frame. Unlike traditional figurative sculptures, moreover, in which transitions in the round are gradual, Katz's changes from front to back are abrupt. As Lippard wrote of the cutouts: "They aren't sculpture. You have to accept two versions, two paintings. There is no volumetric transition."[41] Although she considered them paintings that dispense with background, she admitted: "They seem more at ease fending for themselves in their own space. They enjoy their ambiguities."[42] To be sure, for the cutouts are freestanding objects, but as Berkson saw them, "not exactly sculptures, because whatever sense of volume they possessed came from the painting and the 'drawing' at the edges."[43] John Perreault viewed them in both ways, insisting that "Katz's cutouts . . . are flat—flatter than the flattest flat painting. This is because they are not merely paintings, but works of painted sculpture."[44]

Working in the space between painting and sculpture, Katz raised interesting questions about their relationships. *Blackie Walking* (1959), for example, is composed of figures of decreasing size that seem to recede illusionistically into the wall, even while being physically attached to it. In their multiplicity, do they project "the strength of the sitter's presence," as Ashbery suggested,[45] or precisely the reverse: incongruity or disjunctiveness? Or do they constitute an exercise in perspective? Or a witty play? Is it perspective that makes the multiplication of a single subject reasonable, prompting a suspension of belief that only one Blackie can exist? Or are the images to be imagined in time, thus accounting for their simultaneous appearance in diverse places? Yet the figures do not differ only in size. There are also changes in the way they are positioned and painted—subtle

changes, to be sure, but visible. Is the work then intended to depict various aspects of Blackie's being? These are all possibilities; thus, what is seen and what it means tend to shift constantly.

In other cutouts, Katz challenges our expectations of what constitutes a figure. Often fronts and backs of the freestanding cutouts are mismatched. One side of a figure may be blank, or dressed, while the other is naked; or a back on one side may be a back on the other side. In one of the more complex of the cutouts, *Massimo* (1991), on one side of a single sheet of aluminum there are two views of the subject, front and back, but standing shoulder to shoulder. The view of the front slightly overlaps the back and, although both are equally flat, casts a modeled shadow on it. On the other side of the cutout, both figures are presented from the back, adding up to three from the back in this quadruple portrait.

Katz's juggling of painting and sculpture and of illusion and reality came at a propitious time, when formalist critics dominated art discourse. They demanded that artists confine themselves to what was inherent in their medium and purge their art of everything that was not. Painting was supposed to emphasize its flatness above all and sculpture, its objecthood. Katz's cutouts make a charade of these notions, obliterating any boundary between fictive painting and actual sculpture, if only because they are flat sculptures whose surfaces are paintings that generate the volume of the works.

By the end of the 1950s, Katz recognized that his primary aim in art would be to see the world anew; to create, as Emile Zola said of Manet, a new and personal vision of reality;[46] and to paint it beautifully. As for its effect on viewers, Katz later commented: "I would hope that after seeing one of my paintings people would see things differently. I would hope that people could see the world through my eyes for a minute."[47]

Beginning in 1959, leading artists and art professionals did. Katz recalled that during his show at the Tanager Gallery in that year, "Guston came over. He was terrifically nice to me. De Kooning told me he liked the paintings, and I shouldn't let people knock me out of my position. . . . Rauschenberg and Johns came over and were friendly. It was the first time my work had any real impact on people."[48]

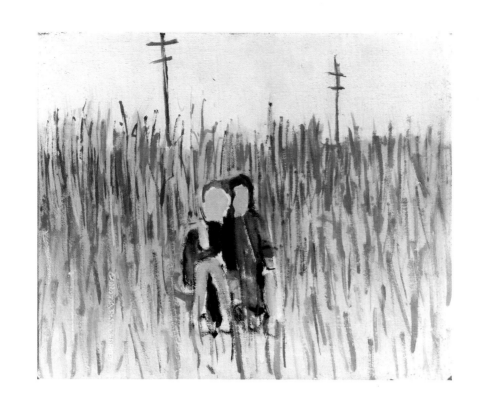

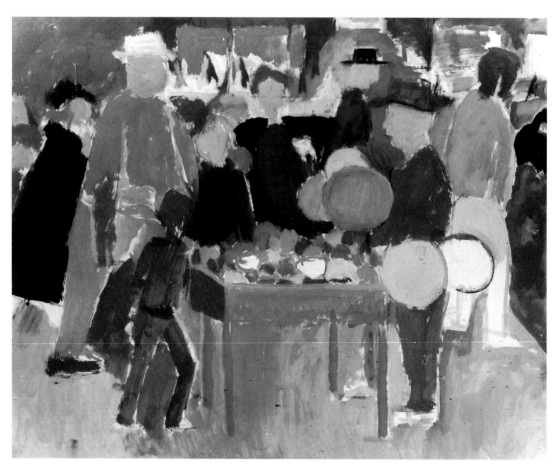

Top: TWO FIGURES IN A FIELD. c. 1951

Above: SECOND AVENUE. 1951

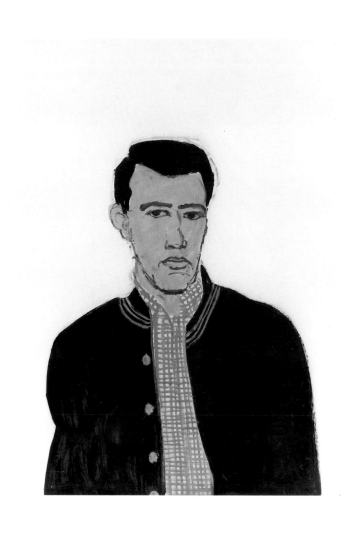

TRACK JACKET. 1956

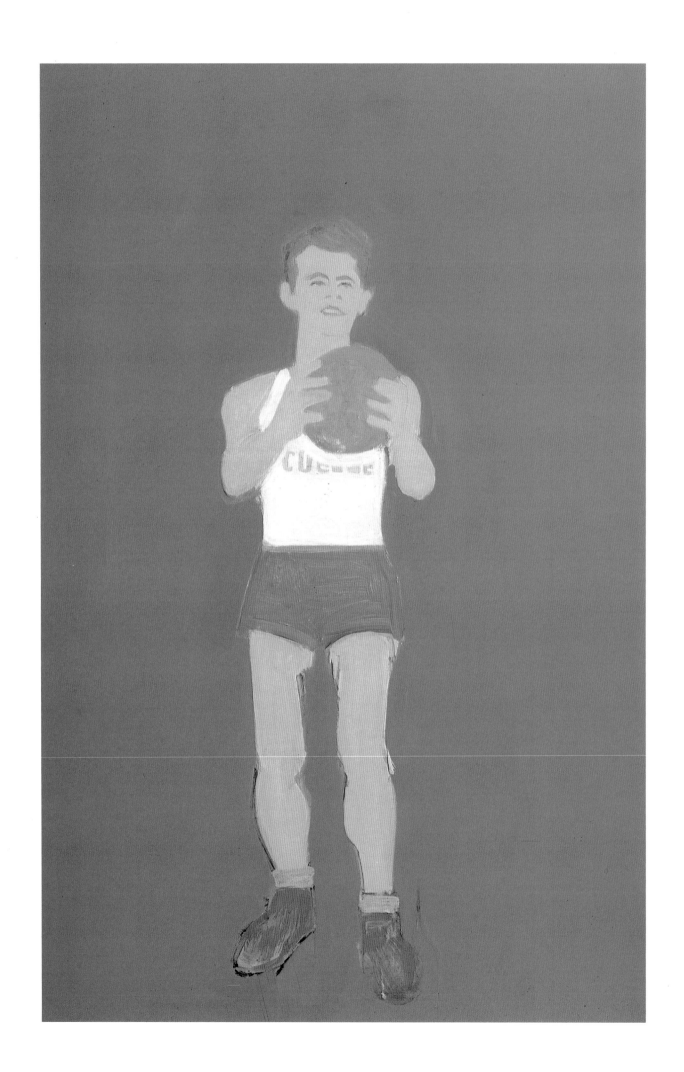

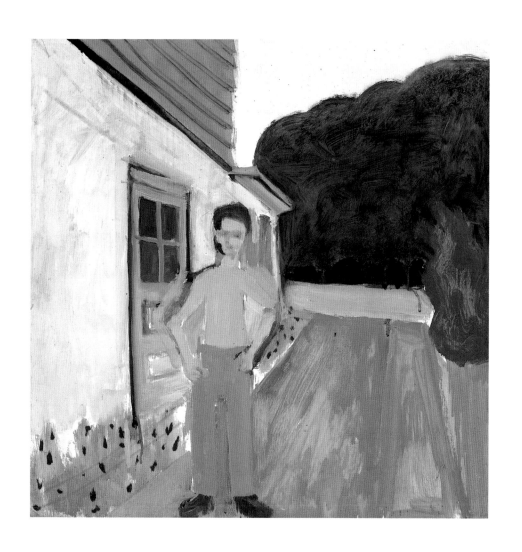

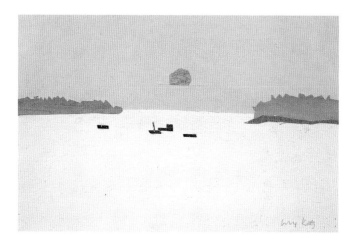

Top: BERNARD IN DRIVEWAY. 1955

Above: SUNSET COVE. 1957

Opposite: GEORGE'S BASKETBALL. 1957

31

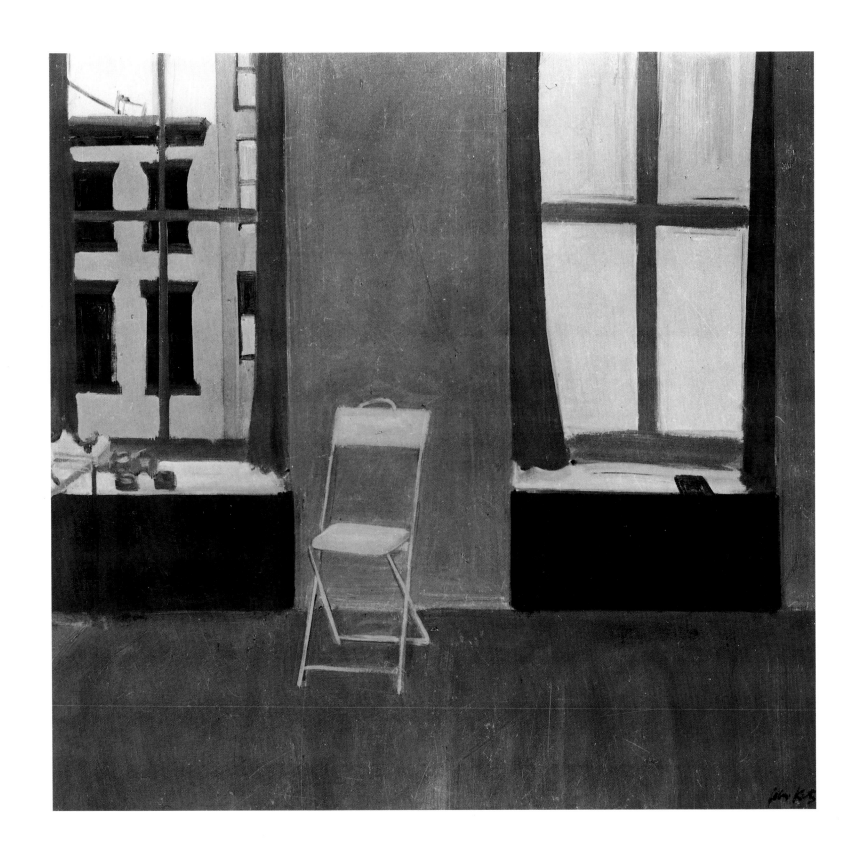

FOLDING CHAIR. 1959

Opposite: LUNA PARK. 1960

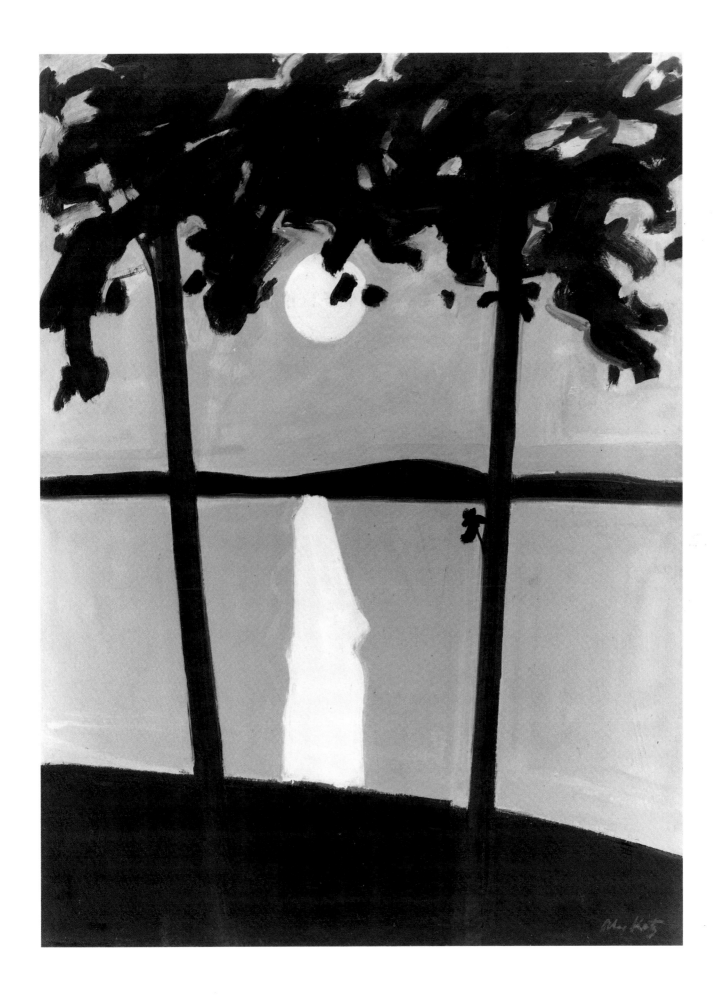

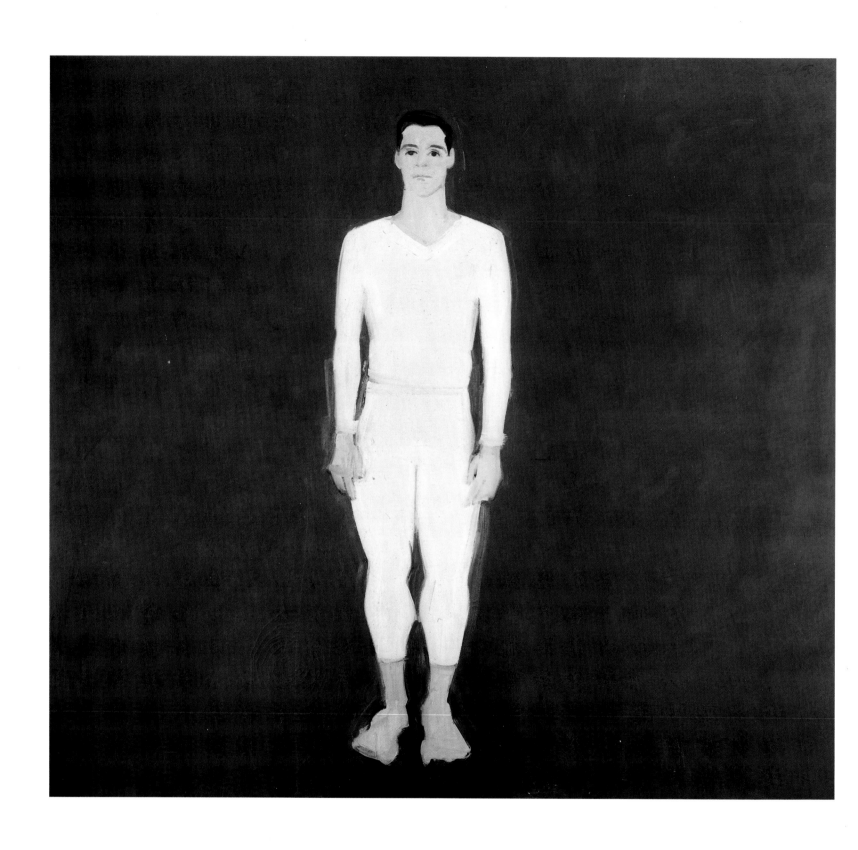

PAUL TAYLOR. 1959

34

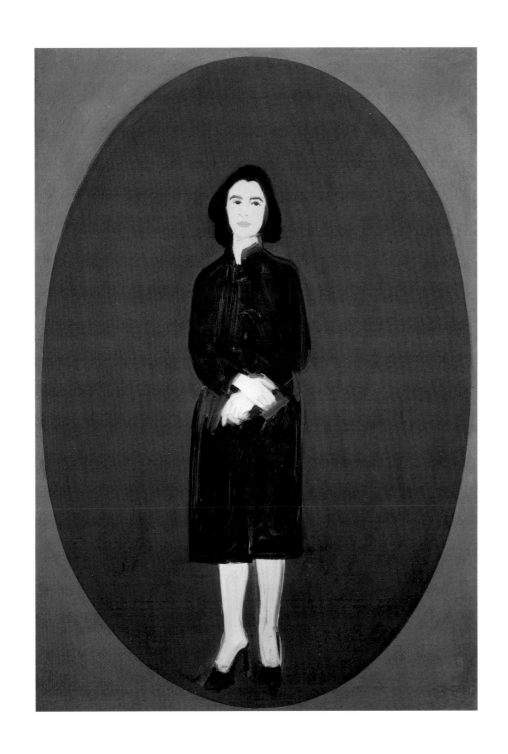

ADA (OVAL). 1959

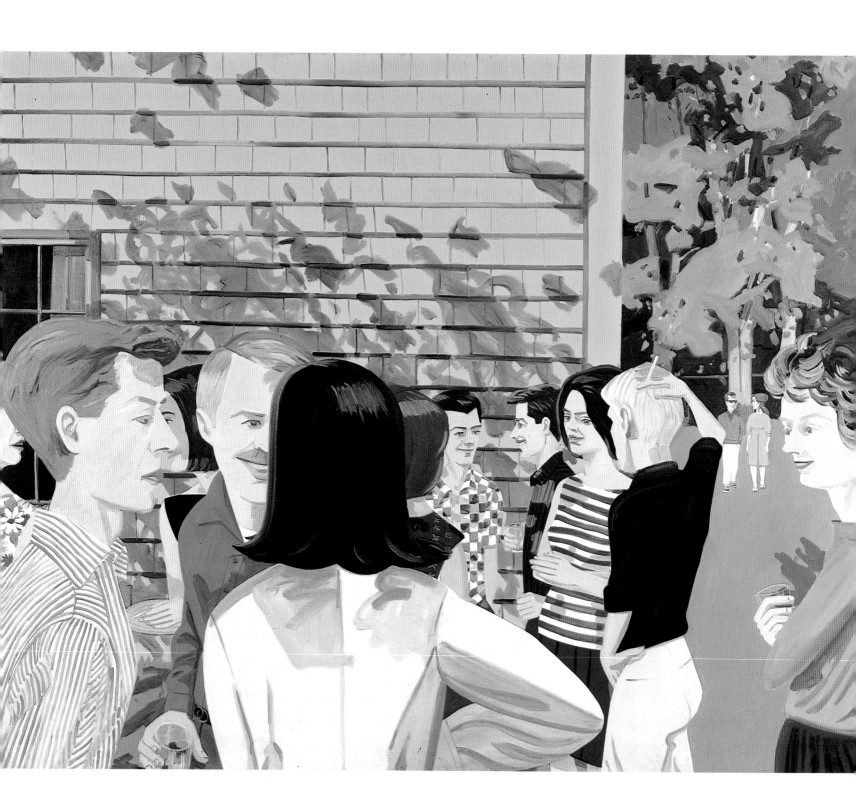

LAWN PARTY. 1965

36

Katz's representational painting based on flat expanses of color was individual, and would become truly unique after 1962. Not only did he again enlarge the size of his pictures and the images within them—now to enormous dimensions—but he further suppressed brushiness and hardened his contour drawing more than he had before. Katz said that he had suppressed painterly facture because it blurred "appearances." But the smooth surfaces and clean contours took on what he termed an "impersonal" look. In fact, Katz was temperamentally averse to "hot" painting that called to mind expressionism. "I prefer cool painters, like Manet." He went on to say that "detachment [was] what I liked in bebop, Stan Getz, John Ashbery, Paul Taylor. All that stuff is impersonal—with fantastic technique."[1]

An individual style does not necessarily command the attention of the art world, but Katz's did. The reason in part, as I see it, is that his work partook of a paradigm shift that was happening in art. Katz's style could not be identified with the avant-garde manner (Gesture Painting), which was in decline by the early sixties, or with provincial figurative tendencies, such as varieties of semi-abstraction as well as older Social Realist, Regionalist, and Magic Realist styles. It clearly related to newly emerging tendencies, notably Pop Art and Hard-edge Abstraction (it might be labeled Hard-edge Realism), that would soon gain recognition. Katz's work was situated precisely in the mainstream of post-Abstract Expressionism. As a result, it was treated as high style and not as retrograde and eccentric.

Katz had scaled up the dimensions of his major paintings when he began to concentrate on specific portraiture. *Irving and Lucy* (1958), the "breakthrough" picture at five feet square, had been the first big jump in size since the start of his career, but others would occur, and each was generally accompanied by a change in style (*The Red Smile*, 1963), or in content (*Lawn Party*, 1965). Katz had begun to enlarge his pictures, in part because he wanted them to be aggressive enough to "stand up visually against anything else being painted at the time."[2] In moving to bigger dimensions, Katz replaced with canvas the pressed wood board he had been using as a painting surface, since large sheets of wood board were prone to warp and chip. As his painting became smoother and more controlled, he no longer required the hard surface of board to resist quick brush stabs.

After 1960, increases in painting size were often accompanied by shifts in internal scale, which made the images even more enormous. In *Passing* (1962–63), for example, a six-foot-high frontal portrait of Katz's own head and shoulders, the face looms in the picture space not only because it is larger than life but also because it is cut off at the shoulders and below the tip of a towering hat. Even more daring because of the way the image is cropped is the ten-foot-long *The Red Smile*. The left half of the picture is all red, and the right half is entirely filled by a profile head and neck of Katz's wife, Ada, cut off at the top of her forehead and behind her ear. Thus the image seems considerably larger than the physical canvas.[3] Katz, however, did not always rely on size to augment internal scale. Several of his monumental images are relatively small in dimensions: three works of 1965, for example, a double portrait, *Donald and Roy;* a medium-size *Upside Down Ada;* and particularly a 22-by-39½-inch *Portrait of Elaine de Kooning,* audaciously and surprisingly sliced right at the lip line.

Katz also remained interested in jumps in internal scale, such as those found in his earlier collages. He often juxtaposed tiny figures in the background against huge fragments of figures in the foreground. In *Ives Field #2* (1964), the distant ballplayers make the close-up, cropped faces appear more enormous by contrast. Yet the small holds its own against the big, revealing at its most extreme Katz's mastery of shifts in scale. Perhaps

the most extreme scale disjunctions are to be found in giant close-up portraits of flowers Katz painted in 1966 and 1967, in which small and delicate stems and petals grow to monumental scale while remaining intimate.

Beyond Katz's ambition to have his paintings compete visually with big abstractions, and his growing confidence in his ability to deal with outsize canvases, there was another reason for his increases in size and scale after 1960. Katz recognized that applying colors in large expanses made them more intense: more of a blue, for example, made the blue bluer. In this he adopted the attitude toward color of Henri Matisse, an attitude shared with Mark Rothko, Barnett Newman, and Clyfford Still of the New York School's first generation, and passed on to Ellsworth Kelly, Raymond Parker, Morris Louis, Kenneth Noland, and Al Held of Katz's own generation. Using a large format also enabled Katz to provide more information about his sitters while meeting the demands of two-dimensionality. And large dimensions allowed him to model the images more than he had before—but with broad brushstrokes that yielded planes of color—thus heightening his representation while retaining flatness, particularly after 1970.[4]

Katz was also inspired to enlarge his canvases by his awareness of how much the contemporary sense of scale had changed. Stimulated by ubiquitous close-ups in movies and billboards, he painted works such as *The Red Smile*. In taking cues from commercial imagery, Katz anticipated the Pop artists. He would not, however, appropriate images of mass-produced commodities directly. Nor would he employ the techniques of commercial art, such as silk-screen and stencil, as Warhol and Roy Lichtenstein did. Instead, he adapted to his own style some of the compositional devices in popular culture. Although Katz influenced Warhol and Tom Wesselmann he was rarely exhibited with the Pop artists.[5] Nonetheless, the affinities to Pop Art in his work gave evidence that his painting was truly contemporary and not backward looking, just as its flatness and crisp contours related it to the newest Hard-edge Abstraction.

References to gigantic cinematic and advertising images enabled Katz to avoid the look of old art while renewing traditional concepts—using the untraditional to reanimate the traditional, as it were. In 1964, I

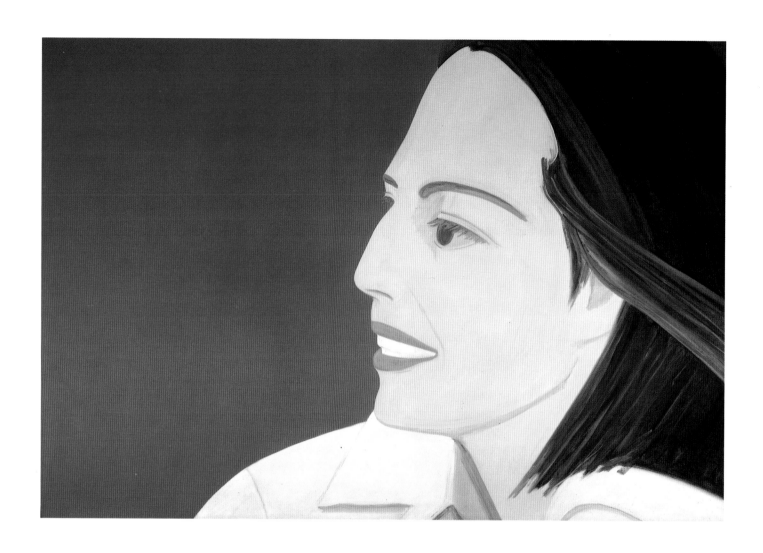

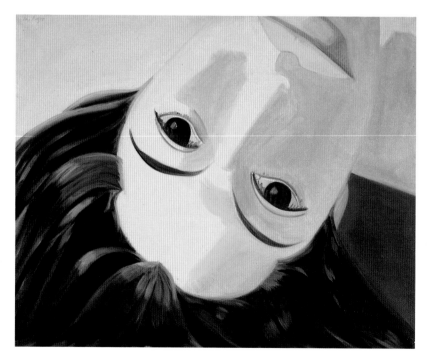

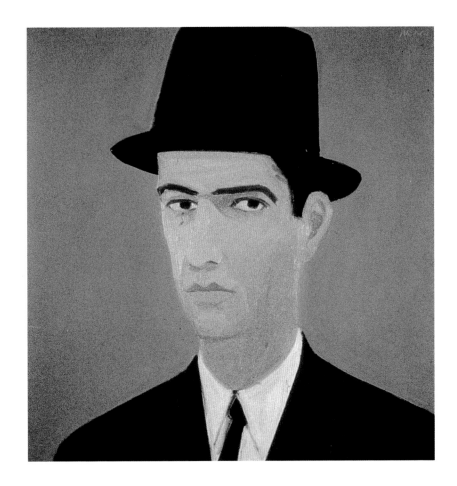

PASSING. 1962–63

Opposite above: THE RED SMILE. 1963

Opposite below: UPSIDE DOWN ADA. 1965

wrote that a cropped portrait of Eli King "is as delicate and tender as any Rococo cupid. But on a road sign scale it is daring [and] dramatic. . . . The tension between Katz's love of tradition and his response to what he sees about him underlies his painting." *Eli* simultaneously recalls billboard advertising in which cropping acts to thrust forms forward dramatically for the sake of visual impact, and Degas's paintings, in which cutoff images suggest "that a world existed outside of the picture frame."[6] In their monumentality, Katz's portraits recall the epic representation of historic notables in past art, while in their intimacy, they refer to humble genre themes, two kinds of subjects that are rarely linked.

41

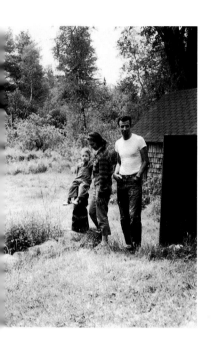

Vincent, Ada, and Alex Katz in Lincolnville, Maine, 1962.

Katz's allusions to billboards struck Robert Rosenblum as peculiarly American. Rosenblum observed that in Katz's paintings "particular people from the artist's daily domestic and social life (wife, son, friends) are suddenly wrenched from the cozy intimacy of a European tradition of private portraiture and relocated disconcertingly in a territory whose scale is that of public, urban experience. . . . Katz intuitively reflects a constant factor in American life, the collision between the public and the private."[7] Katz himself said that he was attracted not only by the dimensions and cropped images of billboard advertising, but also by their "flashy and straightforward ways of representing recognizable things."[8] He was also impressed by the sudden impact a billboard made, what Edwin Denby called "the optic flash associated with advertising,"[9] or, in aesthetic terms, immediacy.

After years of having drawn pictorial ideas from billboards, Katz in 1976 designed a maquette fifteen inches high by eighteen feet long intended to be translated into an actual billboard. This project was realized the following year in New York City's Times Square. Composed of twenty-three portrait heads of women, each a heroic twenty feet high, Katz's street sign extended friezelike for 147 feet along two sides of the RKO General building, and wrapped in three tiers around three sides of a sixty-foot-high tower. This billboard was a sensationally successful work of "high" art inspired by a "low" art medium and executed in that medium by professional sign painters under Katz's supervision. Indeed, his two-decade-long interest in the size and internal scale of billboards contributed to the sign's success as art, for it enabled him to work naturally in one of the world's most hectic settings. Katz's picture belonged to its site in a way that few other public murals did, since most were created in the studio and simply plopped out-of-doors with little if any consideration of the demands made by their surroundings.

In 1960, at the time he was enlarging the format of his pictures, Katz was asked by choreographer Paul Taylor (on the recommendation of Edwin Denby) to design the set for a dance to be presented at the Festival of Two Worlds in Spoleto, Italy. This commission enabled Katz to work on a scale far greater than any of his paintings at the time. For this and later

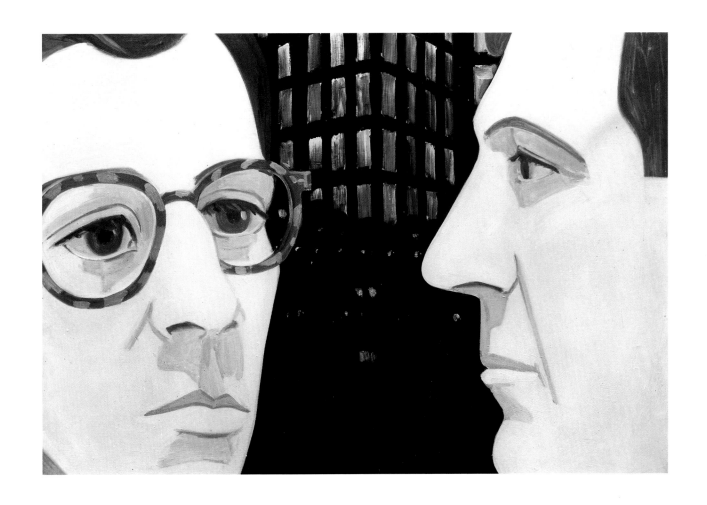

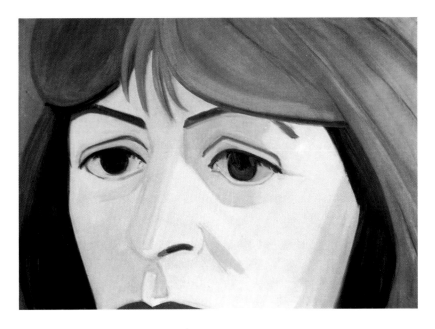

Top: DONALD AND ROY. 1965

Above: PORTRAIT OF ELAINE DE KOONING. 1965

similar assignments he did not fashion backdrops and props as much as create environments for the dancers to move in. As Katz said: "I do not think that sets or costumes should decorate a play or a dance. Rather they should interpret the spirit and present it as strongly as the play, dance, acting, and staging."[10] He was given complete freedom by Taylor, who, as Katz recalled, would try anything, so sure was he of himself, but who would be capable of throwing out an entire set, even on opening night.

Taylor trusted Katz because he sensed that they were kindred spirits, in a word, "cool."[11] Both insisted that their art be antipsychological. Relating the two artists, Jed Perl commented: "The first solo that Taylor choreographed for himself was *Epic* (1957), in which he wore a business suit and performed abrupt but ordinary movements that he later referred to as 'interesting street gleanings.'. . . Denby recalled [that *Epic*] was 'set to a tape of the voice on the telephone, "When you hear the tone, the time will be. . . ."'"[12]

Katz was most daring in his work for Taylor. He said about one set: "Across the street from my loft was an apartment house with many windows. I could see what was going on [but] only bits and pieces of it. I decided to make a set like that and talked to Paul. This became *Private Domain,* 1969. The set consisted of a taut dark purple curtain at the stage apron with three rectangles cut out. The dancers had to dance behind it. Paul was taken by the challenge of it. What I had designed was killing the center of the stage. Wherever you were, you would see a different dance. . . . Paul responded by [choreographing] three dances. It was fascinating to see because it didn't reveal itself all at once. . . . It was wonderful. Regarding the costumes of *Private Domain,* Paul said, 'How about underwear? I've been to parties like that.' And I said, 'How about bathing suits?' The women's costumes were shiny two-piece bathing suits, satin or rayon. The shininess gave a slightly removed eroticism. The idea for the piece came first and the music next."[13]

Alex and Vincent Katz in New York studio, 212 West 28th Street, 1961.

Katz and Taylor found working with each other so satisfying that they collaborated on six more dances, the latest premiering in 1986. Katz recalled: "I learned a lot doing sets and costumes in terms of scale." Taylor also taught him about "gestures and relationships between people," that

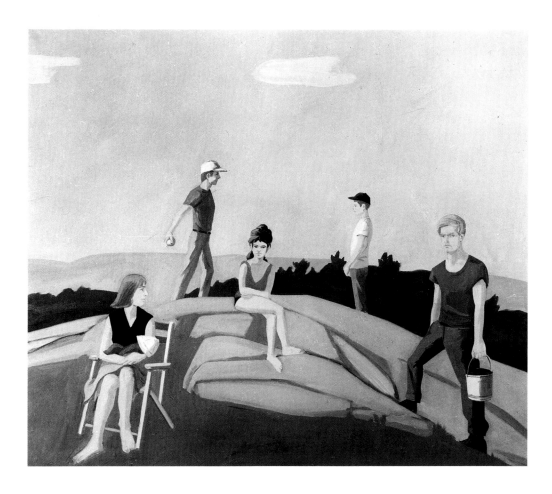

IVES FIELD #1. 1964

"all your pieces don't have to be the same [and] never to be complacent towards the public."[14]

Katz's successful collaboration with Taylor prompted requests for theater sets from friends who wrote or produced plays. When a play seemed to relate in sensibility to his painting, he occasionally agreed. (Theater was in Katz's blood, as it were; his mother had been an actress, and his father had performed in amateur groups.) In 1962, he designed the set for Kenneth Koch's off-Broadway production *George Washington Crossing the Delaware*. It consisted of some twenty nearly life-size painted wood cutouts, including Washington crossing the ice-jammed river in his rowboat, British redcoats and American bluecoats, Old Glory and the Union Jack, and even a cherry tree. The cutouts provided a perfect setting for the delivery of such lines as the following from the father of our country: "I am tired and I need sleep. Good night, America." The collaboration of Koch and Katz was a

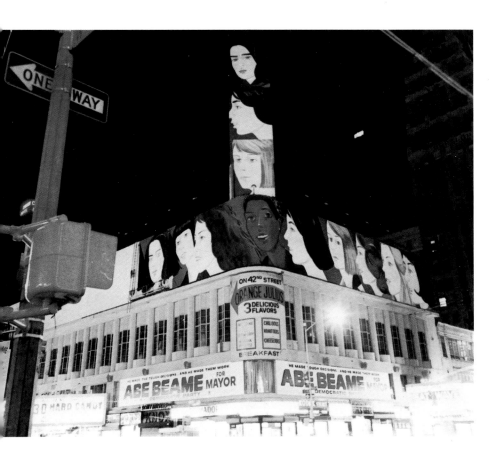

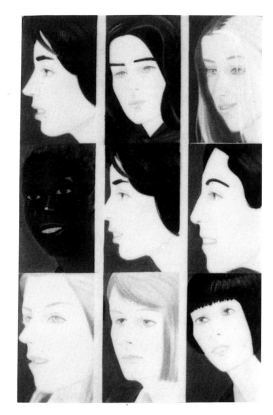

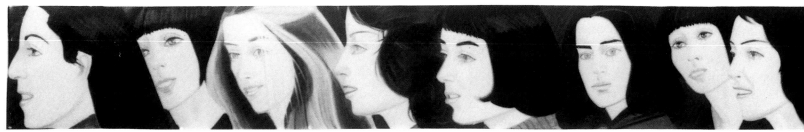

Top, left: TIMES SQUARE BILLBOARD in progress. 1977
Photograph by Rudolph Burckhardt

Above: Maquette for TIMES SQUARE BILLBOARD. 1976

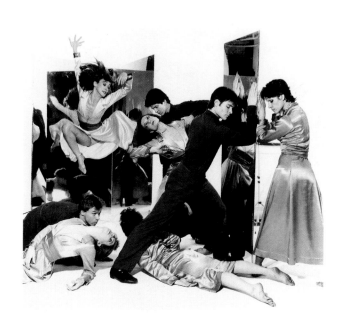

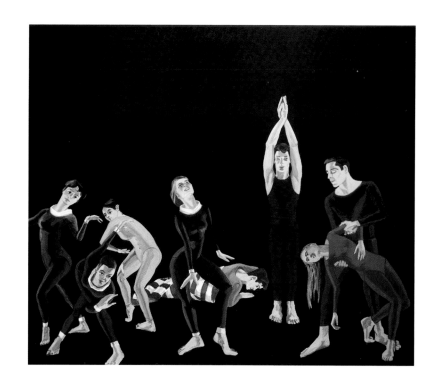

Top, left: LAST LOOK. 1985. Choreography by Paul Taylor. Set and costumes by Alex Katz
Photograph © 1985 by Jack Mitchell. Paul Taylor Dance Archives, New York

Top, right: PAUL TAYLOR DANCE COMPANY. 1963–64

Alex Katz with a cutout
self-portrait, 1968.

particularly happy one, for both shared a sophisticated, deadpan way of making the banal seem fresh. Like Katz's other cutouts, those in Koch's play pit illusion against reality. His wooden soldiers double for live performers, raising provocative questions about the relationship between "real" actors and "fake" props. Katz treated the props that he himself made as he would any of his canvases or cutouts, painting them with his characteristic finesse. In its own right, the set for *George Washington Crossing the Delaware* was exhibited at the Martha Jackson art gallery in 1962.

Other ensembles of cutouts that Katz began to make in the 1960s were also huge and/or environmental, emulating the size of his paintings. *One Flight Up* (1967–70) is a crowded party scene composed of thirty-eight more or less life-size head-and-shoulders cutouts painted front and back and placed in long rows at eye level on a stagelike table whose dimensions are roughly fifteen by four feet. *Rush* (1971) is more of an environmental work than *One Flight Up*. It consists of thirty-nine heads, each fourteen inches high, attached to the four walls of a room, the interval between the units adjustable, according to the space in which they are installed.

In 1965, as if in reaction to the ever larger size of his paintings and ensembles of cutouts, Katz began to make prints. He did so because he wanted to see how the images of his big oils would look in a small format in another medium. Moreover, he thought of the prints as replacements for reproductions, somewhere in between "genuine reproductions" and "surrogate paintings,"[15] but not inferior to his canvases. Indeed, he recognized that such prints as *The Red Band* (1979) and *Red Coat* (1983) were among his finest works.

The subjects of most of Katz's prints are his own paintings—*Luna Park* (1965), *White Petunia* (1969), *Swamp Maple 4:30* (1970), or *Anne* (1973). The prints resemble the paintings (and preliminary studies) in that they are flat and spare but differ because they are simpler. Because of the limited number of colors that are possible in printmaking compared to oil painting, prints cannot achieve the finish of painting. Emphasizing the "nature" of prints, as it were, Katz further cultivated this crudeness by overlapping colors roughly and leaving gaps between them.

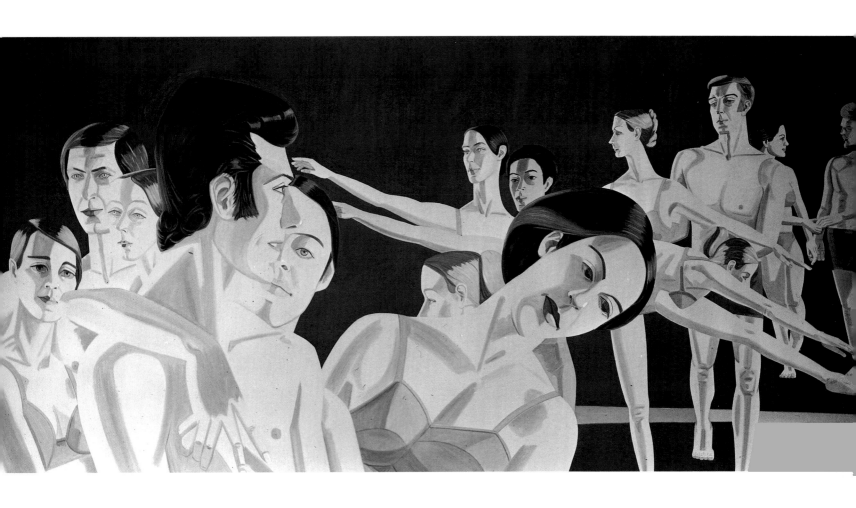

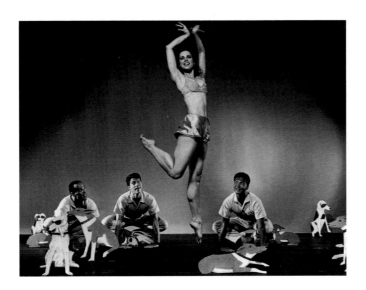

Top: PRIVATE DOMAIN. 1969

Above: DIGGITY. 1978. Choreography by Paul Taylor. Set and costumes by Alex Katz
Photograph © 1994 by Jack Mitchell. Paul Taylor Dance Archives, New York

ONE FLIGHT UP. 1968

Katz decided early on to "do something a little different—technically—in every print, just to extend the range."[16] In *Luna Park,* for example, he experimented with opaque inks, and in *Rowboat* (1966), with transparent inks. In *Alex at Cheat Lake* (1969), he combined a photo-offset lithograph of himself with a handmade, flat-bed lithograph of a landscape, and in *Ann I* (1970), he made a lithograph of a drawing. By 1996 he had executed more than 250 print editions (all but 3 since 1969), establishing himself as one of the leading contemporary printmakers.[17] Working on the scale of prints led Katz to collaborate with poet friends on books, among which are *Interlocking Lives* (Kulchur Press, 1970) with Kenneth Koch; *Selected Declarations of Independence* (Z Press, 1977) with Harry Mathews; and *Fragment* (Black Sparrow, 1986), with John Ashbery.

Because of the growing size of Katz's paintings, he could no longer work entirely from live models—it would have required too much of their time. He had to rely on small on-the-spot pencil and oil sketches in which he captured likeness and fleeting light. That is, he had to paint indirectly. In time, he developed a set practice. Having had an idea for a painting, say a large group portrait, he would decide on the size of the canvas, or canvases, for he often made multiple pictures of a subject in different sizes, preparing each by coating the canvas with gesso and several layers of white lead. He would then invite designated friends to his studio or someone else's space and make oil sketches of them. Katz once described the evolution of *Rose Room* (1981): "I got the idea for the painting a year before and couldn't get it out of my mind. It was like a vision. It *was* a vision. I saw only . . . three middle-class couples in large-patterned rose furniture. The lighting had a

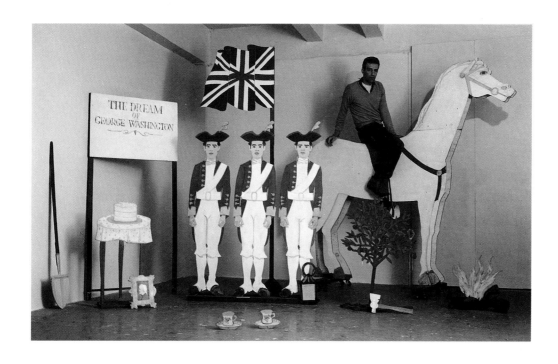

Stage set for Kenneth Koch's GEORGE WASHINGTON CROSSING THE DELAWARE
with Alex Katz on horse, 1962

great flatness to it. It was incandescent but it almost felt like fluorescent.
The effect of the vision was similar to the commercial photos of [Paul]
Outerbridge, the A&P ads—they're total bananas." Then, at a large gather-
ing at Jennifer Bartlett's house, "I started drawing everybody. I ended up
with ten people—it was more interesting than the idea I had had."[18]

Next, Katz invited his subjects individually to model for him. His
aim at this stage was to define the pose and gesture of each sitter and the
light. He would enlarge some of the sketches into full-scale cartoons, lay
them out on canvas, decide on the composition, and transfer them onto
canvas by pricking holes in the paper along the contours of the image and
dusting burnt sienna dry pigment over it. He then mixed the oil pigments
he was going to use.

After weeks of preparation, Katz would finally be ready to paint,
having had a picture "all preplanned and premixed."[19] The painting itself
was a matter of hours, executed in one concentrated shot in order to keep
the surface fresh and fluid. As he said, "painting a twenty-foot painting, wet

on wet for six hours, you have to know what you are doing."[20] And you had to have the technical mastery to do it. Nonetheless, as he worked, the process quickened. "When you paint, the performance part, you have to let your conscious mind go and float. You may know what color is going on top of what color, but the marks you make have to come out of your unconscious." As for revisions in the process of painting, Katz said: "You have to adjust your idea immediately, because you're trying to do something that's past your consciousness in painting. Your conscious brain is . . . constricted to previous experiences." On-the-spot improvisations short-circuited preconceptions.[21] Katz's studio practice was traditional in the sense that it proceeded from life sketches to carefully worked out compositions.[22] In the end, however, "the painting will never look absolutely how you thought it would."[23] And the result often surprised him.

Most of the changes Katz made while painting were dictated by the need to achieve a single light in each of his pictures. This was challenging enough, but he made things even more difficult for himself by introducing diverse light sources into a single work. In *October #2* (1961), for example, Katz subtly recorded the interaction of natural inside light and outside light. A related canvas, *Impala* (1962), shows Ada inside a shadowy automobile in a bright landscape.

Other pictures are more extreme in their light contrasts. In *Donald and Roy* (1965), the cropped heads are in an artificially lit room but are silhouetted against the city at night. Most dramatic of all is *Roof Garden* (1975), in which two figures are seated within a trellised enclosure through whose diamond openings sunlight casts a configuration of diamond highlights that are at once corporeal and translucent. Katz's most complex contrast of diverse lights is found in *The Light #2* (1975), a picture of Carter Ratcliff lighting Phyllis Derfner's cigarette in dimly lit room in front of the image of *Walk* (1970), whose subject is Alex, Ada, and Vincent outside their house in Maine. *Twilight* mixes indoor evening light in the picture and outdoor morning light in the picture of a picture (*Walk*) in the picture.

Painting from sketches and drawings rather than on the spot enabled Katz increasingly to invent compositions on the one hand, and on the other, to focus on style—while retaining the *appearance* of things—and

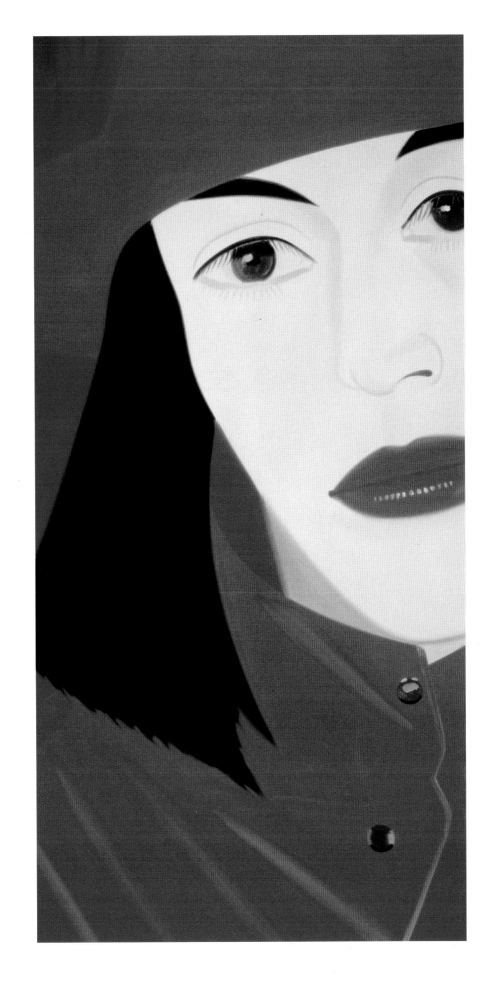

RED COAT. 1982

53

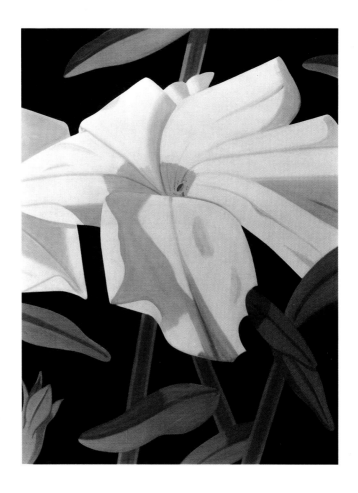

WHITE PETUNIA. 1968

that remained a major aim for him. He had always *arranged* his imagery, adjusting it to make it look right. Now he deliberately *composed* with pre-conceived and increasingly complicated ideas of design, that is, with artifice, but without sacrificing representation. But artifice had come just as naturally to Katz as rendering appearances. After all, almost from the first, he had condensed and flattened his images and had then magnified them. Manipulating composition enabled him to devise new pictorial structures and, thus, to continually renew his painting.

The range of Katz design can be viewed in a comparison of his two paintings of Paul Taylor's troupe of dancers. *Paul Taylor Dance Company* (1963–64), the first of the deliberately composed pictures, and *Private Domain* (1969), one of the most extreme. The earlier canvas, at 7 by 8 feet, consists of figures of more or less the same size aligned across a stage. It looks the way a dance company performing before an audience actually

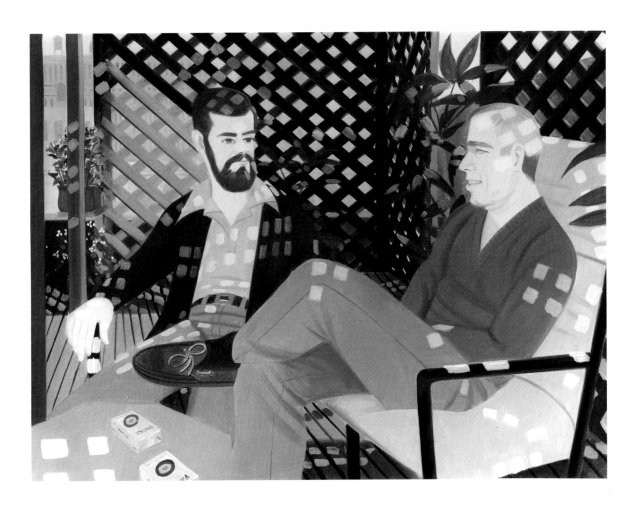

ROOF GARDEN. 1975

appears. The gestures are artificial, but that is what the dancers are doing naturally. In *Private Domain* at 9 feet 6 inches by 19 feet 6 inches, the artificiality is carried into the design of the painting. The dancers' stylized gestures now constitute a studied—choreographed—structure of taut horizontals and verticals varied with diagonal thrusts. The left stage is filled with a mass of intricately overlapped large, frontal and profile heads, shoulders, and chests of five dancers. From this layered group a sixth figure leans out to the right, extending to more than three-quarters of the picture width. In the right background, in counterpoint to the massed image in front, is a complex of seven full-length figures. These figures constitute an open and linear configuration that stretches toward the left across almost two-thirds of the picture. The lower edge of the canvas cuts the figures on the left at chest level, but most in the upper right are contained within the picture space as if within the natural space of a stage.

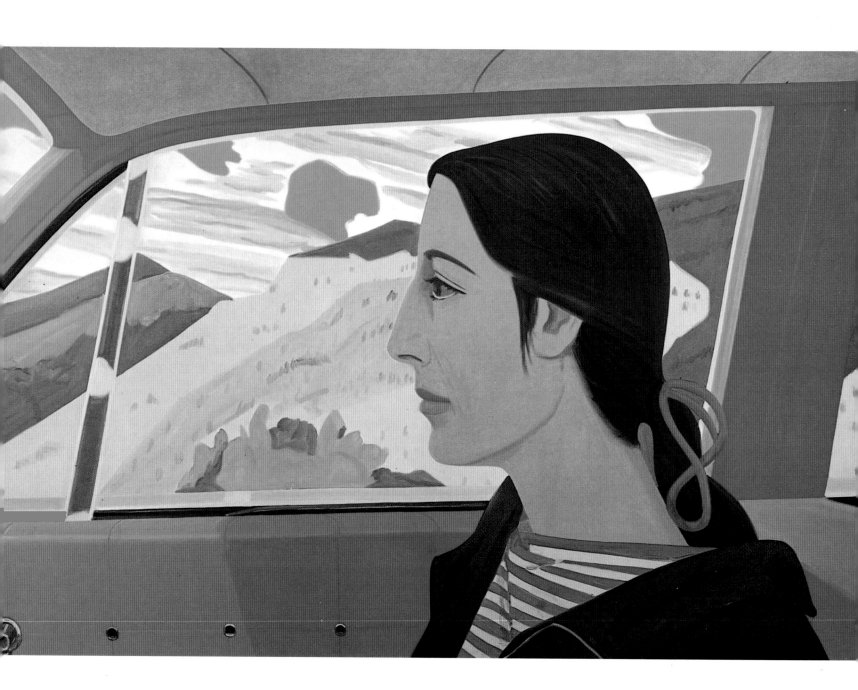

IMPALA. 1968

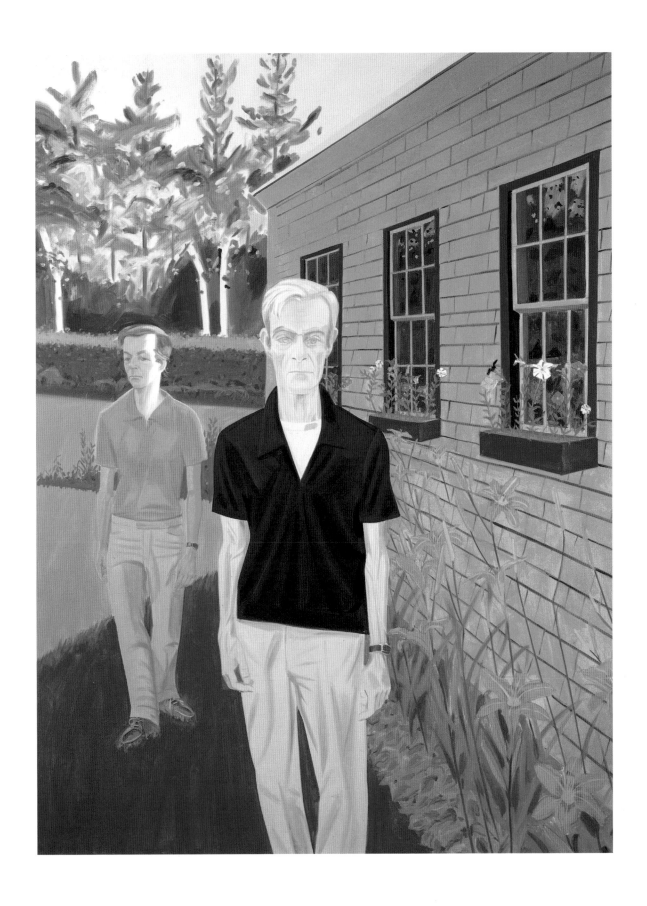

AUGUST LATE AFTERNOON. 1973

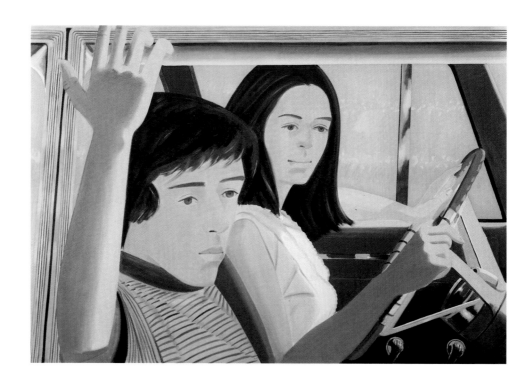

ADA AND VINCENT IN THE CAR. 1972

Other compositions of this period are equally inventive—and star-
tling. One of the most provocative is the off-balanced design. In *August
Late Afternoon* (1973), a house angles into two-thirds of the picture space
on the right. The remaining third shows a landscape in which two figures—
Edwin Denby followed by Rudy Burckhardt—walk toward the viewer. A
comparable spatial scheme characterizes *Supper* (1974), in which three
persons in the right of the picture are seated off-axis at twelve, two, and
five o'clock around a circular table jutting in from the left. In a different
vein, in *Swamp Maple 4:30* (1968), the eye swoops from a tree cut off on
top and bottom, which appears to project out at the viewer, into the far dis-
tant hills. *Ada and Vincent in the Car* (1972) is also marked by a startling
recession of planes, from the boy's arm (in outdoor shadow) projecting out

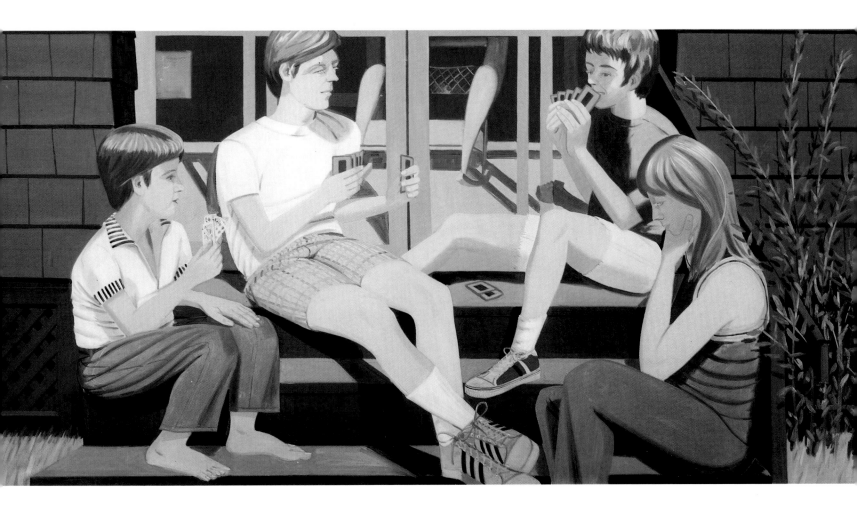

SUMMER GAME. 1972

of one window—and seemingly into the viewer's space—through the interior of a car (in indoor shadow), to a grassy meadow seen through the opposite window (in outdoor sunlight). In *Summer Game* (1972), the side of a cutoff house is so identified with the picture plane that the children sitting on the steps playing cards appear to be located well in front of it, thus carrying the sense of outward projection to its fullest pictorial limit.

Almost from the beginning of his career, Katz forged an individual style in the interface between representation and artifice, that is, by rendering appearances and painting flatly. Style would become his primary consideration. It was not something superficial, like stylization, which he said "is a cheap way to make handwriting identifiable," but was found at the core of his being—the Katzness of Katz.

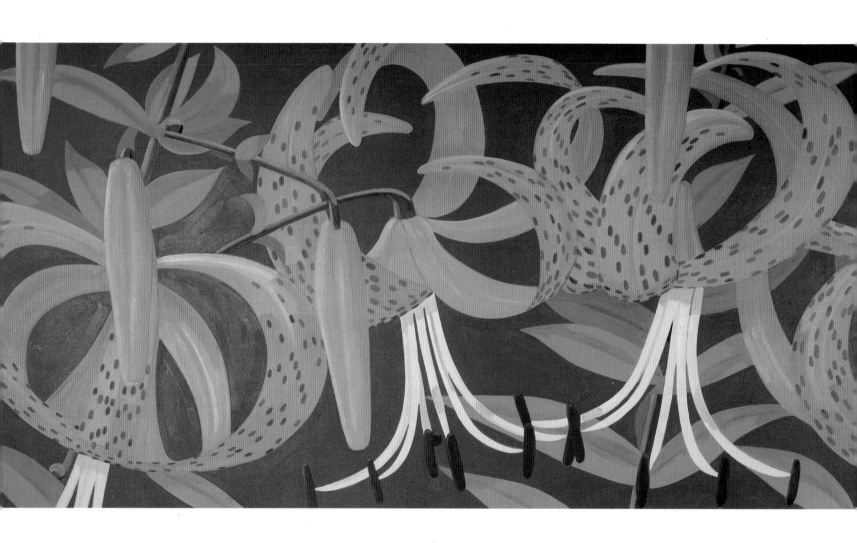

SUPERB LILIES #2. 1966

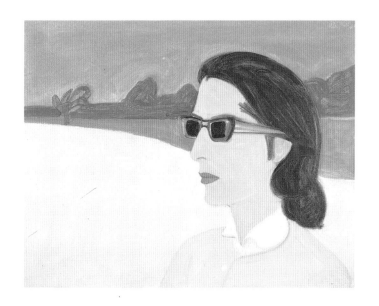

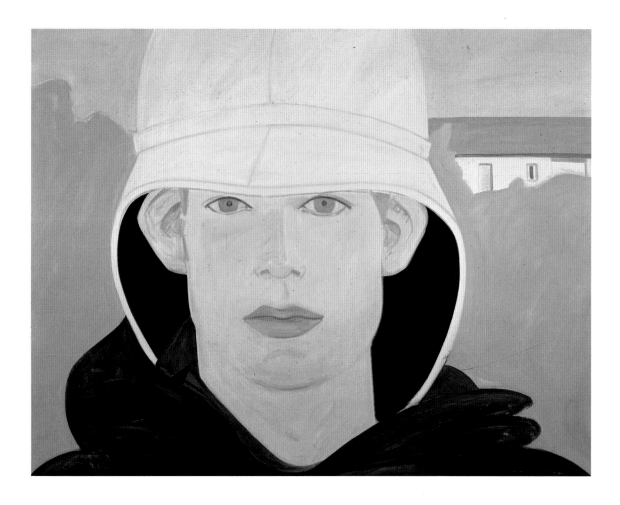

Top: VIEW. 1962

Above: ELI. 1963

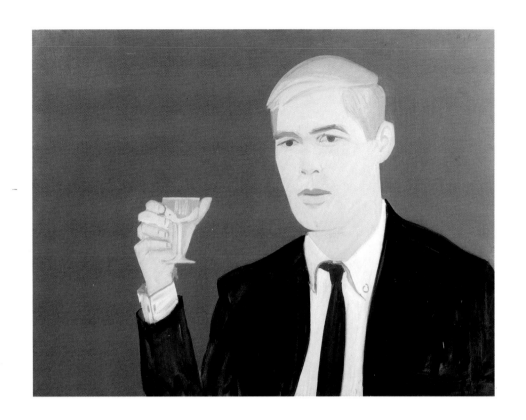

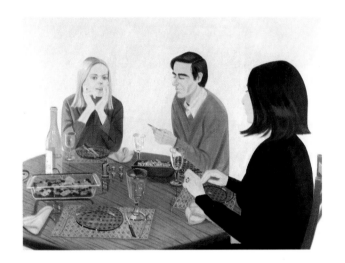

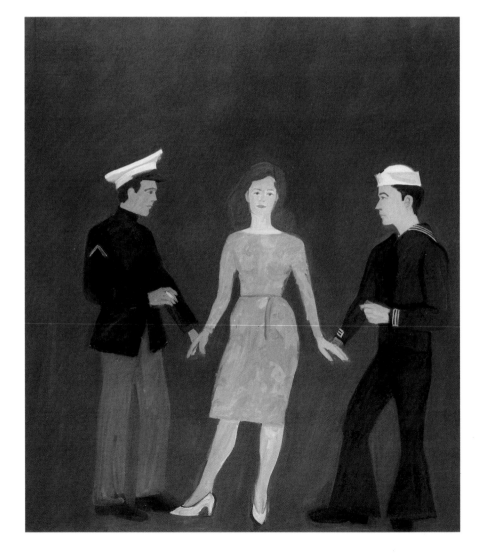

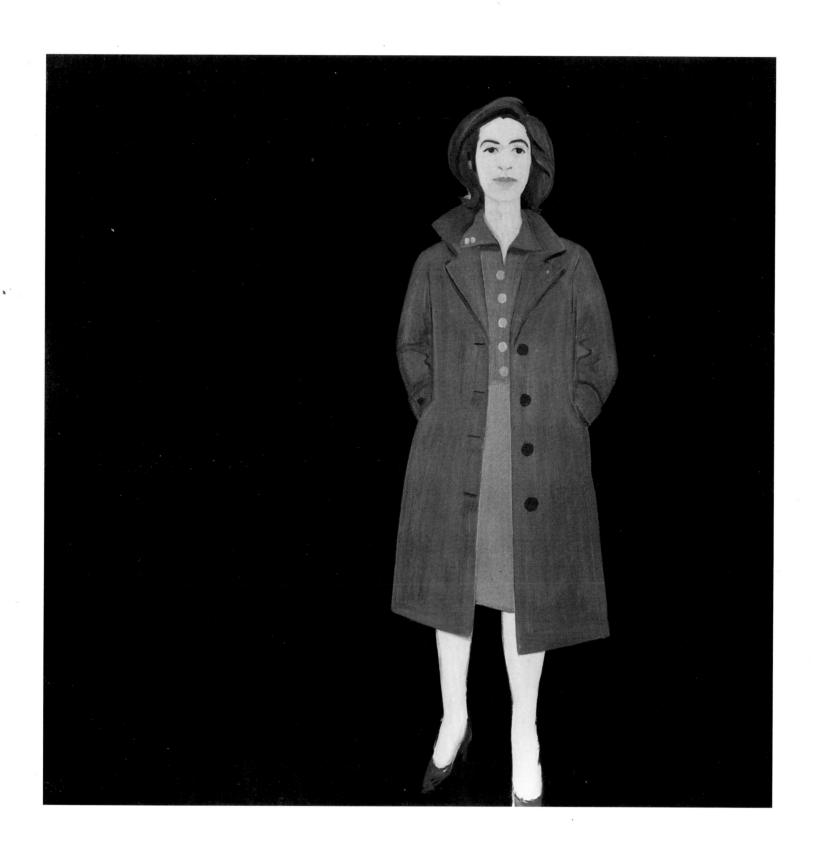

Above: THE WALK #2. 1962

Opposite, below right: ROCKAWAY. 1961

Opposite, top: HERE'S TO YOU. 1961

Opposite, below left: SUPPER. 1974

63

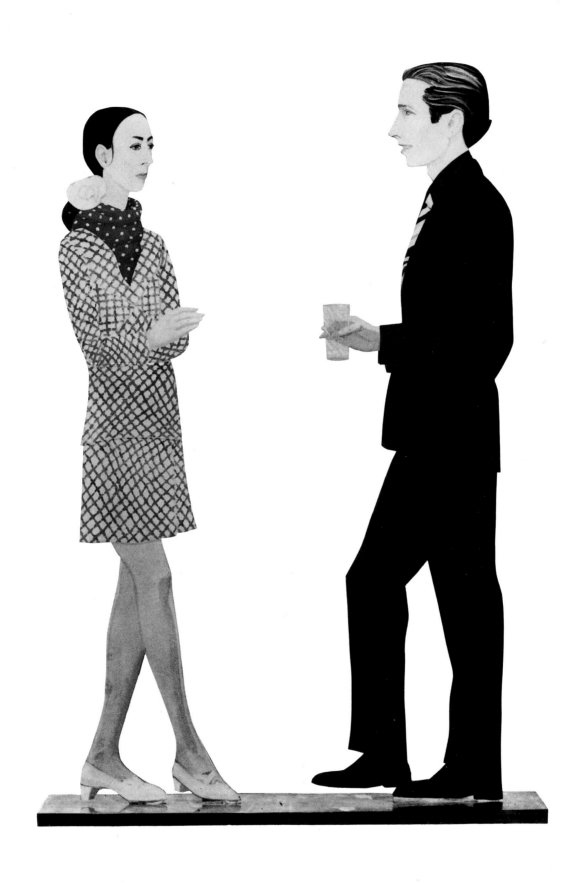

JACK AND D. D. RYAN. 1968

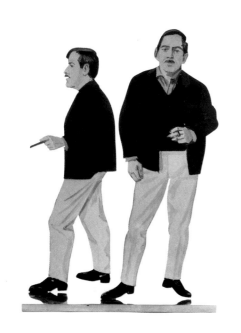

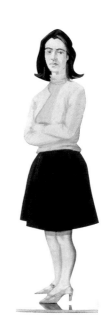

Left: HOWIE. 1966

Right: ADA. 1966

ROAD #1. 1962

JANUARY #4. 1962

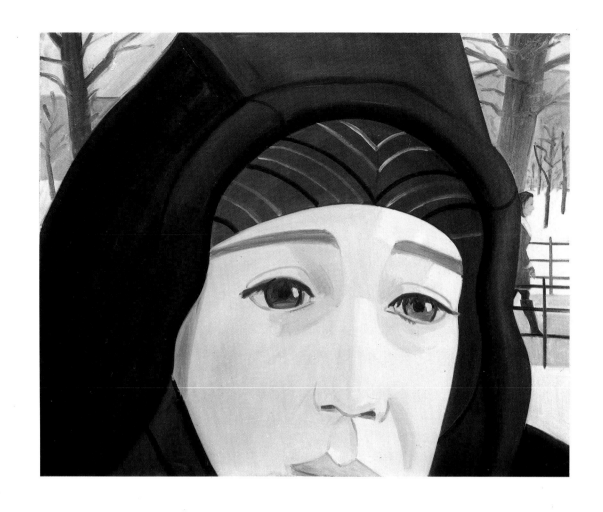

Top: VINCENT IN HOOD. 1964

Above: LEROI JONES. 1963

68

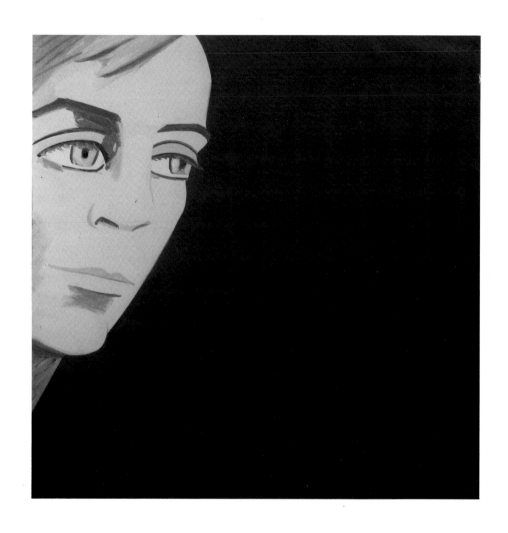

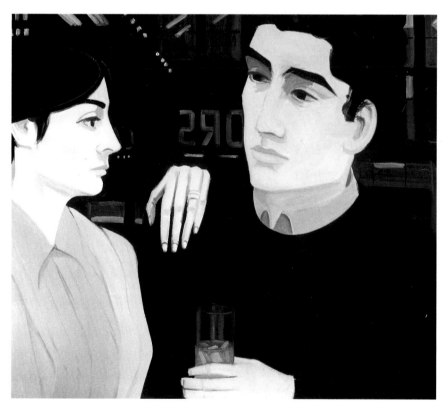

Top: PAUL TAYLOR. 1964

Above: FRANK AND SHEYLA LIMA. 1964

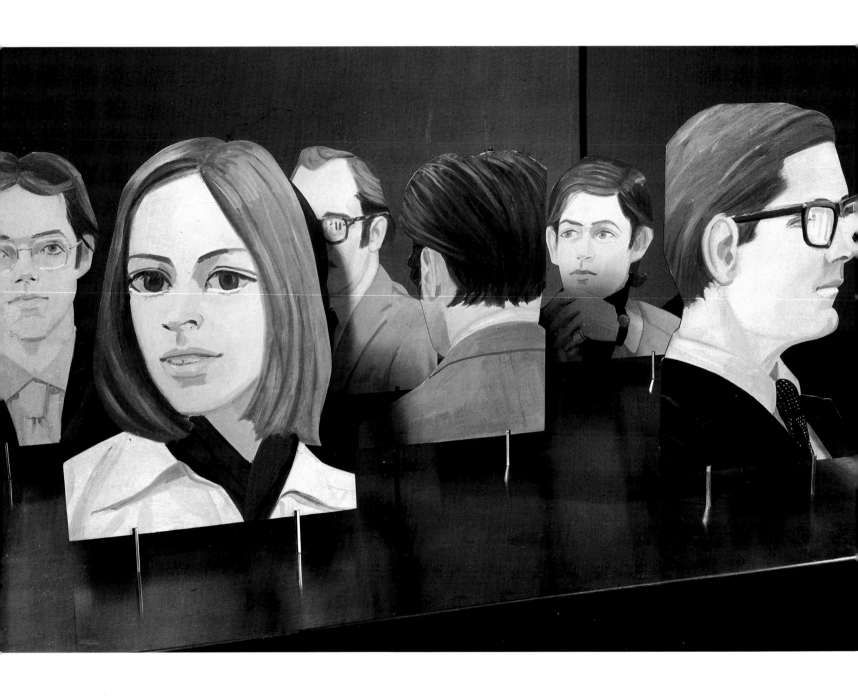

ONE FLIGHT UP, details left, center right, and right sides. 1968

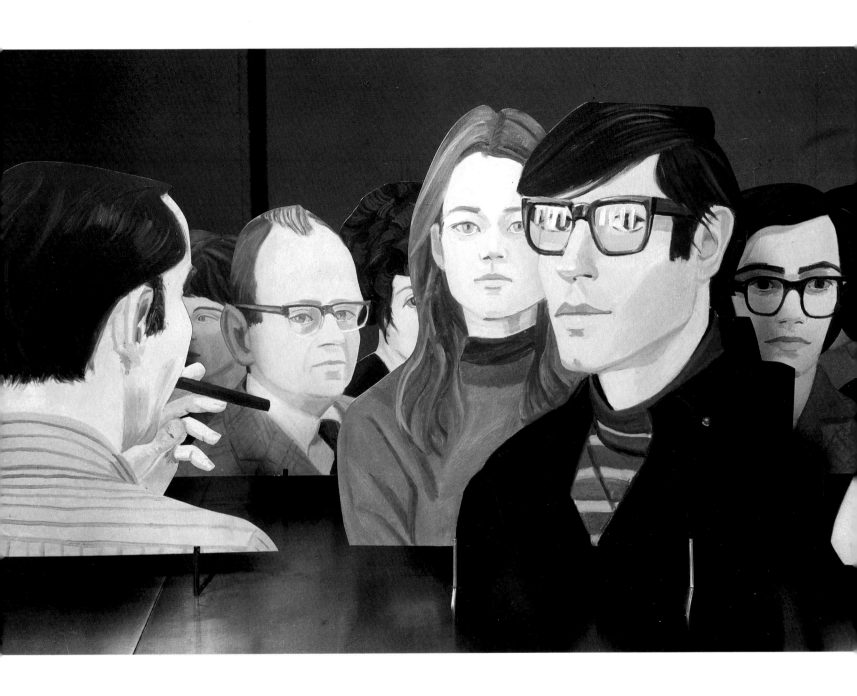

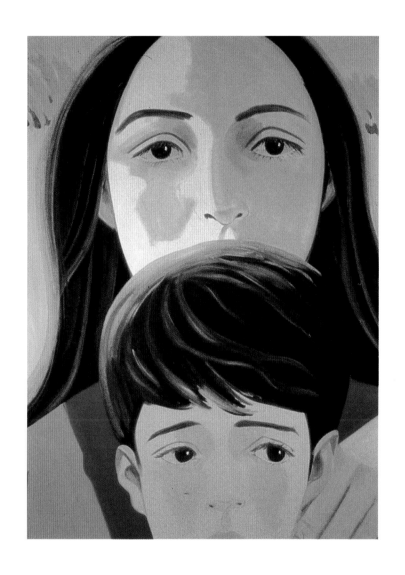

ADA AND VINCENT. 1967

Opposite: VIOLET DAISIES #2. 1966

JOHN'S LOFT. 1969

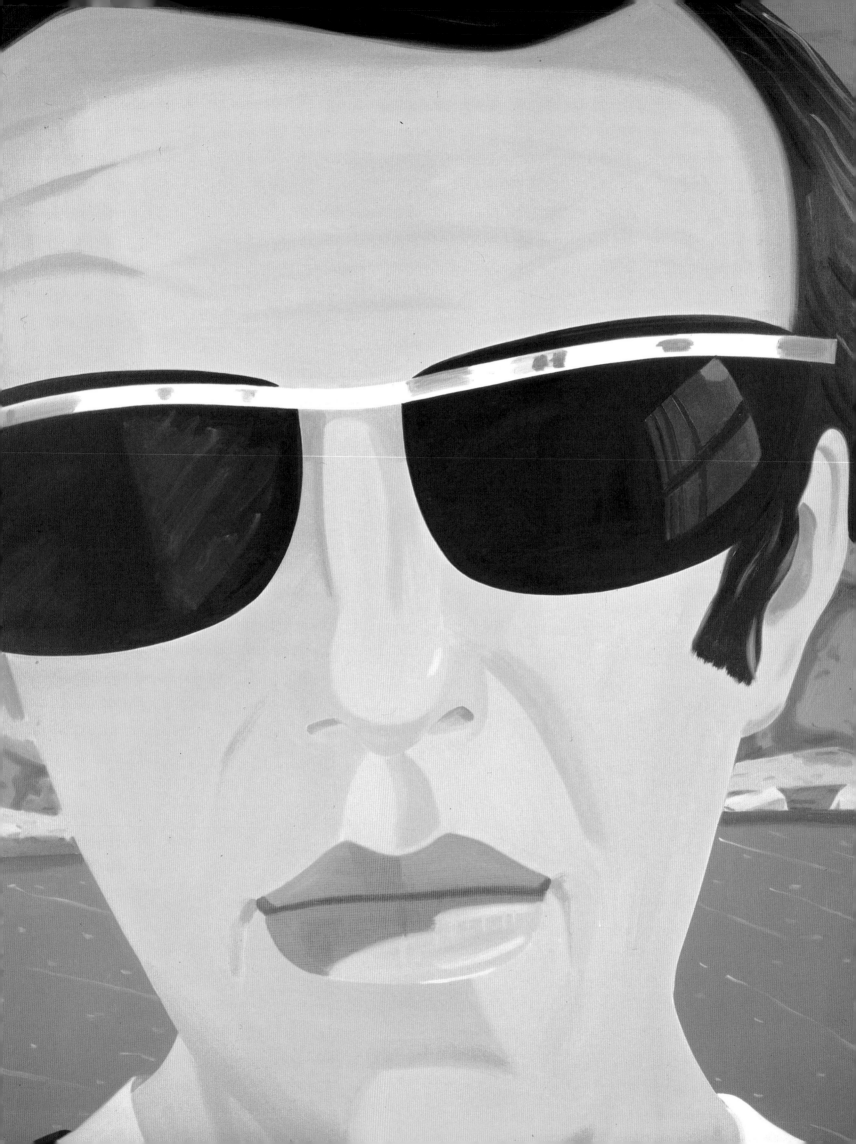

Chapter 3:
THE WORLD
OF A
MODERN
DANDY

After 1962, Katz's primary subjects—his wife, son, and growing circle of artist, poet, and dancer friends—remained the same, but his interpretation of his sitters changed. No longer were they disheveled bohemians of the Eisenhower 1950s. Now, in the affluent Kennedy years, they appeared sleeker, trimmer, smarter (their hair coiffed to look unkempt), more stylish, and grander, as if they had achieved a certain success in the world—which they had.

The election of John F. Kennedy to the presidency in 1960 had closed the stifling Eisenhower era and had given rise to a new cultural climate.[1] Kennedy was charismatic, literate, rich yet politically liberal, and youthful, and as important, his beautiful young wife, Jacqueline, was at one and the same time culture- and fashion-minded, coupling culture and fashion with little loss of either seriousness or glamour. The art world was beguiled by Kennedy's "cool." His style emerged in sharp relief against Nixon's "hot" during their television debates, and it contributed greatly to his election victory.

In response to their new status, Katz and his friends became the dandies of the 1960s, as poet and critic David Antin commented,[2] and as American society grew more affluent and consumerist, they became even more worldly and fashionable. The change is evident in a comparison of Katz's self-images—his rough, guileless *Self-Portrait (Cigarette)* (1957) and *Self-Portrait* (1960), with the street-smart, wary but confident *Passing* (1962–63), and with the suave, man-of-the-world *Self-Portrait with*

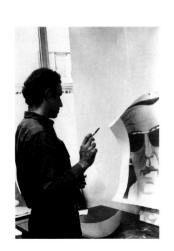

Alex Katz with a working print of *Self-Portrait with Sunglasses*, 1970.

Sunglasses (1969). The changes in content are also expressed in the jumps in size from approximately 2½ feet to 6 feet to 8 feet. In a more recent self-portrait, *Green Jacket* (1989), Katz strikes a pose between a Renaissance nobleman and a basketball star. His knowing facial expression discloses much about him, and so does his stylish garb. Indeed, dress in most of Katz's portraits becomes a kind of extension of the sitter, defining his or her personality. A comparison of this late self-portrait with one of 1960 reveals not only a great deal about what had happened in Katz's life in the two intervening decades, but also about American society as well.

In an essay that consummately defined the cultural phenomenon of dandyism, Charles Baudelaire wrote that the essential attribute of the dandy was to be a sharp observer of contemporary society and its culture, particularly attentive to what made it contemporary.[3] Katz would have agreed, and himself said that "physical appearances are always changing and . . . it is correct to have the new subject matter in a new style. The focus of the new (re-seen) subject matter and the new style makes the work part of a specific time and easy to identify in terms of time."[4] Indeed, the dates of Katz's pictures can often be determined by the styles of dress worn by his subjects: for example, 1959 for Rauschenberg's "suntans, open collar, and rolled-up sleeves," and 1983, for David Salle's "shiny black sharkskin suit."[5] A sitter can be identified, moreover, by his or her fashion, as Bill Berkson did when he called *Self-Portrait* (1960) "an Arrow shirt ad," and Ada in *Salute* (1962) "a Grant's girl."[6]

Baudelaire discovered his age's distinctive "gait, glance, and gesture" in *"the outward show of life,* such as it is to be seen in the capitals of the civilized world." His exemplary painter of "modern life," Constantin Guys, chose his themes from "the pageantry of military life, of fashion, and of love."[7] So did Katz's hero, Manet. Katz, too, looked to the life of the city for subjects, although not to soldiers and prostitutes, who were no longer the prototypes of contemporary dandyism. He chose his models instead from the semiprivate world of New York's avant-garde, for its members were of the moment and, moreover, were in Baudelaire's words "in love with *distinction* above all things," wanting "to create . . . a personal originality."[8] As

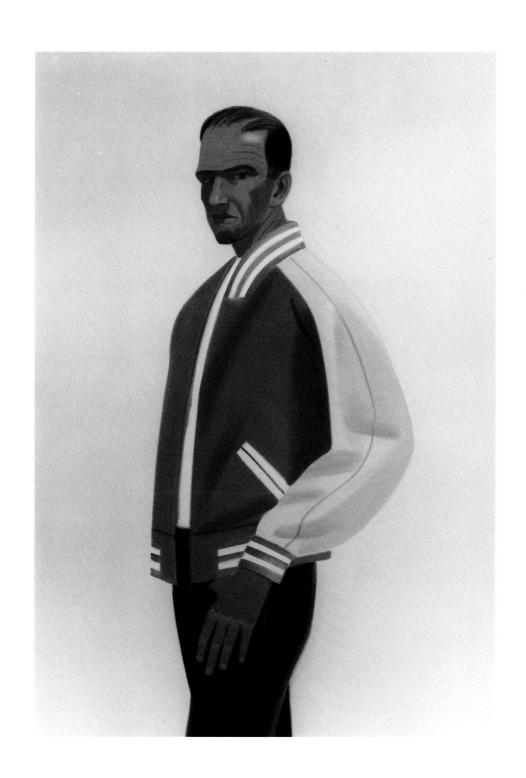

GREEN JACKET. 1989

abstraction commanded growing art-world attention, dandyism, as in the pictures of Guys and Manet, declined and then fell into disrepute. It was one of Katz's accomplishments to have rehabilitated this type of expression.

Katz's subjects are dandyish in a special sense. David Antin wrote that "they are well enough known for most people at all familiar with the art world to know that they are known, though not always well enough known to know who they are. That is to say, they are what we may call 'secret celebrities.'"[9] Katz respects the fame of his sitters because it is worthy of esteem, generated as it is by their lively, original minds and serious, creative efforts, and by the kind of physical beauty and natural grace that derives in part from their manner of living and artistic activity. Theirs was style at its highest.

In contrast to the bohemians of the 1950s, Katz's dandies, beginning in the 1960s, were at home in the world of fashion. Indeed, from the 1960s onward American culture differed from that of the earlier decade partly in the coming together of the world of fashion and the cultural meritocracy, a social development that could not help but affect a realist artist like Katz.[10] The lifestyle and art of the 1950s were heated, tending to be emotionally and anxiously self-revelatory, alienated, and frenetic. In contrast, the subsequent decades were cool and reserved, at ease and assured. Where the one was inward looking, the other was outer directed.

The cool that Katz cultivates is conveyed by the smoothness of the painting, by the flatness of the pared-down images, and by their huge size and expansive internal scale, all of which distance the subject from the audience. Flatness reduces the illusion of graspable corporeality and, paradoxically, brings the image closer to the viewer. Bigness causes viewers to back away so that they can take in all of a picture. To sum up, Katz and his sitters are cool in their self-projection and so are his representations of them.

After 1964, Katz increasingly portrayed groups of figures in each picture. The figures do things and go places more than in earlier canvases. Major works are often of parties, picnics, dinners, and other ordinary social events and rituals, notably *Lawn Party* (outside his summer house in Maine) and *The Cocktail Party* (in his New York studio), both of 1965; *One Flight Up*

(1967–70); and numerous pictures of the 1970s, '80s, and '90s, such as *Round Hill* and *The Place* (both of 1977), *Rose Room* (1981), and *Basketball* (1991).

Katz's attitude toward his subjects was primarily documentary. As he said: "I tried to show a segment of our time and our crowd. That's the way we looked at that time, that's what we did [in the sixties]. We drank and smoked cigarettes. Right! All those things, like the black dress, were social things at the time."[11] As conversation pieces, Katz's group portraits are related to Frank O'Hara's gossip-filled poetry, and it is not surprising that O'Hara was one of Katz's most sympathetic and acute critics.

Many of Katz's friends had been poor at one time and had lived bohemian lives, but most had originally come from the middle class. With growing affluence, they had reentered it. In representing them, Katz depicted their class—sympathetically. Rob Storr pointed out that avant-garde artists generally "have mocked the bourgeoisie great and petty for most of this century, but have rarely paid close attention to it. Nor have they readily acknowledged themselves . . . as a part of the same milieu." Because he was candid in recognizing his social status, Katz has been "*radically* middle class." (Italics mine.) Storr went on to say: "Like all radical stances, Katz inflects every aspect of his activity. His landscapes, thus, bear its imprint as strongly as his gigantic faces or crowded interiors. . . . A tree in the foreground, a cottage across a lake . . . the moon or setting sun on the water. This is the stuff of tourist brochures and Katz knows it. What's more he likes it that way. In pastoral terms [they] are the outdoor equivalents of his indoor scenes of enviable conviviality."[12]

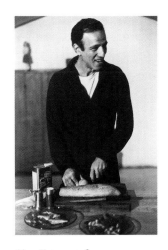

Alex Katz, 1976.
Photograph by Blaine Waller
for the Museum of Modern
Art's *Artist's Cook Book*.

Katz portrayed his sitters' distinctive outward show of life, as manifest in their leisure activities, perhaps because, as contemporary dandies, it was only this aspect of their being that they were willing to reveal in public. He did, however, suggest, if inadvertently, their personalities and intimate interpersonal relations. Most who attended Katz's social gatherings and appeared in his paintings were not strangers to each other but friends, artists in various fields who shared the fellowship of creativity. They had a common bond or group identity. They understood that each wanted to exhibit a vivid social self, a dramatic presentation of the way one desired to

appear in the company of one's peers—but they could read each others' private feelings, joys, anxieties, tensions, and doubts, and so could Katz. He claimed not to pay attention to the body language of his sitters, but as a sharp observer of appearances, he could not help recording the expressions and gestures that reveal the personalities of individuals and their interactions, how they negotiated their social roles, "appear to one another, how they register in the world."[13] Katz did so in a cool manner which often looked impersonal, but as David Antin remarked, "inevitably characterizes a 'personal style' of loaded restraint, relying on minimal gesture."[14] As Ann Beattie summed it up: "They are at once actors and real people whose inner lives shine through no matter what their positioning."[15]

The settings in Katz's pictures are pleasant, clean, and bright; there is no grime or any sign of the assorted miseries that we know the sitters must experience, despite their "Katz-neat apparel and Katz-cool cocktails."[16] He rejected as sentimental the traditional idea that realist art has to picture life as sordid and brutal. Showing life at its better moments is no less valid. In truth, Katz's painting extends the Western tradition of arcadian painting, exemplified in the pictures of Watteau and Matisse, and the American dream of a natural paradise that was invented by the early settlers of the New World. This idyllic vision is exemplified in *Summer Triptych* (1985), in which three elegantly attired couples promenade across the deep soft light-green grass against a darker green woodland setting. It is as if the decendants of Watteau's voyagers to Cythera had emigrated to Maine.

Many commentators on Katz's work were moved by the easy conviviality of his group portraits, in which, as John Russell observed, "no one has ever looked vicious, nasty, hung-over, left out of the party or bored."[17] Other critics were made uncomfortable; for example, Hilton Kramer, who had long admired Katz's artistry, was repeatedly taken aback by "a certain emotional vacancy" in his work: "It is very explicitly 'our' world—the observable world of contemporary manners and styles, very 'young' and up-to-date in its easy sophistication . . . and its air of untroubled sociability. It is a world in which the darker shades of feeling are, for the most part, unacknowledged. We are not invited to penetrate beyond an amiable and appealing surface."[18]

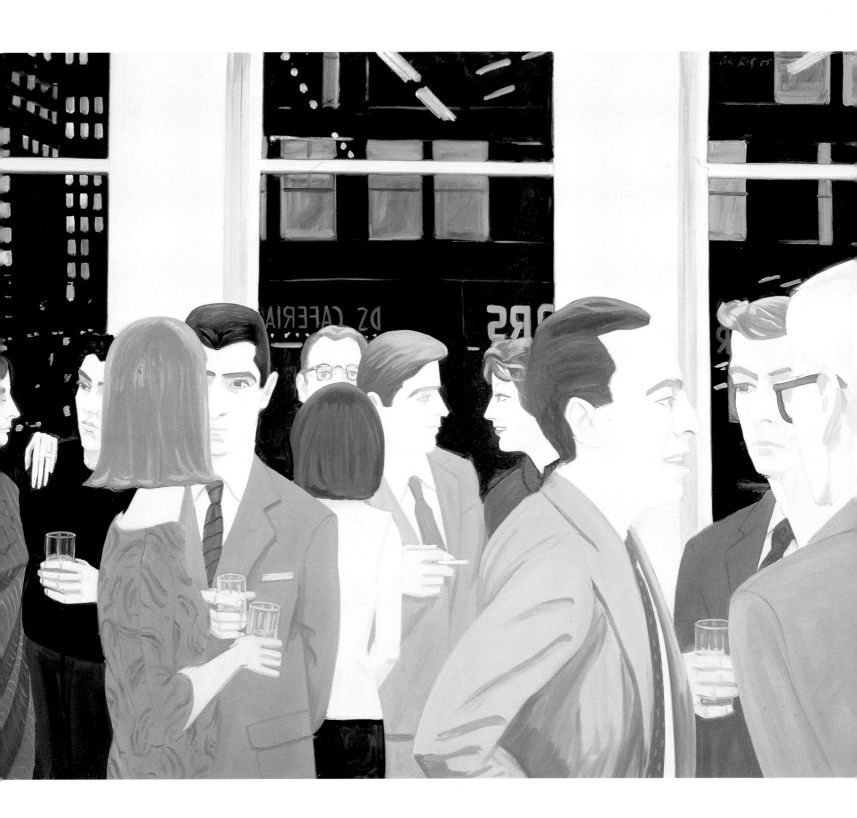

THE COCKTAIL PARTY. 1965

83

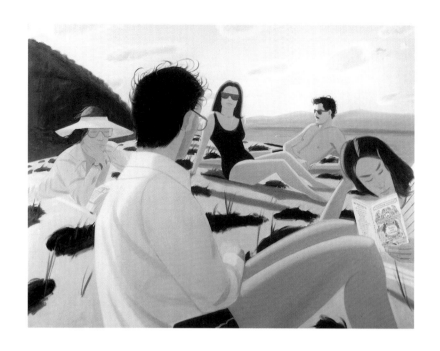

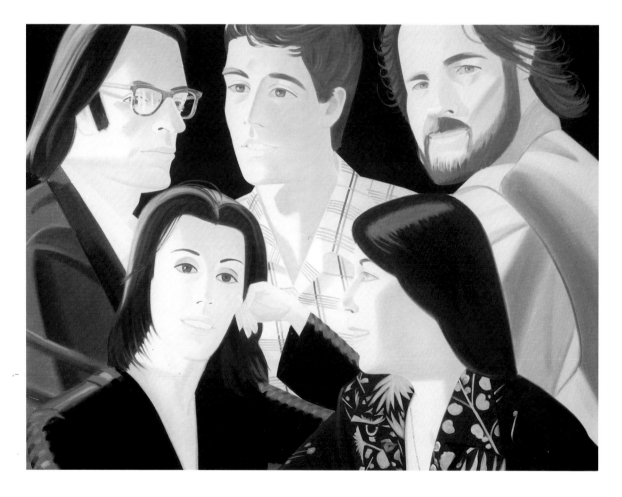

Top:. ROUND HILL. 1977

Above: THE PLACE. 1977

Opposite: ROSE ROOM. 1981

84

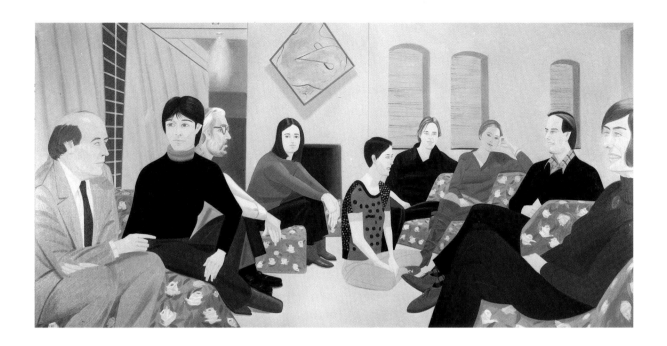

Kramer found this "a shocking notion—an artist in love with surfaces . . . and eager to stake his work on his affectionate attachment to the here and now. So little that we value in modern art has prepared us for such inspired insouciance."[19] Good-humored subject-matter is shocking enough because of its presumed facetiousness, but what is even more aggravating is the aplomb, often bordering on insolence, with which Katz flaunted it on an enormous scale. It may be, however, that he was motivated by a desire to present his milieu as epic, recalling Baudelaire's yearning for "modern heroism."

Nevertheless, because of Katz's cool depiction of appearances and the distancing of his subjects, his work has often been viewed as ironic. Indeed, critics have linked "cool" and "ironic" as if the terms were hyphenated. But irony involves the assertion of something while meaning something contrary. It is duplicitous. With this in mind, John W. Coffey maintained that the repetition of a figure in Katz's "reduplicative portraits" "mocks its precious individuality." He also commented that Katz's self-portrait in *Green Jacket* "strikes a taut, balletic pose in imitation of baroque court portraiture [signifying] power and dominion." But he dressed the figure "not in silk, but in synthetics [yanking] the image back to late twentieth-century reality. The man is not a prince. He is an aging jock."[20] As Coffey viewed it,

the one image subverted the other. But Katz's self-portrait is basically straightforward. In introducing two aspects of his personality, it is more likely that he intended to enrich the content of his representation than to undercut it. Katz's other portraits are equally direct and candid, and, thus, not ironic. Then why the common coupling of "cool" and "ironic"? Dave Hickey suggested that critics who have done so have been blinkered by prevailing social and psychological theories. They could not accept that Katz was serious about documenting his milieu, say a cocktail party, and concluded that he was ironic.[21]

Katz's bright and grand, self-possessed and urbane vision rendered in a seemingly impersonal and impassive, bland style could be unnerving. The most shocked were the socially conscious, who expect painting to provide "statements" about the sorry lot of the world. Moralists of every stripe were also appalled by an art that aspired only to record appearances and did so with what seemed to be "mindless hedonism."[22] So, too, were devotees of Expressionism, who expected a heavy load of psychological and/or existential information and agonizing emotionality, expressed in turbulent brushwork, as in Lucian Freud's portraits.

Indeed, Freud can be considered a kind of antithesis to Katz, as if Katz's worst nightmare. For Katz, clothes are telling signifiers of personality and social occasion; consequently, he has rarely painted the nude. For Freud, flesh, not dress, makes the "man." Katz's sociable subjects, though painted in his studio, are in the world, presented with dignity and tact. Freud's models are more often than not cornered in the studio, stripped of their clothes and hence their social roles, often sprawled on the floor in contorted positions, private parts prominently displayed, amid strewn rags, towered over by the artist. Freud seems to want to make paint stand for repulsive naked flesh, and flesh for the psychology and existential condition of his sitters. In actuality, he does not manage to penetrate beneath the paint-clogged skin of his models. What he does convey is a generalized statement about human beings as pathetic sufferers, ravaged by existence, confronting their mortality and racked by dread, a statement he imposes on his models. Dave Hickey commented, with artists like Freud in mind,

that Katz's mission has been to rescue figurative painting from the throes of private expression and restore it to the social realm.[23] But this mission is also "personal in that it represents what one man *feels* art should be."[24]

But just how inexpressive and impassive is Katz with regard to his subjects? Is each sitter given, as Kramer wrote, "a mask designed to conceal his interior life"?[25] Or, was Bill Berkson right when he said, "Surface is the great revealer"?[26] Are not the expressions, glances, and gestures, even the clothes and hairstyles by which an individual identifies himself or herself, cues to the psyche? And does not an artist, like Katz, who is sensitive to these hints and documents them, present a psychological interpretation of the sitter, even if inadvertently?

These questions were answered in the affirmative by the novelist Ann Beattie in a book on Katz's painting. She proposed to decipher the body language of Katz's characters and their interactions. "I did essentially a pyschological study—not radically different from the world of my fiction [e.g., *Falling in Place* and *Love Always*]." So she wrote, "It is difficult to look at some of Katz's paintings and not imagine that there must have been times when his powers of observation pained him." He "has painted people failing to connect . . . pulling away from one another; he has chronicled the end of relationships that have not yet officially ended. Quite often the light that Katz is so interested in falls beautifully on a world of alienation, sadness, and conflict."[27]

Discussing the psychological and social dynamics in a series of Katz's portraits of couples, Beattie acknowledged that "when more than one person is moved into a frame has as much to do with sociology as with psychology." But she went on to detail their inner feelings. She wrote, for example, of *Red and Lizzie,* that this "couple melds physically; they seem like two people forming a joint entity, yet the fallacy of this is . . . immediately apparent because Lizzie is clearly concentrating on something that has nothing to do with the present situation. . . . Here Katz acknowledges that the couple is out of synch. If they do not know this, the painter knows this, and the audience knows it. . . . This portrait implies a critique. . . . One person is lost in himself, the other is preoccupied, even angry. Lizzie has a harsh look that, sadly, no touch, no other person's swoon can temper."[28] As

Alex Katz (right), Vadim Sidur, and Isabel Bishop at a U.S.–U.S.S.R. Art Seminar, Moscow, 1978.

she summed it up, "what begins as mimesis finally radiates as metaphor."[29] Commenting on Beattie's intepretation, Katz said that she "explained things . . . I wasn't even aware . . . were there. But I do take responsibility for their being there. [If] you can get fully engaged in painting, I think you reveal aspects of your personality, or things that you don't have to be responsible for or even know about. It just happens."[30]

Occasionally, Katz's painting is strange in a manner that might be characterized as Surrealist. *The Black Jacket* (1972) consists of five cropped Adas arranged in a shallow semicircle against a brown backdrop. They range in pose from full frontal to profile. Katz has raked them with a powerful light from the right that severs each of Ada's heads in two, a light and a dark side. Roberta Smith described how *The Black Jacket* becomes "a vehicle for the light." It "warps her face, flattening out her nose, making one eye lighter than the other, and giving her lips a peculiar purse. A section of her hair is also highlighted." However, "The repetition confuses the notion of the light source, since the figure moves back and forth and around, but the light never changes."[31] Although the facial bisection can be accounted for by the lighting, it becomes part of Ada's expression, introducing an arresting and unsettling psychological dimension—Ada as a dual or divided or even conflicted personality. The effect of these four figures gazing out and the one in profile smiling (enigmatically?) is a strange one, a strangeness that the viewer cannot help reading into the matter-of-fact representation.

As the 1960s drew to a close, the challenge for Katz was to transform each of his particularized representations into a synthetic symbol that transcends its time, "a symbol that is clear as well as multiple . . . rather than a sign [whose] meaning is singular." He used the bust of Nefertiti as an example of what a symbol meant to him: "It is a specific woman. It is a beautiful woman. It is realism. It is an aristocrat. It is elegance. It is mother. It is queen. It is power. It is a god. It is steadfast and unchanging and, therefore, security. It is fleeting beauty. It is the unattainable."[32]

Katz's extension of factual notation into symbolism was facilitated by his indirect approach to painting, because it enabled him to take greater liberties with the appearance of things without sacrificing likeness and natural light. He increasingly schematized modeling and details. Katz believed

that his symbols were primarily social and literary, by which he meant that they could be read, not as a story line but as a kind of symbol line.[33]

Berkson recognized the new dimensions in Katz's representation early on, writing that *Self-Portrait* (1960) was "an Arrow shirt ad translated into the gravity of a Coptic funerary portrait," and that in *Salute* (1962) "Ada toasts you head-on as a Byzantine epiphany of the Grant's girl."[34] There are references to mythology—as well as to popular culture—in *Trophy #3* (a 1973 cutout of a boy holding a fish), which suggests a corny photograph and a gesture associated with Greco-Roman art. Allusions to mythology in Katz's work are subtle but clear, constituting one dimension rarely found in modernist art. The very bigness of Katz's portraits mythologizes them. In the 9-by-17-foot *Face of a Poet* (1972), two gargantuan profiles of Anne Waldman looking right and left refer to the Janus head of classical mythology. It also calls to mind Picasso's two-faced images as well as close-ups in billboards and Cecil B. DeMille–type spectaculars.

Ada and Alex Katz at Skowhegan School awards dinner, 1975.

Katz's own Nefertiti was his wife Ada, whom he married in 1958, and who immediately became his favorite subject. To date he has painted her more than one hundred times, far outstripping Velázquez's portraits of Philip IV. She is woman, wife, mother, muse, model, sociable hostess, celebrity, myth, icon, and New York goddess. Katz referred to her as "the all-American girl . . . the Latin beauty . . . her mother."[35] The Katzes' son, Vincent, enumerated other of Ada's roles, "as mother in the Madonna-and-Child-like *Ada and Vincent* (1967), as a fashion statement in *The Black Dress* (1960), as a lover in *Upside Down Ada* (1965), as a woman at home in *Ada with Bathing Cap* (1965), [and] as the mystery woman in *Blue Umbrella #2* (1972)."[36] Art history provided other roles. Beattie commented that Ada's pose in *Parrot Jungle* (1985) is reminiscent of Goya's reclining Maja.[37]

Lawrence Alloway viewed the portraits of Ada as "a paradigm of composure [and] a celebration of vitality and well-being . . . the contemporary extension of active life."[38] Beattie focused more on the enigmatic quality of her inwardness and "a transcendent stillness about her—something we associate with divinity."[39] Jed Perl emphasized Ada's role as celebrity, commenting that as America moved out of the Eisenhower era into the Kennedy years, cultural figures became stars and the subjects of

paintings. Frank O'Hara "set up a line of succession that consisted of Willem de Kooning's *Marilyn Monroe* . . . Katz's series of Ada slightly later, and then (though Katz's Ada series is still continuing) Andy Warhol's series on Marilyn Monroe, Elizabeth Taylor and Jacqueline Kennedy." Indeed, Katz made Ada the First Lady of the art world,[40] and it is no surprise that he painted her in a pillbox hat—Jackie's signature headgear. In a sense, the layered meanings of Katz's work imply a kind of depth, not the depth of Expressionism but of Symbolism.

Just as Katz wanted his specific images to become synthetic symbols, so he wanted them to constitute his unique style, a "high style," which he defined as new and grand, elegant, sophisticated and nonprovincial, visually strong, unique, impersonal and timeless.[41] High style was not narrowed by Expressionist obsessiveness but was expansive, open to multiple meanings.

Katz forged a high style in a number of interrelated ways. His subjects look real, of their moment in time, but they are edited. Certain elements are left out, others stressed, flattened, and distorted. Thus, they are transformed into the inhabitants of a distinctive world of Katz's invention. As Sanford Schwartz observed, "there are faces and flowers, even trees, that could only exist in a Katz—just as there are people who we're sure could only exist in Yoknapatawpha County."[42] Or, as Simon Schama put it, Katz's works "all begin with sensory impression and studious observation but are then worked up into something frankly and magically unnatural: a realm existing within the artist's inner eye."[43]

As a dandy, Katz is alive to contemporary art as well as to contemporary life, responding to what is freshest and liveliest in recent painting. He is what Baudelaire called an aristocrat of taste. He has been able continually to anticipate or respond quickly to provocative moves in art, using his sophistication and knowledge of what has become stale and what is fresh in the painting around him to renew his own style, but on his own terms. Consequently, he has been able to maintain his own direction and not get carried away on other artists' ideas, no matter how novel, exciting, or fashionable each may have seemed. He has recognized that followers may make personal statements but that they cannot create major art.

TROPHY #3. 1973

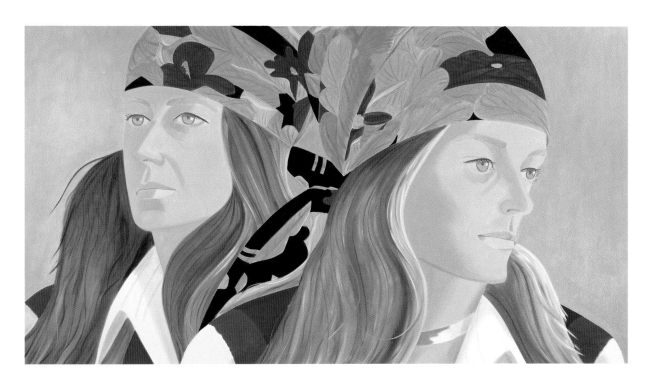

FACE OF A POET. 1972

Because of his interest in up-to-the-minute appearances, Katz has long been attracted to high fashion and fashion illustration, and he has introduced ideas culled from both into his painting. This was risky, since fashion and fashion illustration have generally been denigrated by the art world as commercial and frivolous. But Katz has always kicked up his heels at taboos, and, as Robert Storr observed, chose to scrutinize "the superficialities of fashion . . . for truth-telling signs of the times."[44]

Early cases of Katz's flirtation with fashion are *Karolyn* (1976) and the Times Square billboard (1977). In 1982, *Esquire* asked a group of artists to make use of designer clothes in their art. Katz recalled: "I started with Norma Kamali [and] made two paintings using a yellow coat. . . . I found it challenging to transform the aggressiveness and rawness of advertising into fine art." This led Katz to paint pairs of men and women holding each other; the upshot was *Pas de Deux* (1983), consisting of five panels, each 11 feet high by 5½ feet wide, of "beautiful" couples in stylish clothes who act out a charade of courtship at what seems to be an upscale cocktail party. As well as being fashionable, they "catch perceptible dancelike pos-

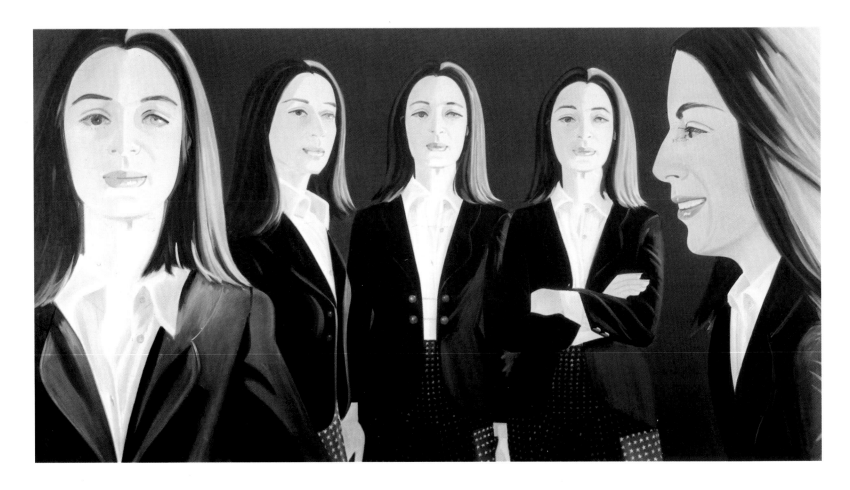

THE BLACK JACKET. 1972

tures in everyday life, postures that are part of the theatrical forward thrust of character associated with contemporary New York."[45] *Pas de Deux* may be viewed as a social realist picture because of its depiction of a significant American phenomenon, although old-timers would probably not accept it as such. Because of its references to fashion, moreover, the five-part picture can also be considered a sophisticated variant of Pop Art, but avoiding, as Katz commented, "the predictable social content of Pop Art, which is just illustration, however ironical it may or may not be."[46]

In 1984, Katz followed up on *Pas de Deux* by painting *Eleuthera,* a four-panel picture whose overall dimensions are 10 by 22 feet. Each of the sections contains two frontal, glamorous young women in Norma Kamali swim suits against a blue sky. The subjects are friends of Katz who could pass for fashion models. He diverts attention from fashion illustration to bravura painting technique by highlighting the frieze of figures with rec-

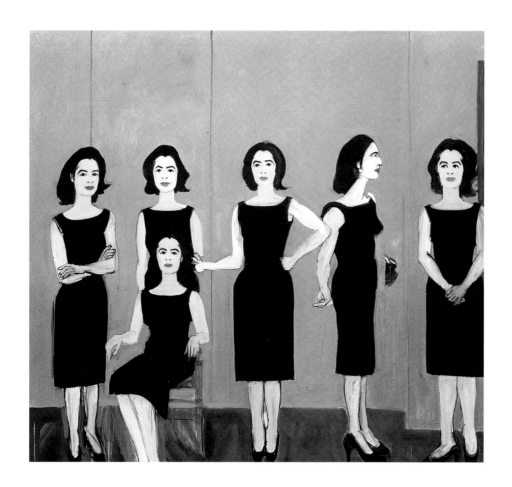

THE BLACK DRESS. 1960

tangular swatches of white pigment that are echoed in the wisps of clouds.

Katz is well aware that high style and high fashion are very different, although high style is often trendy. Fashion is ephemeral, ever-shifting; high style is essentially shaped by artistic vision and identity and aspires to timelessness. High style also differs from fashion because it aims to connect with tradition while remaining up-to-date. When Katz wrote in 1961, "I would like my paintings to be brand new . . . and terrific," he meant both of their moment and of enduring high quality. Katz would not "pinpoint qualities that make something new and lively and something dull," since these are magical qualities. But when high art borrows from other art, it gives something of its own in return. If, as he said, it "just takes, [it] is in the tradition of—and never in the tradition."[47]

To sum up, Katz attempted at one and the same time to record visual appearances, to transform them into symbols, and to forge an indi-

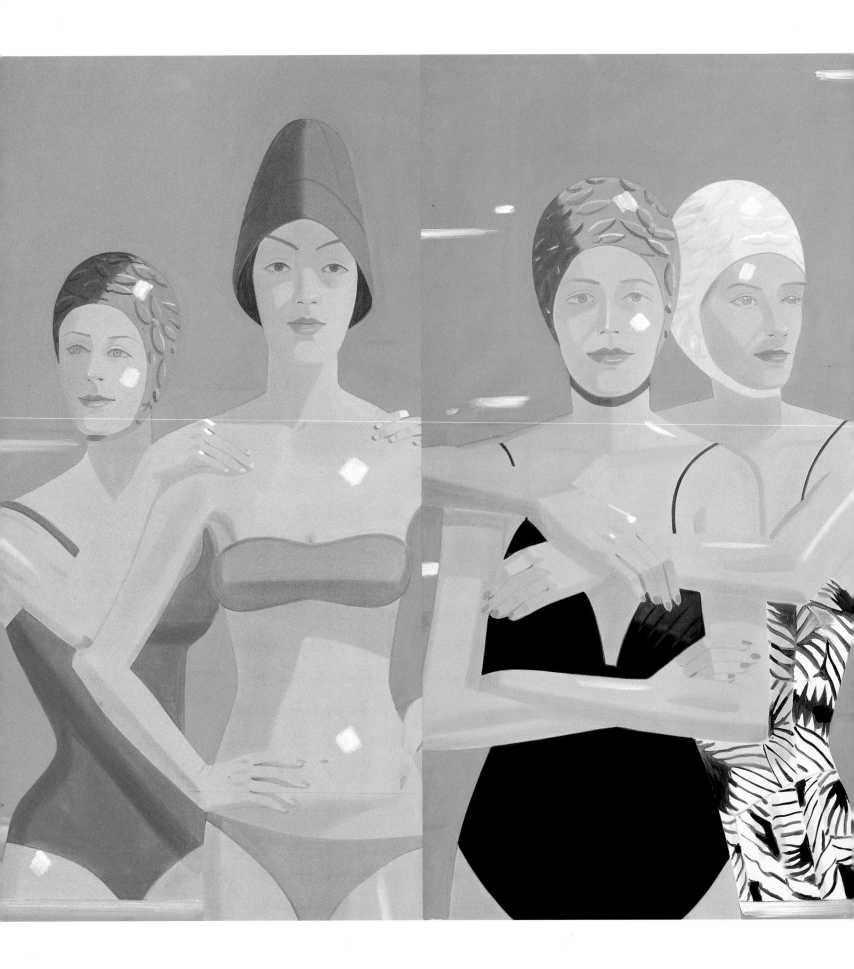

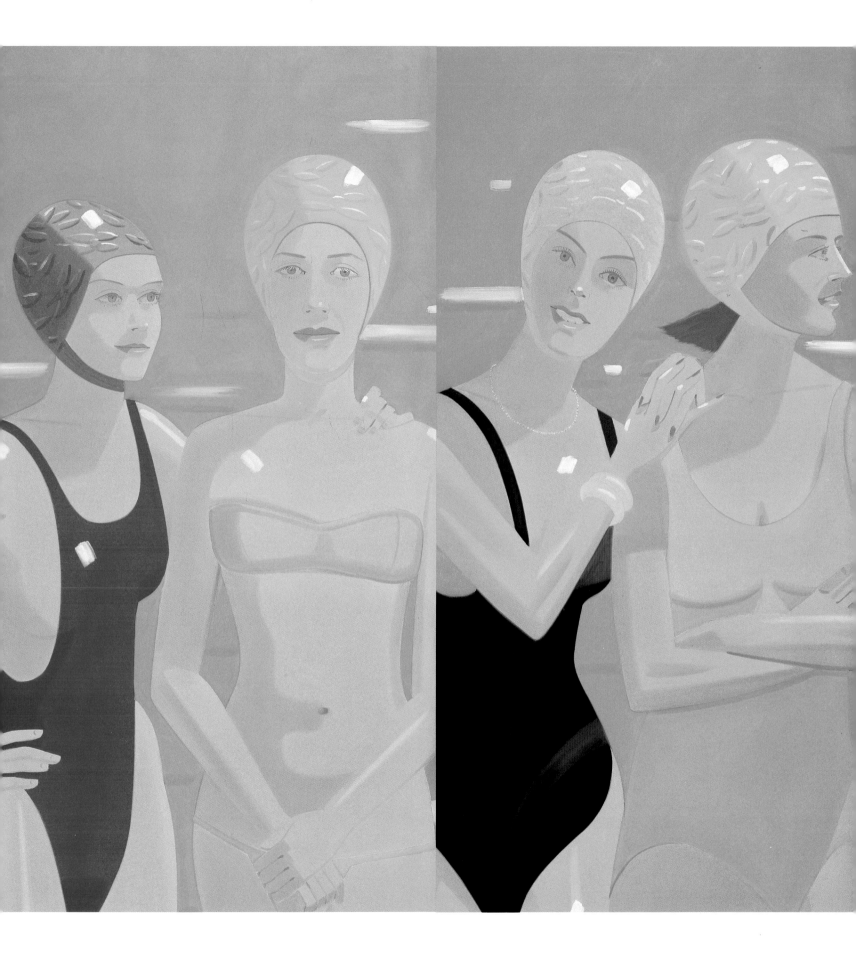

ELEUTHERA. 1984

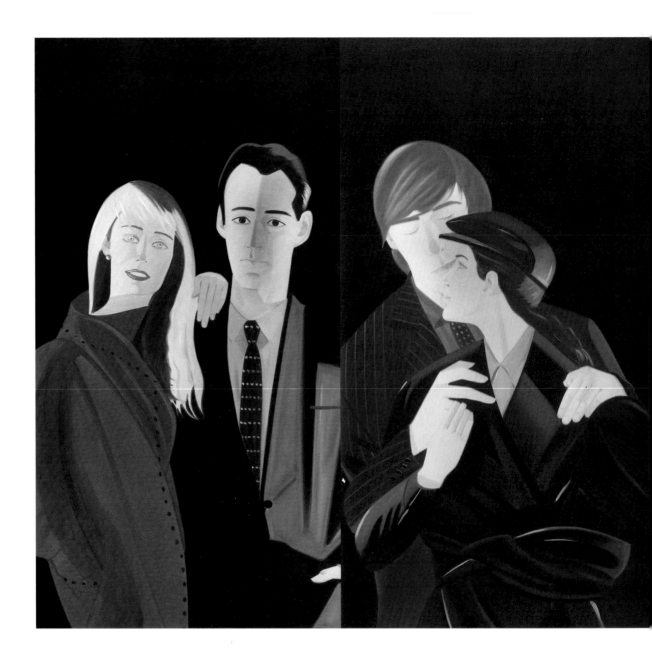

vidual high style. The recognition of these three ambitions and Katz's nego-
tiation of their divergent demands is central to an understanding of his
painting. Style, however, has become so important to Katz that it comes
close to eclipsing representation and imposes itself as the primary subject,
the Katzness of each portrait (or landscape or interior) generating its
enduring impression.

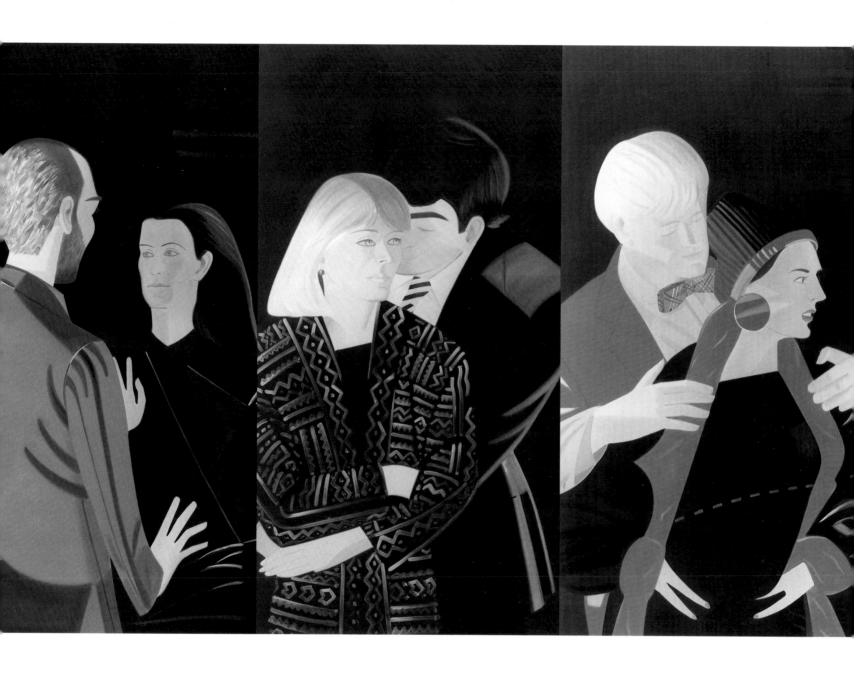

PAS DE DEUX. 1983

WALK. 1970

Opposite: SUNNY #4. 1971

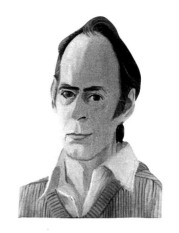

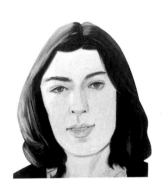
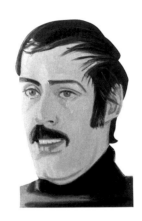

RUSH (details). 1971

Above: GREY DAY #2. 1971

Opposite, above: JOAN. 1971

Opposite, below: MR. AND MRS. R. PADGETT, MR. AND MRS. D. GALLUP. 1971

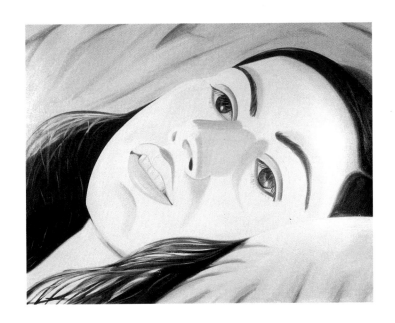

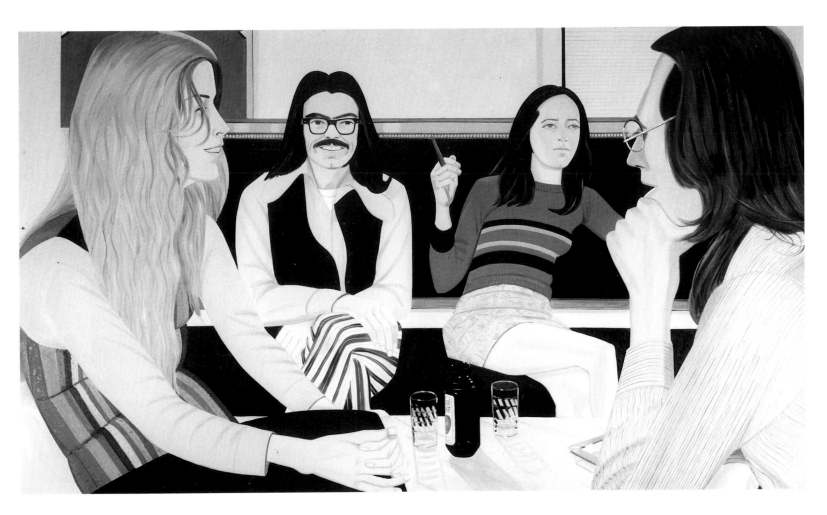

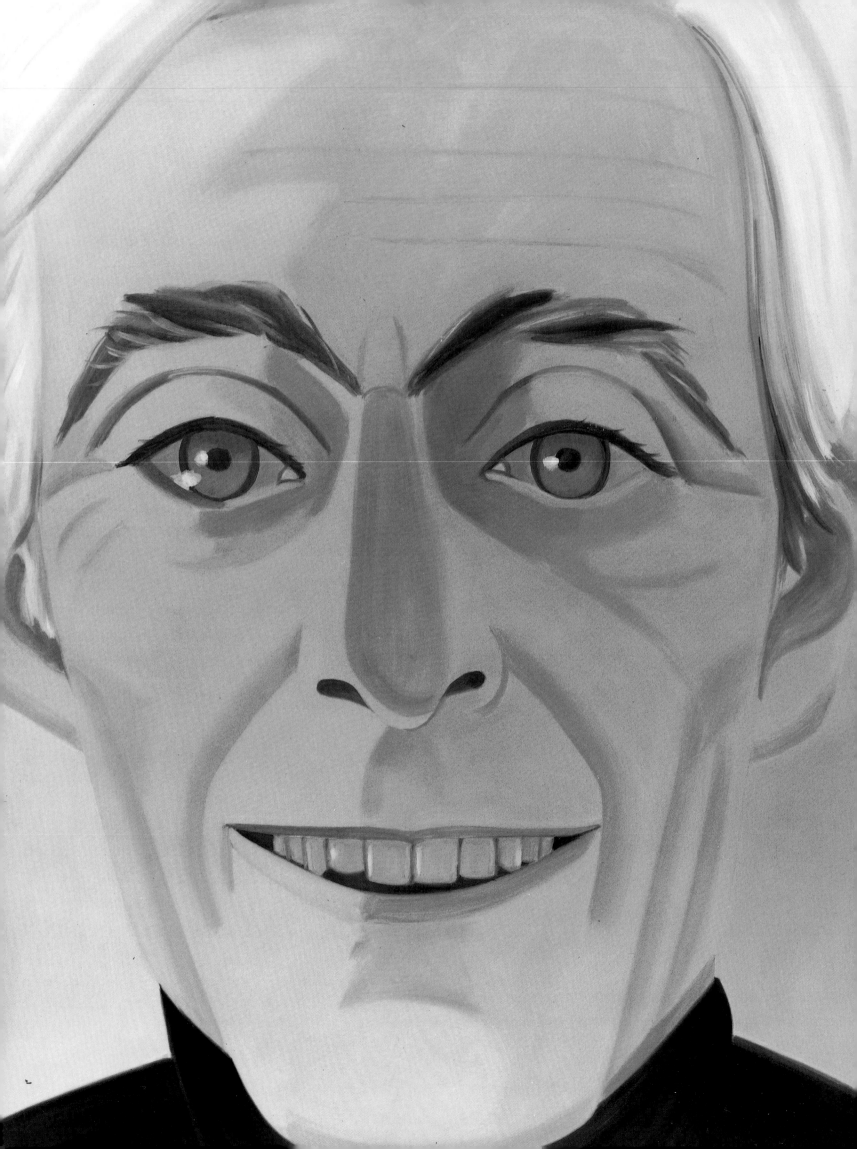

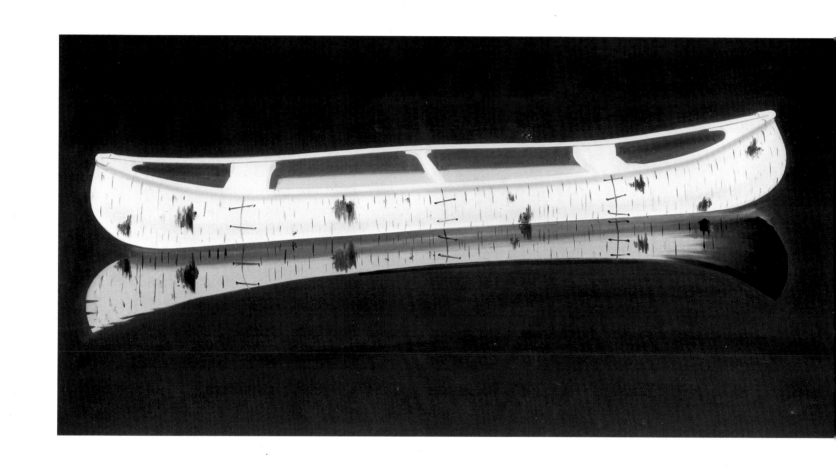

CANOE. 1974

Opposite: EDWIN. 1972

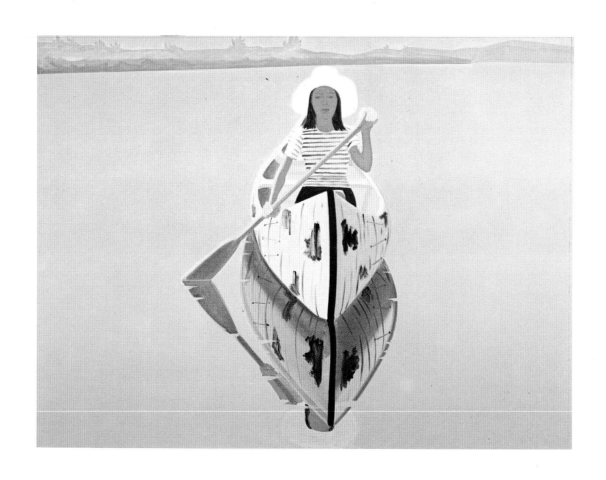

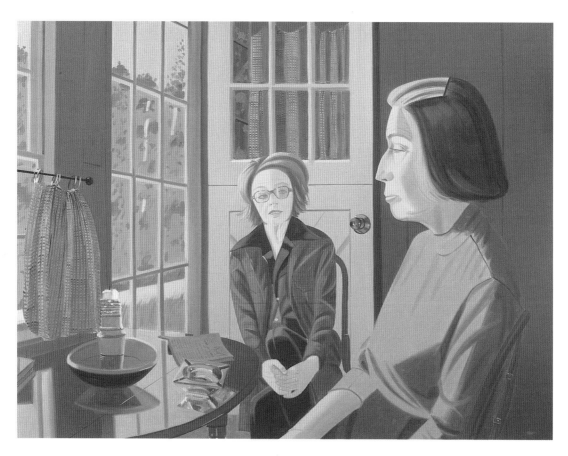

Top: GOOD AFTERNOON #1. 1974

Above: DOROTHY AND NETTI. 1974

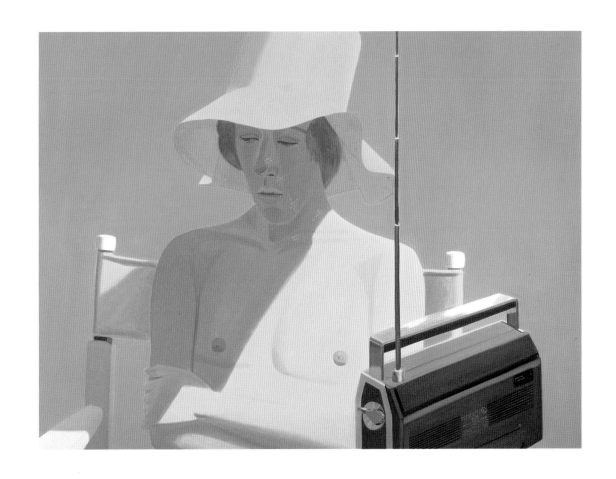

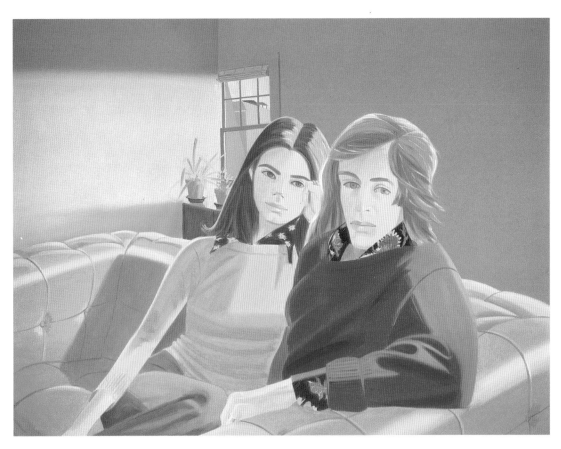

Top: VINCENT WITH RADIO. 1974

Above: DECEMBER. 1974

107

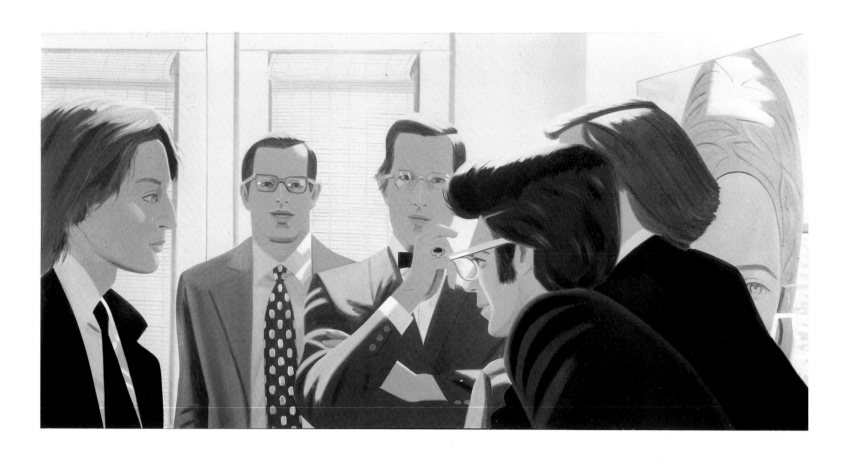

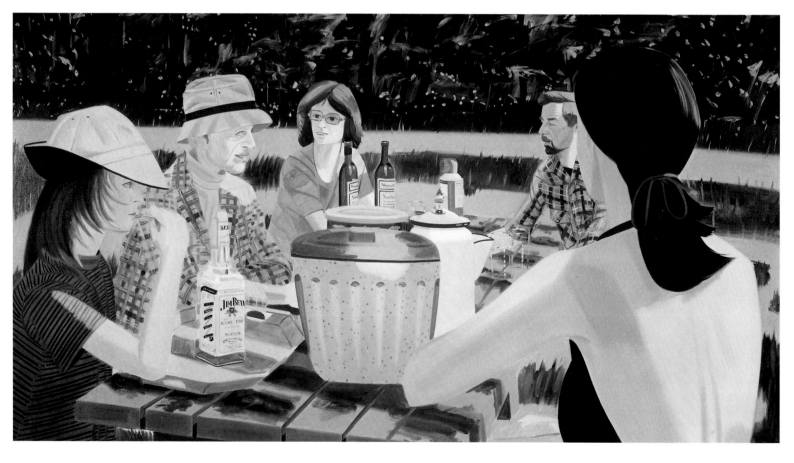

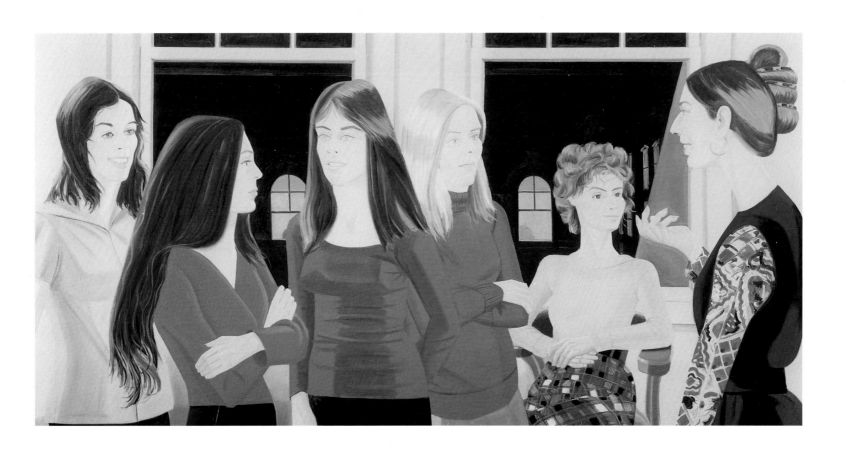

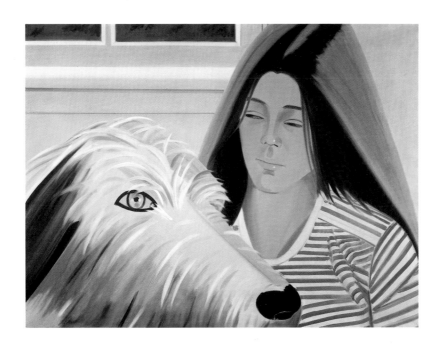

Top: FEBRUARY 5:30 P.M. 1972

Above: SYDNEY AND REX #2. 1975

Opposite, above: THURSDAY NIGHT II. 1974

Opposite, below: SUMMER PICNIC. 1975

Top: REX #2. 1975

Above: MOOSE HORN STATE PARK. 1975

Opposite: TWILIGHT. 1975

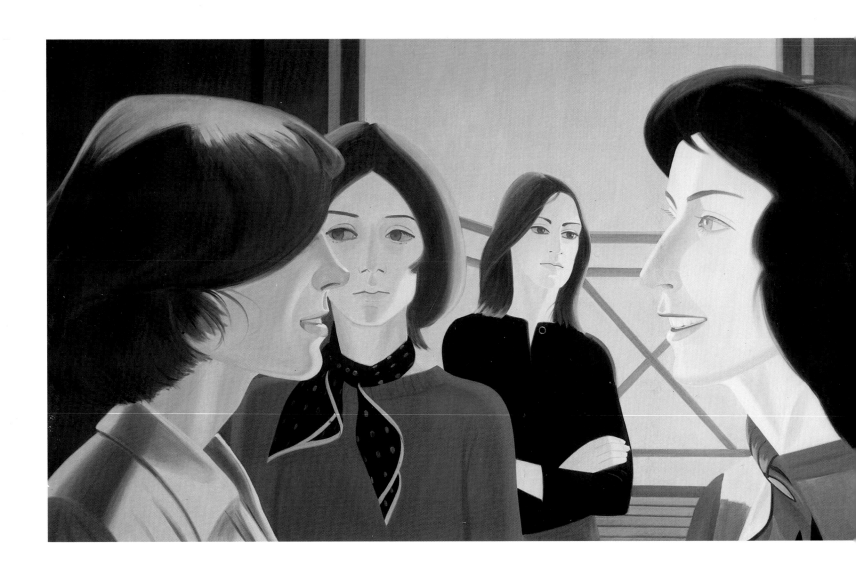

Top: SIX WOMEN. 1975

Above, left: VINCENT FACING RIGHT. 1974

Above, center: EVY. 1974

Above, right: SUSAN. 1974

Opposite, left: BOY WITH A HAT. 1974

Opposite, right: ANNE. 1978

112

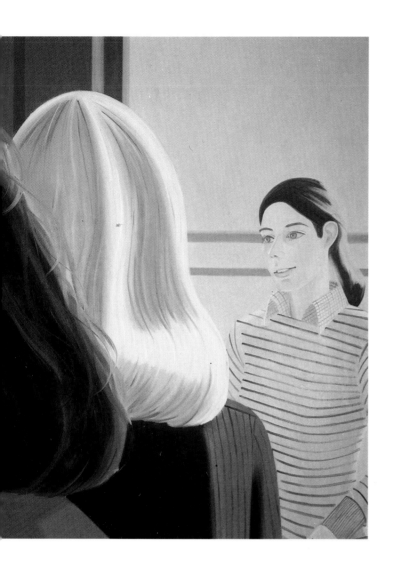

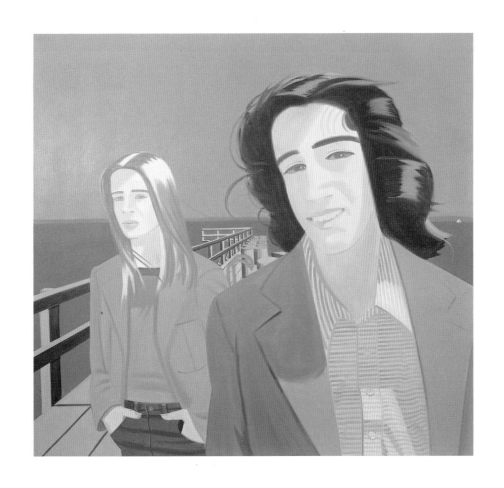

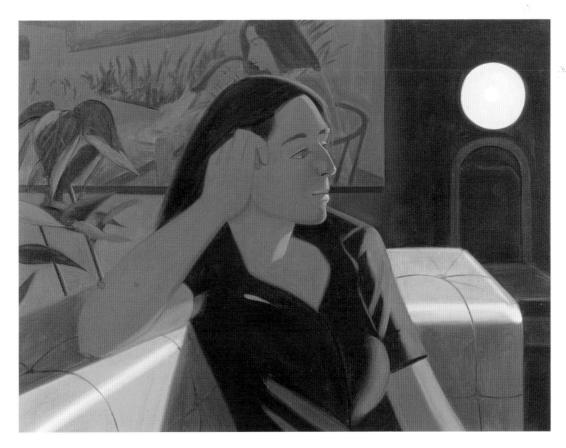

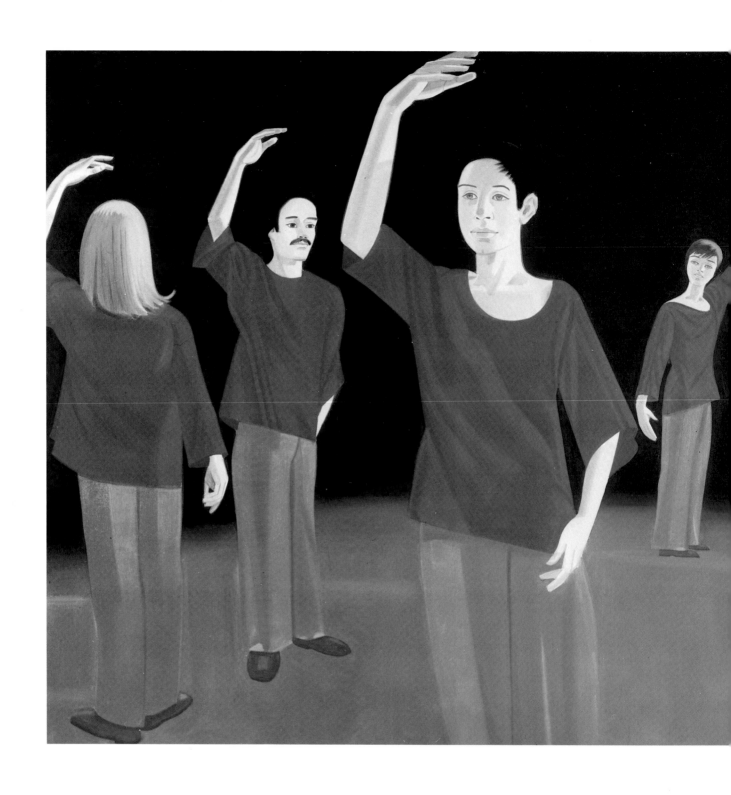

Above: SONG, LAURA DEAN DANCE COMPANY. 1977

Opposite: VINCENT, RUTH AND PAUL. 1979

116

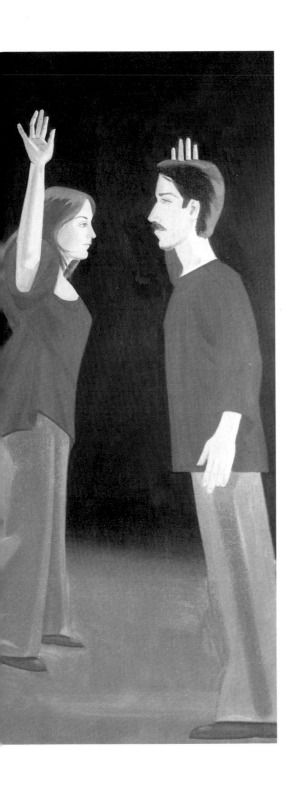

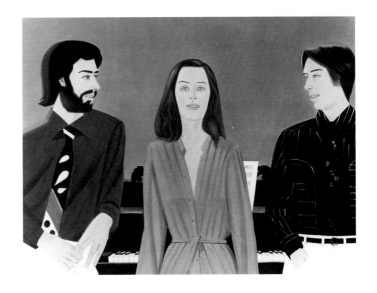

117

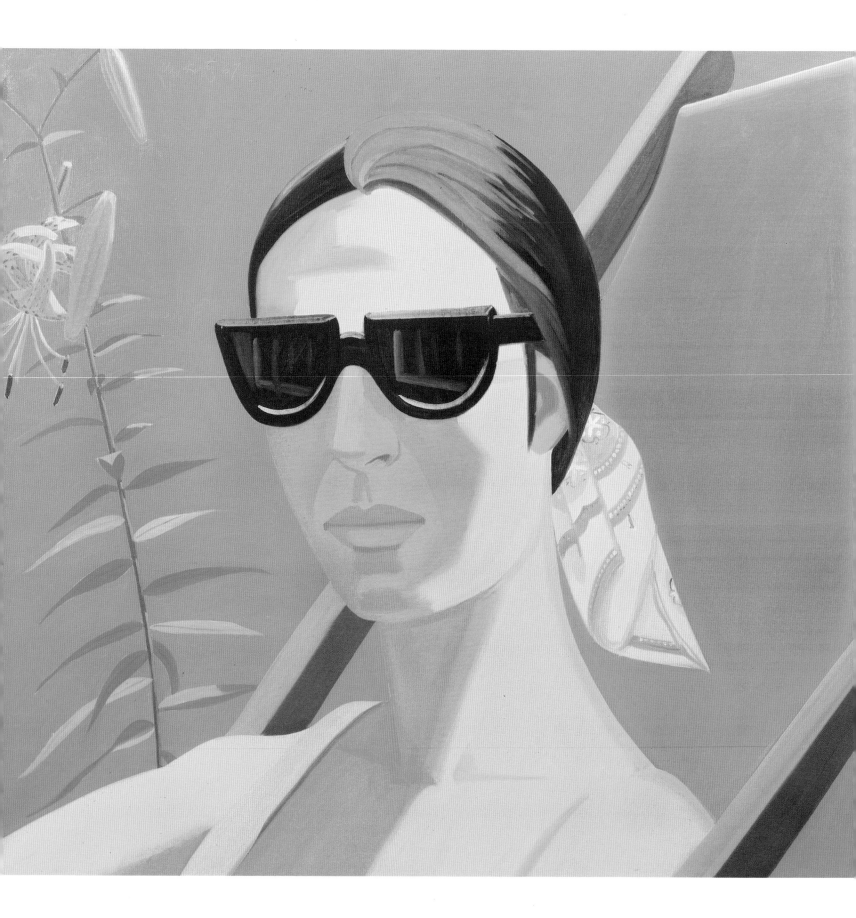

ADA WITH SUPERB LILY. 1967

118

Chapter 4:
AVOIDING
BOREDOM

In the 1980s, Katz faced a problem: How to proceed? The problem became urgent after his retrospective at the Whitney Museum in 1986. Taking stock then he said that he could have become "like a grand master, making masterpieces." But, "That's my idea of dying."[1] He decided that for him the issue in painting was to avoid boring himself. His aim was to perpetuate in his painting the "exhilaration of being completely absorbed. . . . There isn't anything—there hasn't been anything else in my experience—where you can get that kind of complete satisfaction. There are other things that have enormous kicks to them, but none that involves so much of you. Also, there is the challenge of living up to the greats."[2] Since then, Katz has looked for ever-new challenges: new subjects, light effects that he had not painted before or had not painted as daringly as he might have—brilliant sunlight, hazy twilight or foglight, pitchblack night in all seasons, as well as artificial light of various kinds. He also invented new compositions and employed different ways of painting.

Among Katz's newer subjects were the fashion models in designer clothing treated in the last chapter. As if to underline the importance of clothes in his body of work, Katz also made portraits of *Beach Shoes* (1987) and *The Black Dress* (1989). In the late 1960s, he began to paint figures in summer sunlight, brighter than he had before. In *Ada with Superb Lily* (1967), a yellow Ada shadowed in orange is set off against an orange beach chair and a grass-green field. The sun shines even brighter in *His Behind the Back Pass* (1979), in which Vincent tosses a Frisbee to Alex, and *Chance*

(1990), in which three glamorous models in bathing suits and caps appear against a light-flooded field of brilliant yellow. There is nothing quite so sunstruck in the history of art.

Katz continued to paint pictures in which different lights are sharply contrasted. A brightly illuminated *Hiroshi and Marsha* (1981) are posed against night black, punctuated only by the lit windows of hidden skyscrapers. In contrast, *Anne* (1988) is a dark figure against a white ground. In later pictures, the light effects are increasingly complicated. *Summer Triptych* (1990), is composed of three vertical panels, the center one containing a portrait head, and the two flanking panels, landscapes, one daytime, the other night. The picture not only juxtaposes day and night, but two other kinds of light as well: a direct light on the figure and a cross light on the landscape.

Other pictures are equally complex. In the *Black Brook* series (1988–90), Katz focused on a small area of the surface of water. Trees, shrubs, grasses, leaves, and rocks, which cast shadows, float on or are suspended in rippling, coursing and bubbling water, and moreover, are reflected or refracted in it, make it difficult for viewers to make out readily what they are seeing. At the same time, they are drawn close to the surface of water. Katz said that his "desire [was] to make a landscape that was different from a traditional landscape. I wanted to make an environmental landscape, where you were *in* it."[3]

The *Black Brook* paintings are part of a large number of landscapes that would occupy Katz in the late 1980s and 1990s. Indeed, his turn to landscape was the main change in his recent work. He began each canvas with "an idea of the landscape, a conception" and then, if lucky, he found the image in nature. "When I see the image, I make a quick nine-by-twelve-inch study of it. The light is very quick, particularly with sunsets. I have only a twenty-minute interval, depending on what I see. . . . For some twilight paintings, I remember sitting all day waiting for that interval around 8:45 p.m."[4] In the landscapes, Katz loosened the edges of forms and brushed them more freely than before. Painterliness was carried to an extreme in allover canvases, composed of dabs of pigment, that call to mind Jackson

120

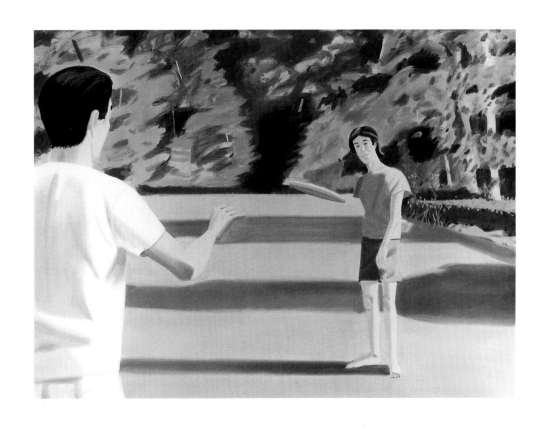

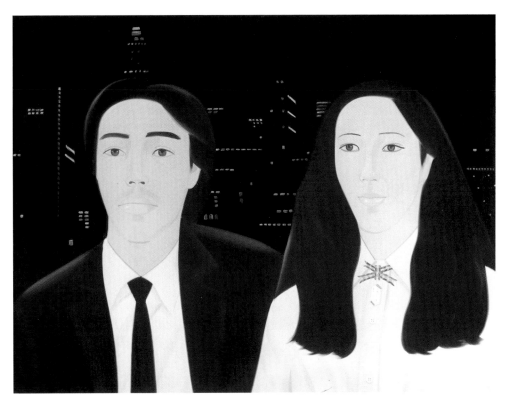

Top: HIS BEHIND THE BACK PASS. 1978

Above: HIROSHI AND MARSHA. 1981

Pollock's poured paintings. In particular, the frieze of trees in *Woods* (1991) seems to refer to Pollock's *Blue Poles* (1952). *Apple Blossoms* (1994), a 96-by-120-inch picture of a garden between two high-rise buildings near where Katz lives, offers a glimpse of foliage in a totally urban setting—a panoramic view of a small slice of nature. The effect is at once monumental and delicate, reminiscent of Japanese brush drawing.

Poplars (1994) relates to *Apple Blossoms,* but is a gray winter scene. In it, Katz reverts back to his allover pictures of trees of the early 1950s; his direct painting of trunks and branches in articulated brushstrokes is a gloss on the kind of "action painting" that held sway then, but on a 108-by-144-inch canvas. It is a virtuoso reenactment—and was meant to be: how to *really* paint an action painting.

In contrast to *Poplars, Lake Light* (1992) is dazzling. In it, sunlight (or is it moonlight?) reflects off the surface of water. The picture is dominated by a vertical wedge of blinding white that covers most of the center of the canvas. All that defines the image as a waterscape is a strip of green grass from which a tiny pier projects along the left side of the lower edge. As Dave Hickey viewed it, "for all intents and purposes, it is an abstract painting,"[5] and so it seems to be. From another point of view, however, as Katz said of an even more extremely pared-down picture, *Afternoon Light* (1989), he wanted to "make a painting with so little in it and still have it seem like a concrete landscape."[6]

Purple Wind (1995), in contrast, is one of Katz's complex paintings. It frames a segment of a New York building at dusk, with the building brought right up to the surface. Five windows are placed along the upper and right edges, leaving most of the picture a field of flat purple. The windows, ablaze with light, are composed of loose vertical brushstrokes that contrast with the smoothly painted purple. In front of the building, branches of a tree sweep in from the lower left and cover most of the building. Each element—color, surface texture, brushstroke—is handled differently in a breathtaking bravura performance.

In 1986, in a 180-degree turn from his sunlit landscapes, Katz began to paint a series of night pictures, because they were about another kind of

Top: THE BLACK DRESS. 1989

Above: CHANCE. 1990

ANNE. 1988

ADA IN FRONT OF BLACK BROOK. 1988

125

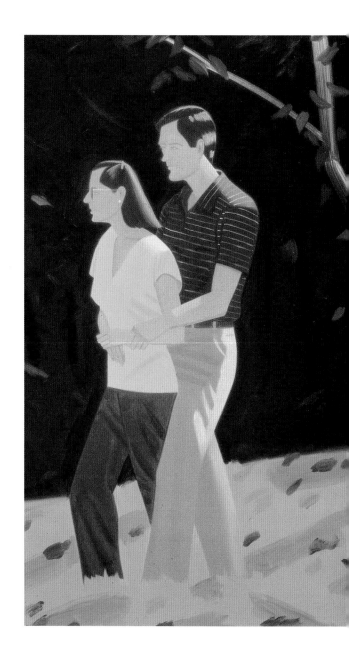

light that he had not sufficiently explored. He had painted an occasional dark picture in the past, *Self-Portrait with Black Background* (1959), for example, and *Twilight* (1975), a dark silhouette of trees in waning light, but now he "deliberately painted" them.[7] He recalled: "It started with [an] 11-by-11-foot square, called *Wet Evening*. . . . I'd had the concept of night paintings in mind for twenty years, but you have to see it for it to happen."[8] "One night I looked out my window at a building, and there was this purple fluorescent light. It was this light I wanted."[9]

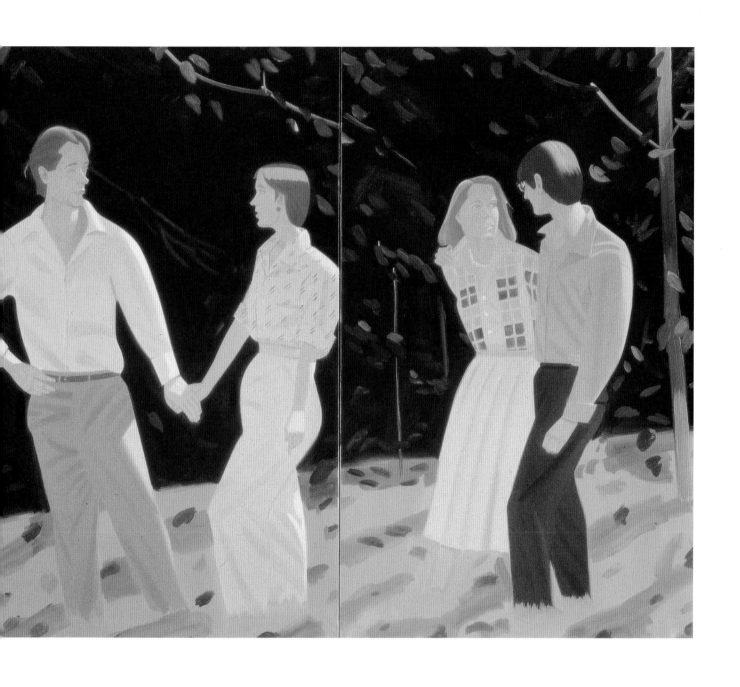

SUMMER TRIPTYCH. 1985

The settings of the Night Paintings are both urban and rural. In the blackest cityscapes buildings can be made out only because the electric glow of a few windows is visible. *Night II* (1987) is an impenetrable, vertical, black color field (shades of Barnett Newman) that is transformed into a nocturnal urban scene by a zigzag of three banks of three tiny lit windows—painterly gray-white swaths—at the top of the picture. The windows, which recede diagonally into the flat black plane, suggest office blocks in the opaque darkness. Equally difficult to make out are the rural nocturnal pictures, such as *Twilight* (1988), in which the black of the silhouetted tree is shrouded by a darkening sky.

Because of their darkness, the Night Paintings have elicited diverse interpretations. Katz allowed that they were more romantic than his earlier works, and more suggestive of the unconscious.[10] The blackness in them has also been viewed as a metaphor of nothingness, emptiness, even the void; as the shadowy unconscious or dark side of Katz's psyche, or as an attempt to conceal it; and as a sign of melancholia. Images of the night and what it shrouds certainly cannot help being apparitional, enigmatic, uncanny, or dreamlike—and also awesome, evoking a sense of the sublime, calling to mind the Abstract Expressionist paintings by Still, Rothko, and Newman. At the same time, though, they are literal representations of night.

Katz has had a career in art that spans a half century, and his work now is more varied than it has ever been. He keeps opening up new possibilities. Sanford Schwartz wrote in 1973—and it remains as true in 1997: "Unlike many other first-rate painters in New York, he hasn't been trapped by his ideas; he doesn't operate as if he were his own academician-in-residence. He works patiently . . . exploring every possibility that's open to him, and yet he is always going somewhere with the exploration. You don't get the feeling that in five years he'll just be refining what he's doing now. He has an intellectual liveliness about his hunches, a restlessness to see where any of them will lead, and it's sensed in the way he goes out on a limb. . . . He's open-ended about his goals, and this makes him refreshingly unpredictable."[11]

Top: WOODS. 1991

Above: POPLARS. 1994

129

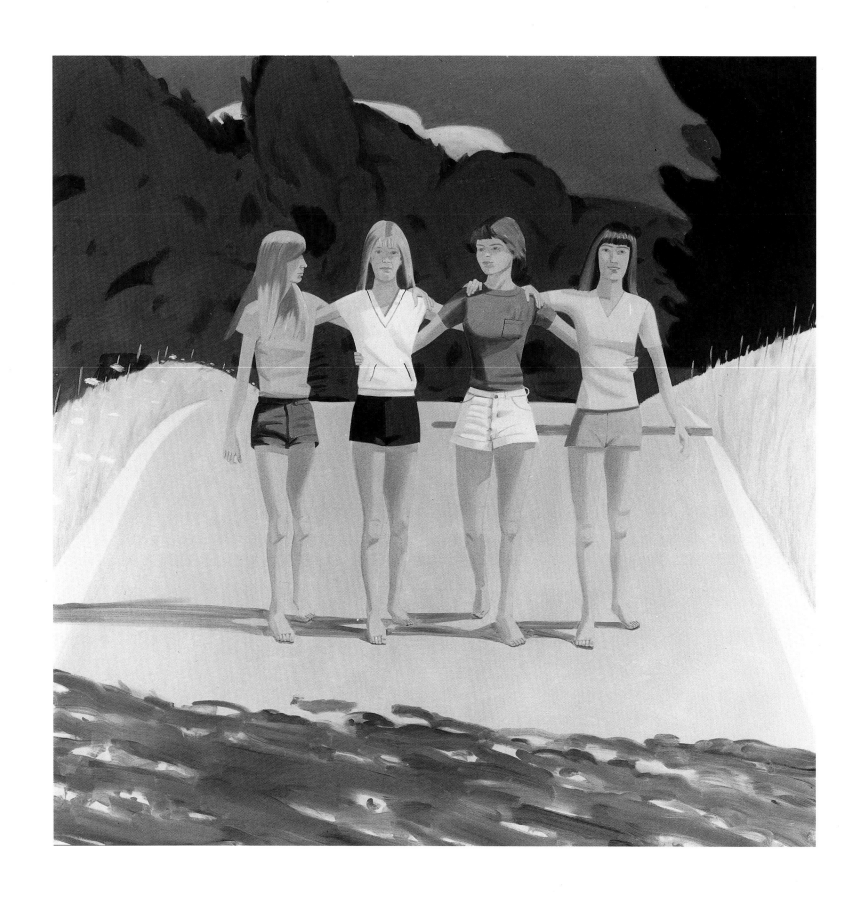

THE RYAN SISTERS. 1981

130

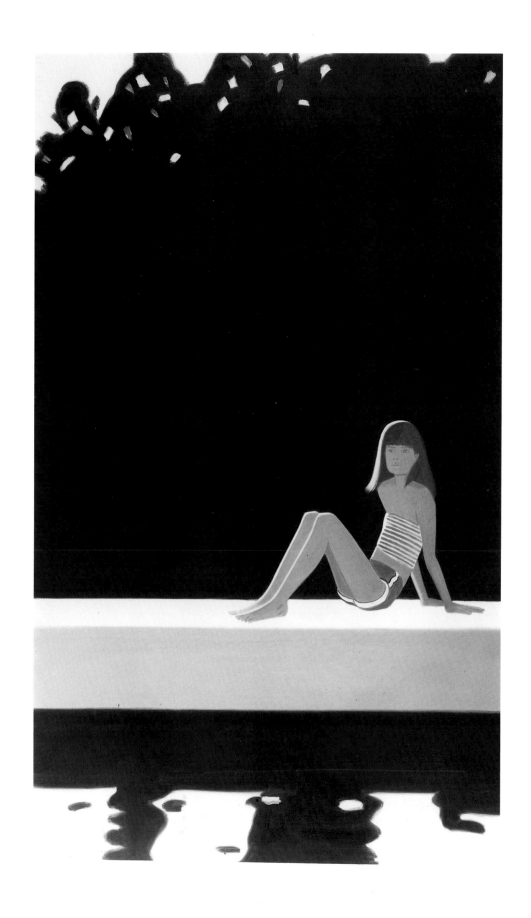

TRACY ON THE RAFT AT 7:30. 1982

Top: SONG. 1980

Above: SIX SOLDIERS. 1981

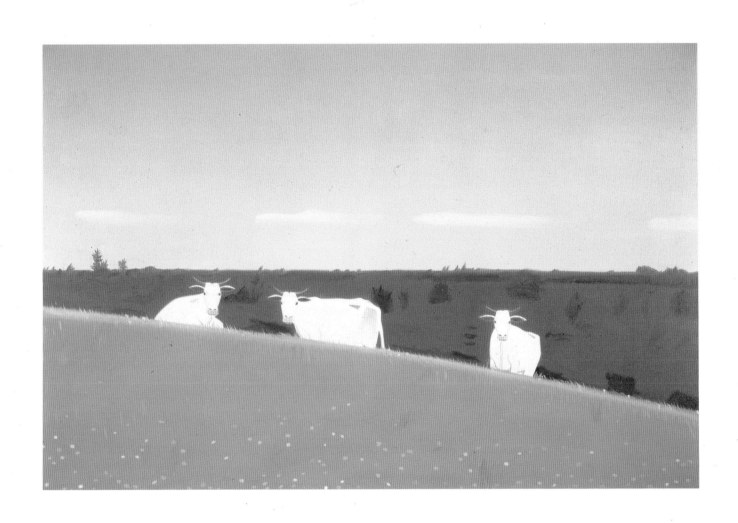

THREE COWS. 1981

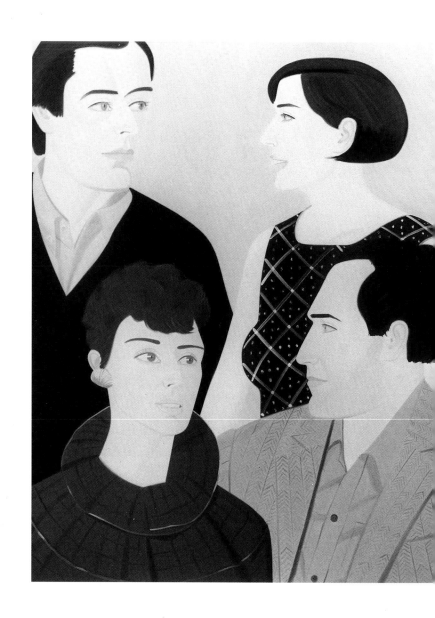

Left: ADA AND FLOWERS. 1980

Top: UP IN THE BLEACHERS. 1983

Right: LAST LOOK. 1986

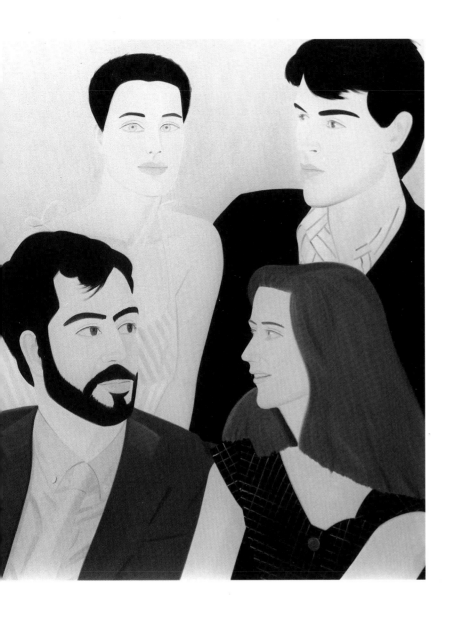

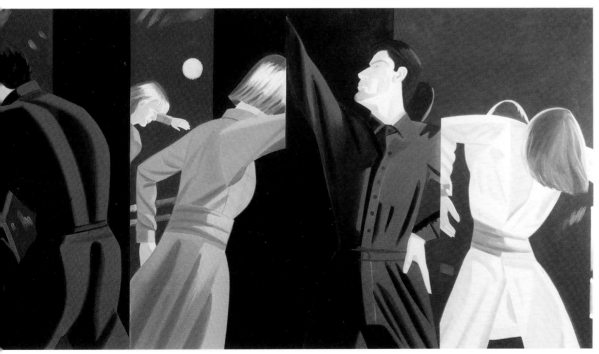

135

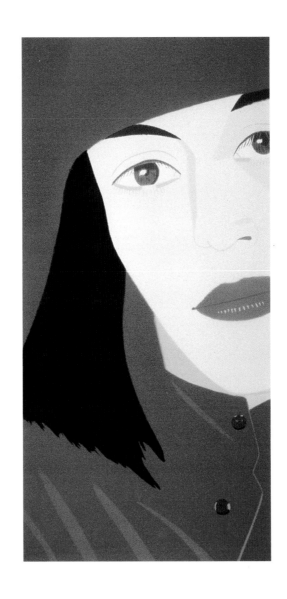

THE RED COAT (print). 1983

Opposite: LILIES AGAINST THE YELLOW HOUSE. 1983

Following pages, left: VIEW. 1987

Following pages, right: SUNSET. 1987

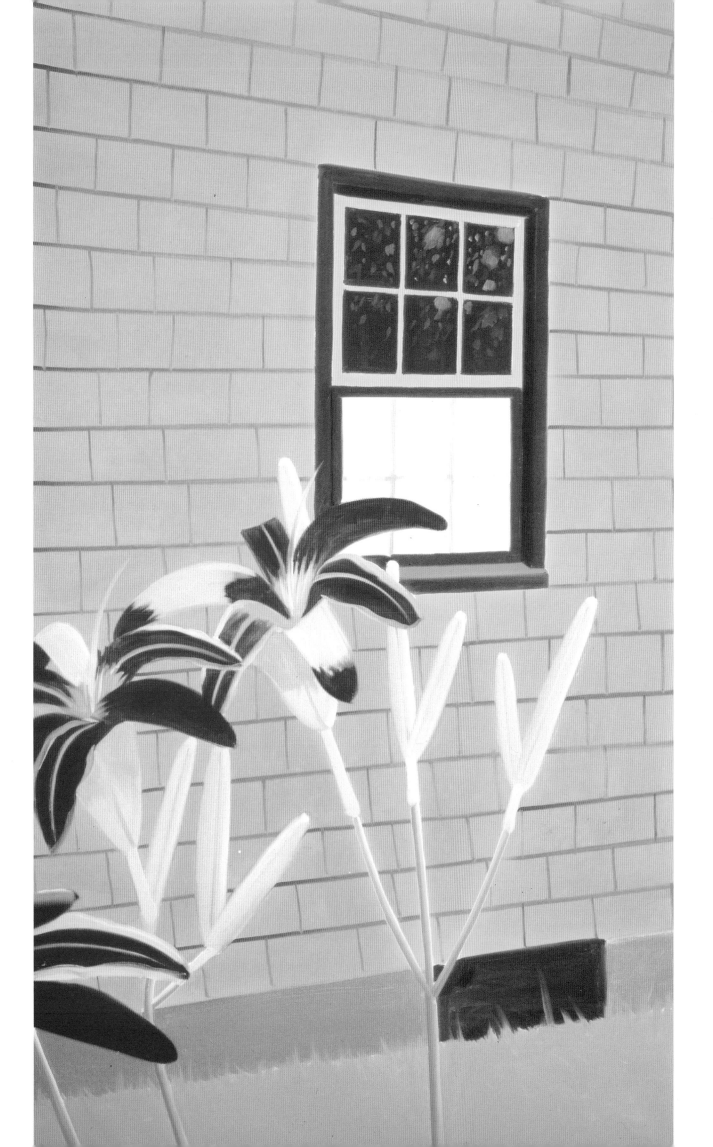

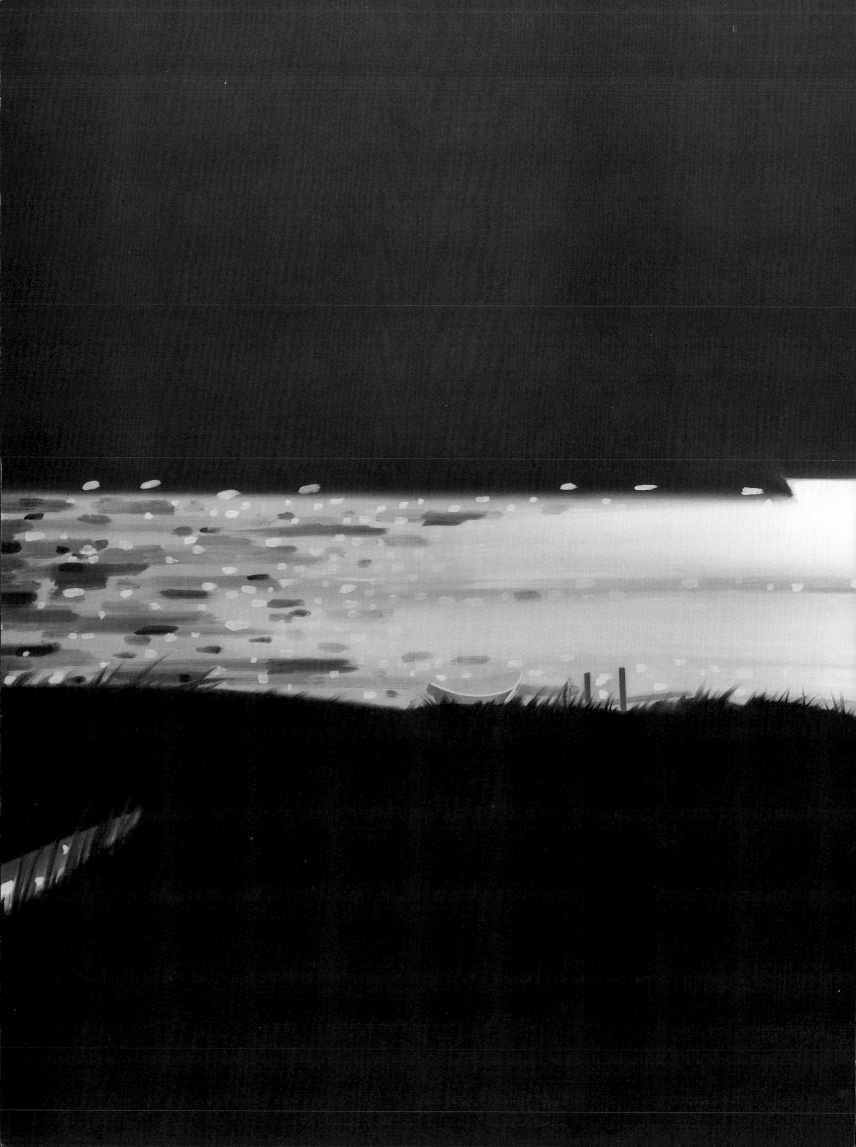

WET EVENING. 1986

PURPLE WIND. 1995

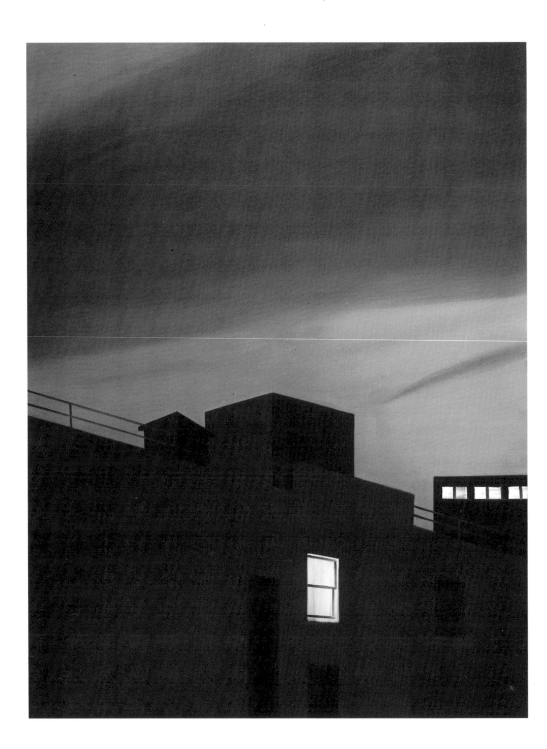

Above, left: NIGHT II. 1987

Above, right: SOHO MORNING. 1987

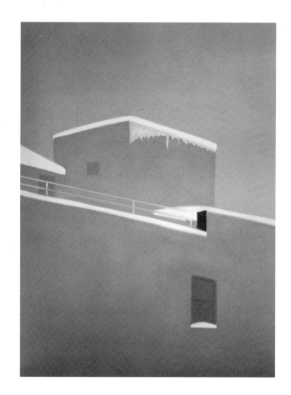

Top: VARICK. 1988

Above: SNOW. 1988

143

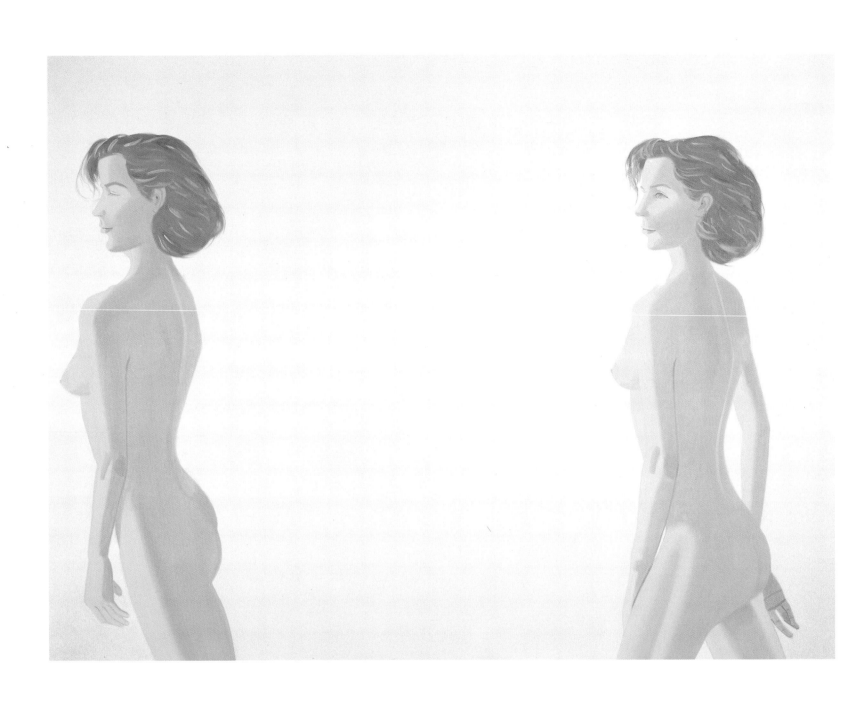

Above: RED NUDE. 1988

Opposite, above: ADA AND LUISA. 1987

Opposite, below: ADA IN AQUA. 1988

144

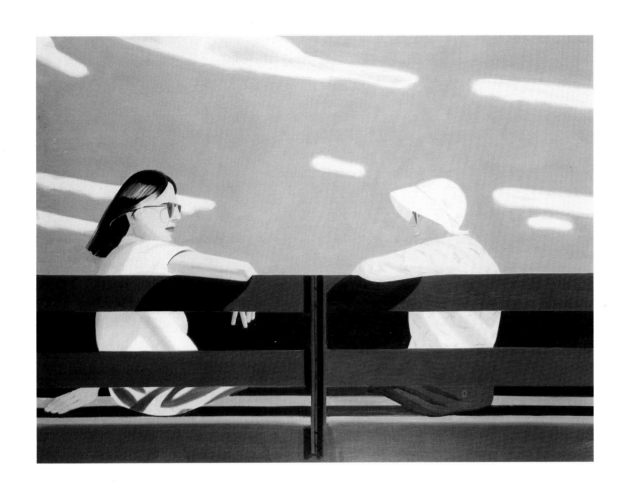

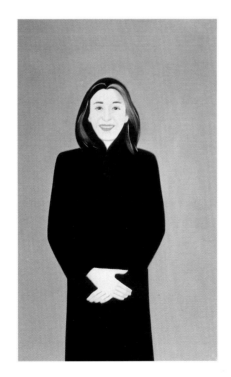

145

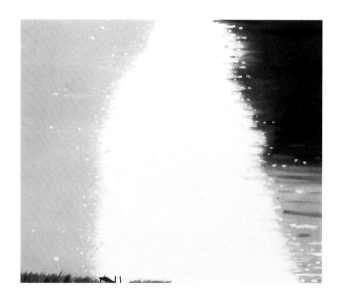

Top: APPLE BLOSSOMS. 1994

Above: LAKE LIGHT. 1992

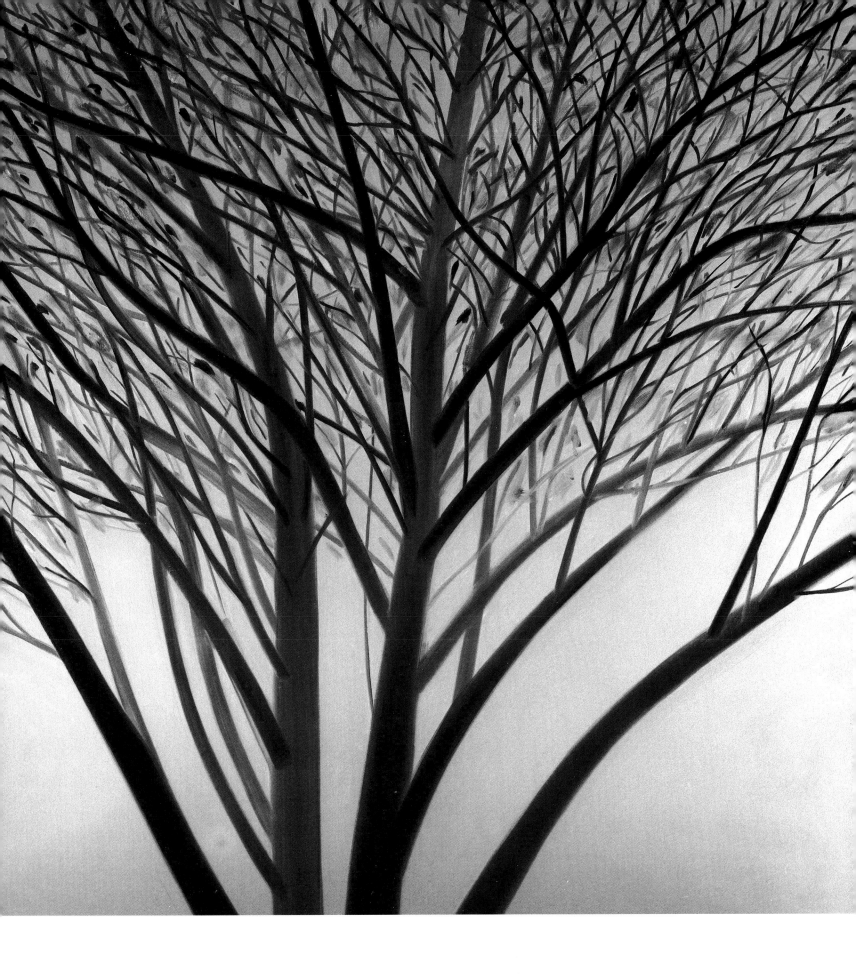

A TREE IN WINTER. 1988

147

In 1987, Ada posed in front of *Ada in Aqua*, 1963.

Chapter 5:
THE
DECLINE
AND RISE
OF
AMERICAN
REALISM

H istorians and critics have few (if any) convincing answers to the question of what constitutes aesthetic quality. A related problem, and one almost as difficult to treat, is why and how works of art command recognition. We do know that it has been usual for a successful modern artist to be recognized initially by a peer group (generally very small) that shares his or her sensibility, then by growing segments of the art world, and later by a larger public. Perhaps most important in this process is a succession of loose consensuses by certain key artists and art professionals—art editors, critics and historians, museum directors, curators and trustees, and dealers and collectors.

Katz first earned the esteem of artists and art professionals with his show at the Tanager Gallery in 1959, and he achieved a widening reputation with each subsequent show. His success depended on the growing originality and quality of his work, but it was also influenced by the fortunes of figurative art in America from the 1930s on—and this historic context will be considered first. In the Great Depression, the prevailing painting styles were figurative, either left-leaning Social Protest or right-leaning Regionalism. It was natural in a time of economic crisis for artists motivated by social ideologies to take and hold the center of interest. Their dogmatic attitudes, moreover, led them to attack, often viciously, all modernist tendencies as either bourgeois decadence and ivory-tower escapism or as un-American. Social Protest and Regionalist styles, however, were progressively challenged in the 1930s by a small avant-garde composed

mainly of Cubist-inspired geometric artists and were deposed in the 1940s by the Abstract Expressionist vanguard that followed next. Art in the service of proletarian or nationalistic causes was discredited for lacking formal values and for being academic and banal. No matter how noble its aims, none of it stood up against the best—or even second-best—of modernist art. Most damning of all, propagandistic illustration did not look or feel true either to life or to art.

Unfortunately, with the downfall of politically conscious styles, all realist art went into an eclipse, at least in the eyes of the audience that favored advanced art. More than that, it was widely assumed that the creation of major new figurative styles, neither retrogressive nor provincial, was highly unlikely, if not impossible. This belief was more implicit than explicit, since the Abstract Expressionists whose art and/or ideas commanded most attention in the 1950s—Pollock, de Kooning, Kline, and Hofmann—were painting pictures with recognizable imagery as well as abstractions. In fact, they themselves strongly denied that one was superior to the other. But the reputations of even these masters were based primarily on their abstract work.

In truth, abstract artists of the forties and fifties, unless they were obviously retardataire, derivative, or decorative, never had to worry about being minor, but purely figurative artists did. This certainly was the case as late as the 1961–62 season in New York. In that year, Sidney Tillim, in "The Present Outlook on Figurative Art," hailed a new realism; the Museum of Modern Art mounted a major survey, *Recent Painting USA: The Figure,* meant to convey the range and quality of realism in the best light, with a catalogue introduction by Alfred H. Barr, Jr.; and, almost as consequential, the Kornblee Gallery organized a show, *Figures,* with a catalogue introduction by Jack Kroll.

All three writers implied that figuration was inferior to abstraction. Even Tillim remarked that it "has far too many flaws to be considered a serious contender for the throne it is far from certain abstract art has surrendered."[1] Barr remarked that the figurative pictures selected by him "were painted in a period (a glorious period in American art) when the painted surface often functioned in virtual and even dogmatic indepen-

Ada, Vincent, and Alex Katz after Vincent's last exams at Oxford University, England, 1985.

dence of any representational image."[2] And Kroll, much as he predicted that "the best and most interesting of them [figurative artists] are moving toward the next authentic and historically secure image of man, [abstraction] is still the seminal and resolving image of contemporary art."[3]

Certainly, the figurative artists in the New York School who received the most attention in the fifties worked in an essentially abstract, gestural vein. The more representational or perceptual a picture, the more clearly delineated and rendered, the less chance it had for serious consideration. And yet, in the early sixties, young painters and sympathetic critics became uneasy about the role of recognizable subject matter in an art whose manner of painting was essentially abstract. They questioned whether the human figure ought to be used merely as a spatial counter. Did not responsibility have to be taken for the human subject—by dealing with it in its own terms? They concluded that if figurative art was to be renewed and to yield major new styles, it would have to become more literal and less gestural.

Alex Katz in an ad for Barneys, New York, 1994.

At the time, Gesture Painting, both abstract and figurative, was in crisis, and it offered decreasing resistance to the new representation. But challenges came from other emerging tendencies: Pop Art and Hard-edge, Stained Color-field, and Minimal Abstraction. Pop Art achieved instant notoriety as *the* avant-garde realism because, shockingly, it took its subjects from beyond the boundaries of what was commonly thought to be high art, namely commercial art, advertising, and comic strips. At its most extreme, Pop Art copied, or appeared to copy, preexisting images using mechanical means. The New Perceptual Realists met the challenge of Pop Art by appealing to the historic tradition of realist painting, a tradition that they revealed was open to fresh developments.

The New Perceptual Realists also had to meet the challenge of new abstract styles, notably Stained Color-field painting. Stained Color-field painting had been justified by the formalist theories of Clement Greenberg. He insisted that modernist painting had to purge itself of all that was not inherent in the medium. As a two-dimensional surface, a picture had no room for figurative subjects and illusionistic space, which were inherently three-dimensional, and hence bored into the surface and/or appealed to the sense of touch, that is, the tactile as opposed to the purely

optical. As early as 1954, moreover, Greenberg had declared that figuration could yield only minor art.[4] The future of painting was with Post-painterly Abstraction, as he labeled it. Greenberg's opinions grew in influence with the publication in 1961 of his book of essays, *Art and Culture,* and dominated art discourse throughout the decade. The formalist rhetoric of the new painting was reinforced by that of Minimal sculpture, which was heavily influenced by Greenberg. The new move in art, it seemed, would be in sculpture, not painting. Such was the aesthetic temper of the times that Donald Judd, a leading Minimal sculptor (and critic), not only refused to accept any figuration in art, but even condemned the crossing of two lines as looking too much like anatomy, too "anthropomorphic," as he put it.

The New Perceptual Realists countered the assaults of formalists and Minimalists by formulating a contemporary and rigorous conceptual framework for literal representation, a rationale that in time helped establish realism as a serious alternative to abstract art. The realists confronted head-on the whole line of thinking that had begun with Maurice Denis, who said in 1890 that before a painting is viewed as a battle horse or nude woman or some anecdote, it is essentially a flat surface covered with colors in a certain order. Denis's approach was carried to a reductionist extreme by formalist and Minimalist aestheticians. Indeed, the New Perceptual Realists reversed this position by insisting on the primacy of the observed subject.

The urge for specificity led realists to suppress pictorial elements that obscured details, such as brushy handling. It soon became clear that subtle differences existed between the facture of such realists as Katz and Fairfield Porter, the two having previously been linked by critics on the outer edge of Gesture Painting. In 1961, Tillim drew a line between the old and the new, that is, between a Porter who favored loose brushwork, and a Katz, who was attempting a more imaginative revisionism based, as I have noted, on accurate rendering and "the big picture," the last enabling representation to stand up against abstraction.[5]

The success of the claims that Pop Art and its successor Photorealism were the *new* realist styles somewhat delayed the recognition of perceptual representation, but there did emerge a growing audience responsive to it.

Critics and art historians began to take notice and to organize shows and publish articles that helped change art-world opinion. In 1968, for example, Linda Nochlin and some of her students mounted a large exhibition at the Vassar College Art Gallery. The question posed by the show was whether it was "possible for a realist to be new at all in the second half of the twentieth century." The answer was "an unqualified yes."[6] In the following year, the Milwaukee Art Center organized *Aspects of a New Realism.* Tillim wrote in the catalogue that the new realism was was not " 'minor' art. It is an independent entity with its own 'minor' figures and not a lesser version of some presumably 'major' current statement."[7] In an article in *Artforum,* he reiterated that contemporary representation was authentically new and not "a rehash of some older style like Dadaism, Surrealism or Expressionism or . . . simply another variant of Pop art."[8]

But at the time, painting, both figurative and abstract, was under attack from two new quarters, on the one hand, from Postminimal sculptors who declared (once again) that painting was dead, and from Conceptual artists who proclaimed that all art objects, sculpture as well as painting, had ceased to be viable. Nonetheless, abstract painters, such as Robert Ryman, Brice Marden, and Robert Mangold, began to achieve recognition, as did representational painters such as Katz and Philip Pearlstein. By the end of the sixties, the New Perceptual Realism had attracted growing numbers of young artists, among them Robert Berlind, Rackstraw Downes, Janet Fish, Yvonne Jacquette, and Harriet Shorr.

In 1976, a group of artists organized an exhibition in five SoHo galleries, including works by 140 painters and sculptors, to indicate the scope of current American realism (with the exception of Pop Art and Photorealism). This show proved that much of the best and worst of recent art was based on recognizable subject matter. But it also raised issues about the condition of the new realism at the time. Was it still embattled? No New York museum would accept the show or organize a similar one. But how consequential was that? Certainly, representational art had come a long way in the decade and was receiving growing acclaim in the art world and among a wider public.

Contributing to its new status was a change in art-world attitudes. During the 1960s, one style after another—Pop, Op, Minimal, Conceptual —commanded art-world attention, because they seemed "mainstream" and avant-garde. Katz's painting did not fit easily into any "ism" and was, thus, at a disadvantage. Toward the end of the decade, claims made for art as avant-garde became increasingly unbelievable, particularly after the official acceptance of Conceptual Art by the Museum of Modern Art in its *Information* show of 1970. Artistic tendencies hitherto neglected now commanded growing art-world attention. In *Time* magazine, Robert Hughes remarked with special reference to representational art, "The American mainstream has fanned out into a delta, in which the traditional idea of an avant-garde has drowned. Thus, in defiance of the dogma that realist painting was killed by abstract art and photography, realism has come back in as many forms as there are painters."[9]

But the Postminimalist and Conceptualist polemical war against painting continued into the 1970s. In 1975, the editors of *Artforum,* in a special issue devoted to the current state of painting, claimed that a large segment of the art world had come to believe "that painting has ceased to be the dominant artistic medium at the moment. [Artists] understood to be making 'the inevitable next step' now work with any material but paint."[10] "Brushwielders were [accused of being] afflicted by a creative halitosis."[11]

Despite the attacks on painting, the 1970s saw the emergence of Pattern and Decoration painting and New Image painting. These tendencies developed in part in reaction against the realistic tendencies that had emerged in the 1960s—Pop Art, New Perceptual Realism, and Photorealism —by cultivating a provocative "bad" look. But the Pattern and Decoration painters and New Image painters were *painting,* and most of them painting figurative pictures at that. They and their advocates asserted that painting was a proven medium of sensuous expression, and there seemed to be a need for such expression. The need would seem to grow as the seventies progressed.

Indeed, there appeared to be a virtual Renaissance in painting around 1980, not only in the United States but in Europe—and in the face of a new assault on painting, this one by art theoreticians, most of them associated with the journal *October,* who championed conceptually based,

socially oriented art, produced by mechanical means, notably photography. The contributors to the magazine claimed that painting had nothing new or relevant to say and was, therefore, hopelessly retrogressive and, in a word, dead.

Nonetheless, painters such as Julian Schnabel, David Salle, and Eric Fischl in the United States, Francesco Clemente and Enzo Cucchi in Italy, and Sigmar Polke, Gerhard Richter, and Anselm Kiefer in Germany, suddenly became the center of art-world attention. Rebutting the polemics of the *October* group, the champions of painting maintained that because of the prevalence of conceptually based art, there had developed "a keen feeling of loss . . . a sense that something absolutely essential to the life of art has been allowed to fall into a state of unendurable atrophy," as Hilton Kramer commented.[12] Kay Larson also felt this ache: "Artists are desperate to reconnect with feeling,"[13] and painting seemed the best way to do so.

Schnabel, Salle, Fischl, Clemente, and Cucchi became Katz's friends. They were attracted by the artistry, realism, bigness, and coolness of his painting. Clemente, for example, admired what Katz "does with the edges of the paintings and the scale and the lines and the light, and a mysterious classical measure of his own that can't be defined, but it works."[14]

But it was not only Katz's paintings that attracted younger artists. They appreciated his sharp eye, quick intelligence, and critical demolition of grandiose and pretentious claims. As Sanford Schwartz wrote: "In surprising ways, Katz is a very theoretical person, and his theories and notions about success and failure, particularly in painting, literature and dance, which he shares freely with people, have quietly influenced many. For a wide variety of New York painters and writers about art, especially in the generation after his, Katz is a one-man testing ground for new ideas, and . . . he has become . . . as much of an influence as any other single painter or critic. [His] ideas, for all the concision with which they're delivered, aren't neat, self-contained packages. His ideas are always a shade iconoclastic; they're delivered in a flat, no-contest way, yet they invite a response."[15]

An excerpt from a talk Katz gave to the American Philosophical Society is typical of Katz's verbal style: "As a sixteen year old, when I first saw a Mondrian painting, I thought it was great because the title was

Broadway Boogie Woogie and the painting had a double boogie woogie bass in it. It was thrilling that an artist would do this. . . . Years later, when I became interested in depth of color, Mondrian again looked sensational. The color has atmosphere, it spreads toward one, and away, and horizontally and vertically." Katz went on to say that Mondrian's writings did not account for the obsessive passion of the painting, which was its strongest characteristic. He concluded that "in a sense, I think of Mondrian as expressionistic."[16]

Katz's painting has never been persuasively subsumed under any style. If anything, he is a one-man movement, which he once spoofed might be labeled Katzism. And his independence has worked to his long-term advantage. Movements are always circumscribed by the time in which they are fashionable and thus become dated (although a few innovators continue to command attention). Unclassifiable art does not look dated. Katz then is one of the few artists of his generation to remain in the art world and the public eye. A painting by him was featured on the cover of *Parkett* (no. 29, 1989), and a commissioned portrait by him of novelist John Updike appeared on the cover of *Time* magazine.

In 1996 alone, a museum wing devoted to his art opened at Colby College; the leading international collector Charles Saatchi, who is noted for his acquisition of new art, purchased some thirty of Katz's pictures; and "hip" curators have included him in their shows, for example, *A/Drift,* selected by Joshua Decter, a young critic, for the Center for Curatorial Studies Museum at Bard College, and *Views from Abroad: European Perspectives on American Art 2,* chosen by Rolf Lauter and Jean-Christophe Ammann, the director of the Museum für Moderne Kunst, Frankfurt, for the Whitney Museum of American Art. In 1997, Bice Curiger, the editor of *Parkett,* included Katz in a show he curated for museums in Hamburg and Zurich. All three shows have featured young Conceptual artists, yet the organizers felt obliged to include Katz. Young artists who are making their mark in the 1990s, among them painters Elizabeth Peyton and John Curren, and photographer Beat Steuli, have looked to Katz for inspiration. As my book nears completion, shows are scheduled in New York City, Frankfurt, and London.

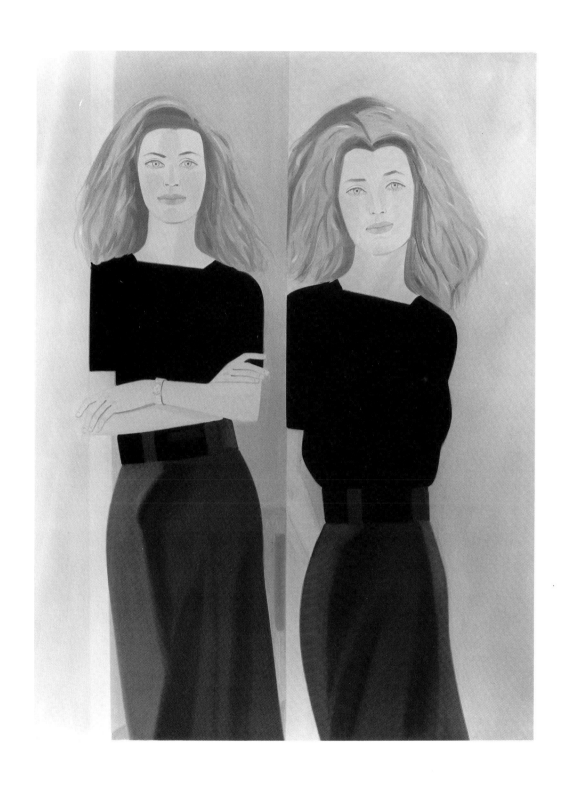

NELL. 1986

157

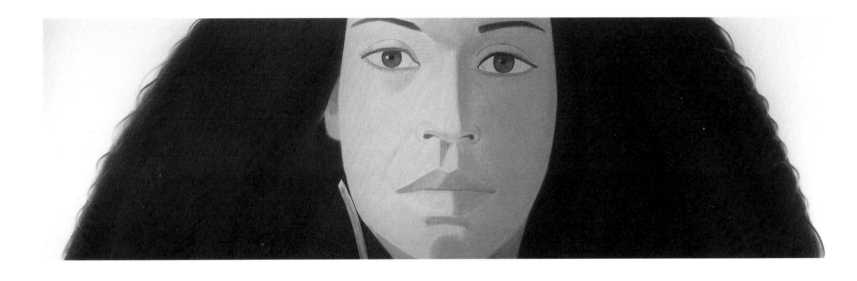

Top: RAIN. 1989

Above: MUNA. 1990

Opposite: BLUE COAT. 1990

158

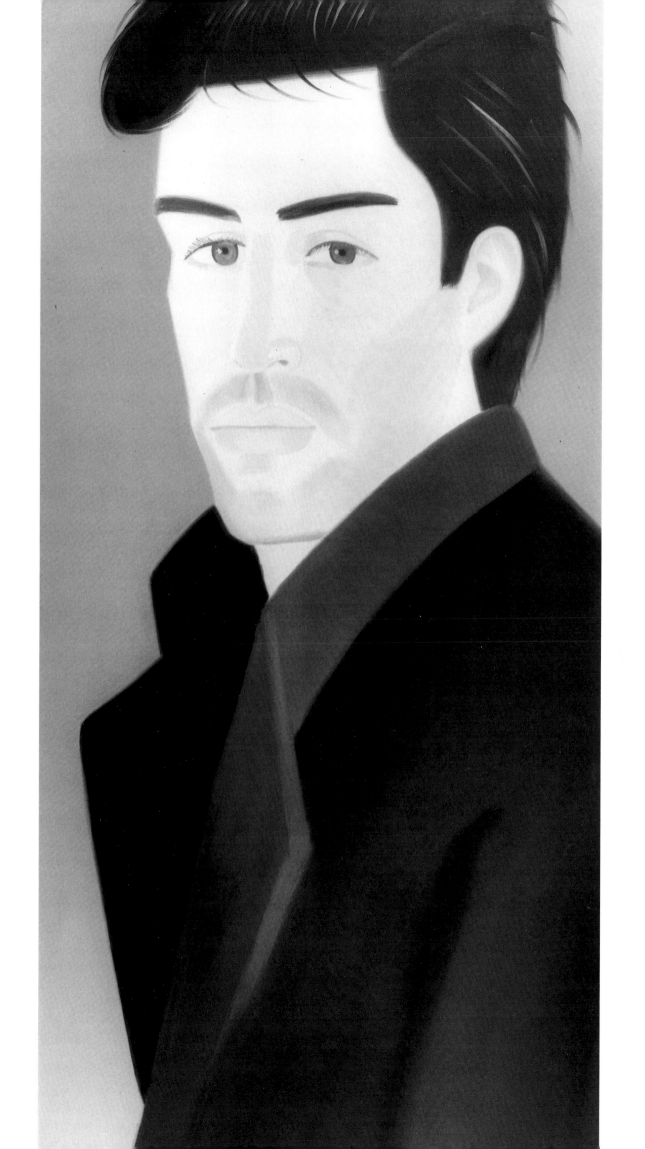

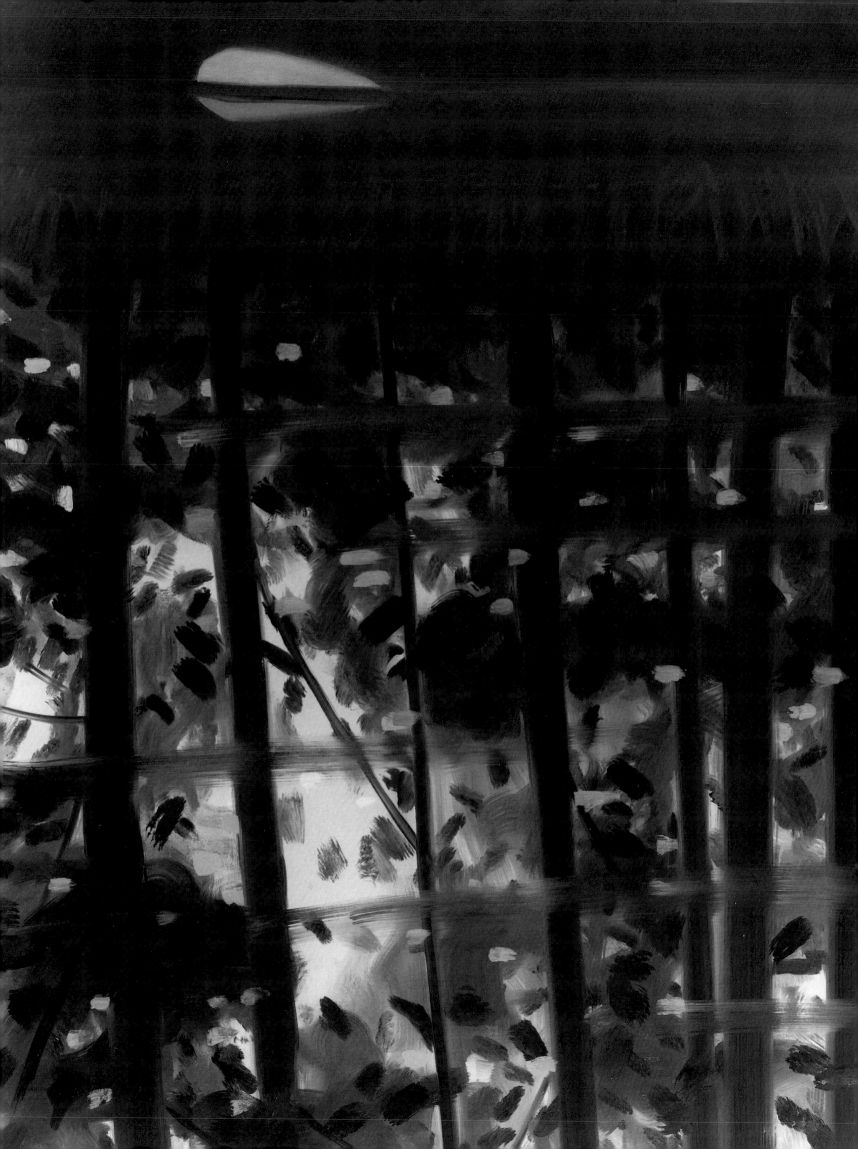

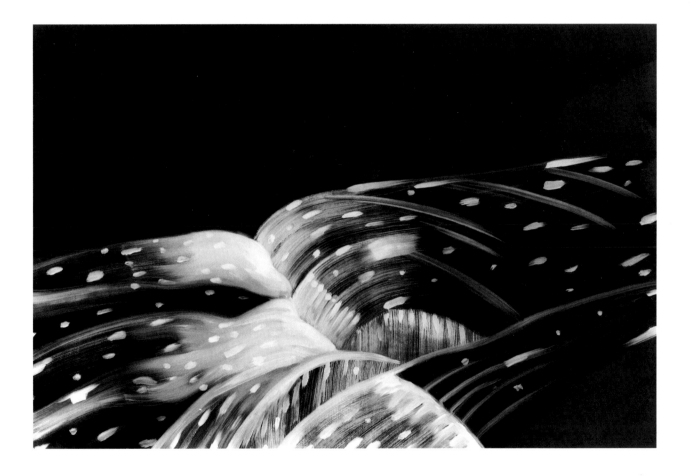

Top: BEACH. 1990

Above: BLACK BROOK 11. 1990

Opposite: BLACK BROOK 10. 1990

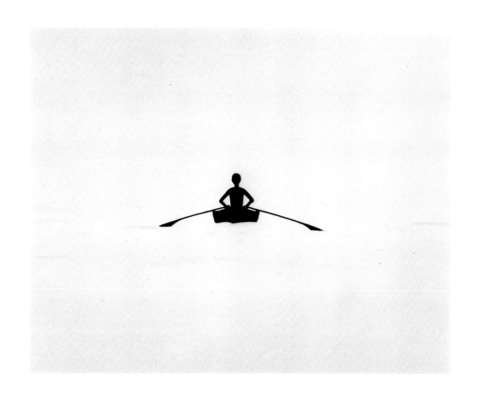

Top: ROWBOAT I. 1991

Above: GREY LIGHT #1. 1992

162

NEW YEAR'S EVE. 1990

163

THICK WOODS, MORNING. 1992

164

MORNING. 1993

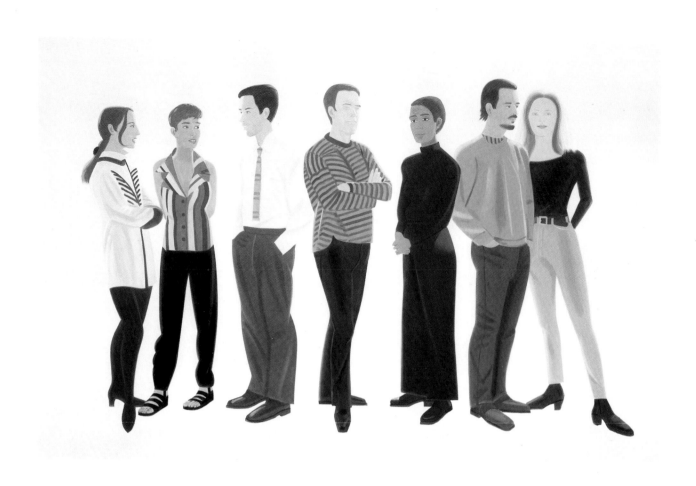

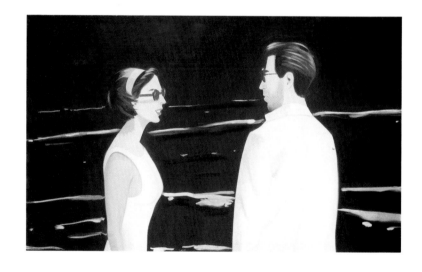

Top: SEVEN PEOPLE. 1993

Above: VINCENT AND VIVIEN. 1994

Opposite, above left: MASSIMO. 1994

Opposite, above center: DAVID AND RAINER. 1991

Opposite, above right: WEDDING DRESS VI. 1992

Opposite, below left: WEDDING DRESS V. 1992

Opposite, below right: WEDDING DRESS IV. 1992

166

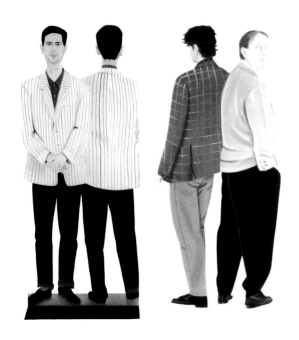

Opposite, top left: KATHRYN SMILES. 1994

Opposite, below left: JESSICA SMILES. 1994

Opposite, right: AHN SMILES. 1994

Above: BIG RED SMILE. 1993

Left: BLACK SCARF. 1996

169

Top: 10 A.M. 1994

Above: WINTER LANDSCAPE. 1993

Opposite, top left: GRASS I. 1993

Opposite, top right: GOLD AND BLACK I. 1993

Opposite, below: MORNING WITH ROCKS. 1994

171

172

VETCH NUMBER I. 1996

Opposite: DAWN III. 1995

YELLOW MORNING. 1996

Opposite: DARK REFLECTION. 1995

JANUARY 7 P.M. 1997

176

WOMAN IN WOODS. 1997

177

GREEN DUSK. 1996

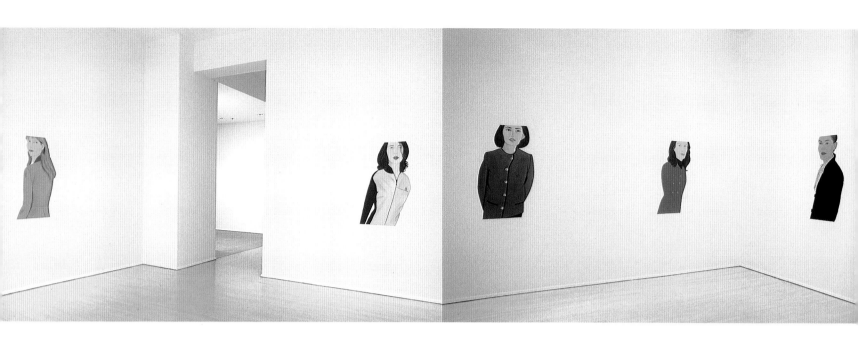

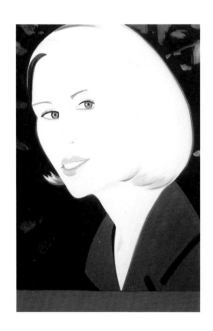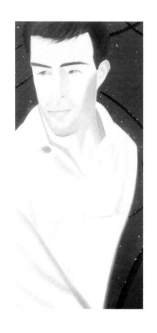

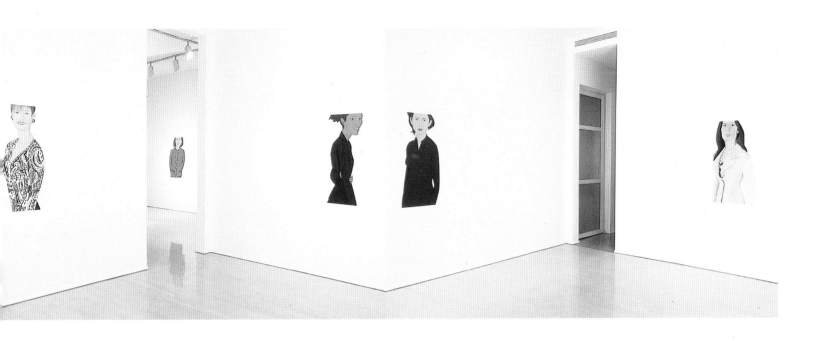

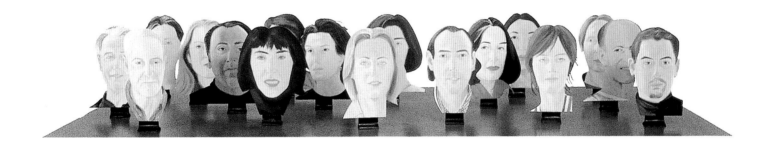

Top and above: NEW CUTOUTS, installation at Robert Miller Gallery, New York, November 19, 1996–January 4, 1997.

Opposite, left: JESSICA. 1996

Opposite, center: MAN IN WHITE SHIRT #5. 1996

Opposite, right: MAN IN WHITE SHIRT #6. 1996

NOTES

Chapter 1: NEW YORK SCHOOLED IN THE FIFTIES

1. Alex Katz in *Invented Symbols,* ed. Vincent Katz, vol. 2 of Positions in Contemporary Art, ser. ed. Rolf Lauter (Ostfildern-Ruit, Germany: Cantz Verlag, 1997), p. 27.

2. Alex Katz said, in *Invented Symbols,* pp. 121–22: "Matisse has an ability to create an overall light and a local color in enough parts of the painting to make the whole thing quite realistic. He can paint a thin wash of brown, and you have a table, a thin wash of blue, and you have silk, a thin wash of orange, and you have flesh. Then he can use a neutral color like red [to] give the whole painting a light that seems the equivalent of a perceived light, and also the objects in the painting seem accurate in that light."

3. Alex Katz said of Marsden Hartley, in *Invented Symbols,* p. 122: "I liked the straight, unfussy, way of painting that he had. . . . I loved the physicality of the forms. . . . Hartley gives you new images of nature."

4. Alex Katz, in "Jackson Pollock: An Artists' Symposium, Part 1," *Art News* (April 1967), p. 32, stated that Pollock "opened up areas of sensation painting and gestural painting, which wiped out all the rules I had been painting by." In *Invented Symbols,* p. 55, he said, "I saw in his paintings a way of going into nature. The idea was to paint faster than you can think . . . and your sensibilities would put it into space somehow," and that space would be "more aggressive, energetic . . . more gestural."

Katz was also impressed by Philip Guston's show in 1951. In *Invented Symbols,* p. 48, he said: "It was the beginning of the cluster abstractions. What I liked about them was how they kept changing as you looked at them—spaces, objects in space, space and ground, ground and object, all shifting and moving. I liked that artless way of painting. I liked the fact that it wasn't psychological. The content was reduced. The painting became the content."

5. Alex Katz, in *Invented Symbols,* p. 52, recalled: "Tenth Street was important—it was real. I'd moved on from Cooper Union . . . where the talk was about Picasso and Miró—great painters who were very, very far away. All of a sudden, there was the chance of dealing with live art. . . . That was when New York became the cosmopolitan art center, and the center of it, at that time, was Tenth Street. The eight or so years I spent there were essential to my development."

6. Katz said, in *Invented Symbols,* p. 54: "I first saw Rudy Burckhardt's movies [at the Club], which I thought were uncommonly beautiful. I went over and introduced myself, and we lived in the same neighborhood and became friends. . . . I learned a lot from Rudy."

7. Brad Gooch, *City Poet: The Life and Times of Frank O'Hara* (New York: Alfred A. Knopf, 1993), p. 367.

8. Katz said, in *Invented Symbols,* pp. 54–55: "Through Edwin, I got involved with modern dance and poetry. [He] was like my graduate school. We became friends, and I guess I saw him every day for ten years."

9. Edwin Denby, "My Friend De Kooning," *Art News Annual* XXIX (1964), p. 92.

10. Ibid., p. 88.

11. Mark Strand, ed., *Art of the Real: Nine Contemporary Figurative Painters* (New York: Clarkson N. Potter, 1983), p. 132.

12. Alex Katz, interviewed by Donald Kuspit in his book *Alex Katz Night Paintings* (New York: Harry N. Abrams, 1991), p. 66.

13. Jane Freilicher and Alex Katz, "A Dialogue," *Art and Literature,* no. 1 (March 1964), p. 206.

14. Alex Katz, in conversation with author, New York, February 4, 1957.

15. Alex Katz statement in "Is There a New Academy? Part II," *Art News* (September 1959), p. 39.

16. Lawrence Alloway, "The Constant Muse," *Art in America* (January 1981), p. 115.

17. Alex Katz, in conversation with author, New York, February 4, 1957.

18. Katz began painting portraits in 1954, but their features are generalized, even in *Track Jacket* (1956), a self-portrait, which is an important transitional work.

19. In his reliance on specific representation, Katz's works diverged from Matisse's, notably from the latter's greatest works, the large and "abstract" paintings of the teens and the cut-paper collages of the 1950s, and are closest to but still more literal than the small pictures of the 1920s. In their large size, however, Katz's pictures after 1962 relate more to Matisse's "abstract" works.

20. Gerrit Henry, ed., "Ten Portraitists: Interviews/ Statements," *Art in America* (January–February 1975), p. 37.

21. Ibid., p. 36.

22. Vincent Katz, "Plunk 'Em Down and Paint 'Em: Alex Katz Interviewed by Vincent Katz," *Inside Art,* no. 8 (1984), p. 59.

23. Ibid., p. 36.

24. Alex Katz, in conversation with author, New York, May 27, 1977.

25. Elaine de Kooning, "Subject: What, How or Who?" *Art News* (April 1955), p. 29.

26. Fairfield Porter, *Art in Its Own Terms: Selected Criticism, 1935-1975.* (New York: Taplinger, 1979), pp. 90–91.

27. Katz suppressed value contrast but did not abandon it completely. His flat shapes and brushstrokes are often subtly varied in value, and he has even modeled them, but he has so tightened the picture plane that the shading appears to sit *on* the surface while defining pictorial space.

28. Alex Katz, in conversation with author, New York, February 18, 1957. He remarked then and reiterated in "Talk on Signs and Symbols," given at the General Meeting of the American Philosophical Society, held in Philadelphia on April 23, 1977 and published in *ZZZZZZ,* vol. 6 (1977), p. 26, that Mondrian's painting is not only flat. His color has space and weight: "It spreads toward one and away, and horizontally and vertically . . . very much like our perceptual world."

29. Alex Katz, interviewed by Kuspit in *Alex Katz Night Paintings,* p. 63.

30. Roberta Smith, "Reviews: Alex Katz," *Artforum* (March 1974), p. 74.

31. Because of the distortions in Katz's drawing, it has been related to folk art and even to comics. In Freilicher and Katz, "A Dialogue," p. 211, Freilicher said to Katz that "you have this almost 'folk art' look crossed with a very knowledgeable frontal, almost Egyptian, style. It's like a blend of Herriman [the creator of Krazy Kat] and Giotto."

32. Quoted in "Prints & Photographs Published," *The Print Collector's Newsletter* (September–October 1986), p. 142.

33. William Berkson, "What Are Masterpieces (Alex Katz)," in *Alex Katz*, ed. Irving Sandler and William Berkson (New York: Frederick A. Praeger, 1971), p. 1.

34. Carter Ratcliff, *Alex Katz*, exh. cat. (New York: Marlborough Gallery, 1973), p. 3. Katz, in "Plunk 'Em Down and Paint 'Em," p. 59, stressed that his idea of "realism has to do with an all-over light, and having every surface appear distinctive."

35. Alex Katz, in "Talk on Signs and Symbols," p. 22, characterized as "humanist" figurative painting in Europe since World War II that was based on socialist ideology (Fernand Léger) and existentialism (Alberto Giacometti and Francis Bacon). The Bacon approach has been continued by younger painters of men-as-monsters in a post-Buchenwald-Hiroshima world.

36. Kate Horsfield and Lyn Blumenthal, "On Art and Artists: Alex Katz," an interview in *Profile: Alex Katz*, vol. 2, no. 1 (January 1982), p. 9.

37. Alex Katz, "Rudolph Burckhardt: Multiple Fugitive," *Art News*, vol. 62 (December 1963), p. 41.

38. Edwin Denby, "Katz: Collage, Cutout, Cut-up," *Art News*, vol. 63 (January 1965), p. 43.

39. Lucy R. Lippard, "Alex Katz Is Painting a Poet," in *Alex Katz*, ed. Sandler and Berkson, p. 4.

40. See Carter Ratcliff, "Alex Katz's Cutouts," in *Alex Katz: Cutouts*, exh. cat. (New York: Robert Miller Gallery, 1979).

41. Ibid., p. 4. In addition, both sides of a cutout need not correspond logically. *Maxine* (1961), for example, wears a blue bikini in front, nothing behind.

42. Ibid., p. 6.

43. William Berkson, "Alex Katz's Surprise Image," *Arts Magazine*, vol. 40 (December 1965), p. 25.

44. John Perreault, "Cut-outs," *The Village Voice*, January 26, 1967, p. 11.

45. J[ohn] A[shbery], "Reviews and Previews: Alex Katz," *Art News* (October 1970), p. 24.

46. Emile Zola, "Edouard Manet" (1867), in *Modern Art and Modernism: A Critical Anthology*, ed. Francis Frascina and Charles Harrison (New York: Harper & Row, 1982), p. 30.

47. Vincent Katz, "Plunk 'Em Down and Paint 'Em," p. 59.

48. Alex Katz, in *Invented Symbols*, p. 40.

Chapter 2:
THE SCALE OF THE SIXTIES

1. Alex Katz, "Faster than Thought," interview by Alanna Heiss, in *Alex Katz Under the Stars: American Landscape 1951–1995*, exh. cat. (Long Island City: The Institute for Contemporary Art/P.S. 1 Museum, 1996), pp. 27, 29.

2. Ellen Schwartz, "Alex Katz: 'I see something and go Wow,'" *Art News* (summer 1979), p. 45.

3. *The Red Smile* (1963) has affinities with Al Held's *The Big A* (1962), an abstraction related in composition and reference to billboards; its image is a huge cutoff letter A. Katz painted Held's portrait in 1963, but although he and Held were friends and had their studios in the same building, neither seems to have influenced the other consciously. Nonetheless, the similarities between the two pictures are notable, indicating that many of the new pictorial ideas of the 1960s transcended representational and abstract subject matter.

4. Anticipating his introduction of modeling into his painting was a series of drawings Katz made that were more highly modeled and finished than his previous quick sketches. Katz believed that the modeling separated his painting of the 1960s from what followed.

5. Katz was developing close-up imagery prior to the emergence of Pop Art around 1962. Well before that year, in 1959, he began to make his freestanding painted cutouts. After the emergence of Pop Art in 1962, these "sculptures" were likened to advertisements, such as cardboard stand-ups and other cut-out display images, although this had not been Katz's express intention.

Henry Geldzahler included Katz in his comprehensive *Pop Art 1955–70* (1985), organized under the auspices of the International Council of the Museum of Modern Art. He wrote that Katz's painting "touched . . . the borders of Pop" (p. 12).

6. Irving Sandler, "In the Galleries," *New York Post*, February 9, 1964, p. 27.

7. Robert Rosenblum, "American Painting and Alex Katz," in *Alex Katz*, ed. Sandler and Berkson, p. 7.

8. Berkson, "Alex Katz's Surprise Image," p. 24.

9. Denby, "Katz's Collage, Cutout, Cut-up," p. 44.

10. See Sandler, "In the Galleries."

11. See Vincent Katz, "Alex Katz by Sam Hunter," *The Print Collector's Newsletter*, vol. 24, no. 4 (September–October 1993), p. 155.

12. Jed Perl, "Pop Theater," *Yale Review* (January 1995), p. 37.

13. Alex Katz, in *Invented Symbols*, pp. 55–56.

14. Ibid., p. 107.

15. Alex Katz, interviewed by Carter Ratcliff, in Nicholas P. Maravell, *Alex Katz: The Complete Prints*, exh. cat. (New York and London: Alpine Fine Arts, 1983), p. 12.

16. Ibid, p. 11.

17. See John Loring, "Alex Katz," *Arts Magazine* (March 1976), p. 13, and Maravell's *Alex Katz: The Complete Prints*. Katz had made a drypoint in the late 1940s and a number of linoleum cuts and woodcuts in the 1950s.

18. Vincent Katz, "Plunk 'Em Down and Paint 'Em," p. 59.

19. Alex Katz, in "Interview with Alex Katz, New York, November 1990," by Constance Lewallen, *View*, vol. 7, no. 5 (fall 1991), p. 24. See also Alex Katz, in "When Is a Painting Finished?" *Art News* (November 1985), p. 95.

20. Heiss, "Faster than Thought," p. 29.

21. Lewallen, "Interview with Alex Katz, New York, November 1990," p. 24.

22. Sam Hunter, *Alex Katz* (New York: Rizzoli, 1992), p. 74.

23. Lewallen, "Interview with Alex Katz, New York, November 1990," p. 24.

Chapter 3:
THE WORLD OF A MODERN DANDY

1. See Irving Sandler, *American Art of the 1960s* (New York: Harper & Row, 1988), p. 83.

2. David Antin, "Alex Katz and the Tactics of Representation," in *Alex Katz*, ed. Sandler and Berkson, p. 12.

3. Charles Baudelaire, *The Painter of Modern Life and Other Essays*, trans. and ed. Jonathan Mayne (London: Phaidon Press, 1964), pp. 14–15.

4. Alex Katz, in "Talk on Signs and Symbols," p. 23. Katz, like Courbet, believed that art can be called *realist* only if it recorded the period in which it was created. See Vincent Katz, "Alex Katz by Sam Hunter," p. 155.

5. William Berkson, "Alex Katz: First Painter of Character," *Art in America* (November 1986), p. 157.

6. Berkson, "Alex Katz's Surprise Image," pp. 25–26.

7. Baudelaire, *Painter of Modern Life*, pp. 14, 24.

8. Ibid., p. 27. Carter Ratcliff, in "Dandyism and Abstraction in a Universe Defined by Newton," *Artforum* (December 1988), p. 82, offered another interpretation of the dandy, as a do-nothing, taste-mongering, clothes-obsessed, ultimately vacuous and inconsequential fop, whose resistance to conventional taste discomfits the bourgeoisie. Katz does not fit this description. The other great dandy of our time, the silver-wigged, inert, blank Andy Warhol came closer, bridging the two conceptions.

9. Antin, "Alex Katz and the Tactics of Representation," p. 16. "In the future, Katz's portraits should be of great documentary value, since many of the individuals portrayed, such as Frank O'Hara, have become—or will turn out to be—consequential artists."

10. Ibid., pp. 14–15.

11. Hunter, *Alex Katz*, p. 89.

12. Robert Storr, "The Rules of the Game," in *Alex Katz: American Landscape*, exh. cat. (Baden-Baden: Staatliche Kunsthalle, 1995), p. 37.

13. Berkson, "Alex Katz: First Painter of Character," p. 185.

14. Ibid., p. 13. The idea of Katz as a dandy was first broached by Jack Kroll in "Domesticated Hipster," *Newsweek* (December 13, 1965), p. 88. Kroll called Katz "cool," but added, "as if to protect the vulnerable warmth of his affections and appetites." Earlier, Baudelaire, in *Painter of Modern Life*, p. 29, wrote that "the dandy's beauty consists above all in an air of coldness . . . you might call it a latent fire . . . which could, but chooses not to burst into flames."

15. Ann Beattie, *Alex Katz by Ann Beattie* (New York: Harry N. Abrams, 1987), p. 32.

16. Kroll, "Domesticated Hipster," p. 88.

17. John Russell, "Alex Katz," in *Alex Katz: The Cooper Union Collection*, exh. cat. (New York: The Cooper Union, 1994).

18. Hilton Kramer, "The World of Alex Katz: 'Big Numbers,' Fast Moves," *New York Times*, December 16, 1973.

19. Hilton Kramer, "Quite a Lot to Look Art," *New York Times*, November 28, 1971, p. 21.

20. John W. Coffey and Vincent Katz, *Making Faces: Self-Portraits by Alex Katz*, exh. cat. (Raleigh, N.C.: North Carolina Museum of Art, 1990), pp. 10–11.

21. See Hickey, "Those Cool American Blondes," in *Alex Katz Under the Stars*, pp. 47–48.

22. John Russell, "An Olympic High-Flyer," *Parkett*, no. 21 (1989), p. 20.

23. Hickey, "Those Cool American Blondes," in *Alex Katz Under the Stars*, p. 45.

24. Carter Ratcliff, "New York Today: Some Artists Comment," *Art in America* (September–October 1977), p. 8.

25. See Kramer, "The World of Alex Katz: 'Big Numbers,' Fast Moves." See also Kramer, "The Sociable Art of Alex Katz," *New York Times*, December 24, 1967.

26. Berkson, "Alex Katz: First Painter of Character," p. 157.

27. Beattie, *Alex Katz by Ann Beattie*, p. 25. Anticipating Beattie, Roberta Smith, in "A Unique Brand of Modernism," in *Alex Katz in the Seventies*, exh. cat. (Waltham, Mass.: Rose Art Museum, Brandeis University, 1978), p. 7, sensed "strange undercurrents in his paintings, uncomfortable feelings."

28. Beattie, *Alex Katz by Ann Beattie*, pp. 85–86.

29. Ibid., p. 34.

30. Jerry Saltz, "Alex Katz: Cool School," *Flash Art* (summer 1991), p. 107.

31. Roberta Smith, "Reviews: Alex Katz," *Artforum* (March 1974), p. 74.

32. Ibid., p. 23.

33. See Saltz, "Alex Katz: Cool School," p. 107.

34. Berkson, "Alex Katz's Surprise Image," pp. 25–26.

35. Gail Levin, *Alex Katz—Process and Development: Small Paintings from the Collection of Paul J. Schupf '58*, exh. cat. (Hamilton, N.Y.: Picker Art Gallery, Colgate University, 1984), p. 31.

36. Vincent Katz, "Alex Katz by Sam Hunter," p. 156.

37. Beattie, *Alex Katz by Ann Beattie*, p. 38.

38. Alloway, "The Constant Muse," p. 111.

39. Beattie, *Alex Katz by Ann Beattie*, p. 40.

40. Perl, "Pop Theater," pp. 41, 43. The Frank O'Hara quote came from his article on Katz in *Art and Literature*, no. 9 (summer 1966), reprinted in Frank O'Hara, *Art Chronicles 1954–1966* (New York: George Braziller, 1975).

41. Richard Marshall, "Alex Katz—Sources of Style," in *Alex Katz*, exh. cat. (New York: Whitney Museum of American Art in association with Rizzoli, 1986), p. 14.

42. Sanford Schwartz, "Alex Katz So Far," *Art International* (December 15, 1973), p. 29.

43. Simon Schama, "Alex Katz's Landscapes," in *Alex Katz Under the Stars*, p. 11.

44. Robert Storr, in *Alex Katz: American Landscape*, p. 29.

45. Berkson, "Alex Katz: First Painter of Character," p. 157.

46. Kuspit, *Alex Katz Night Paintings*, p. 71.

47. Alex Katz, "Brand-New and Terrific," *Scrap* 5, February 23, 1962.

1. Denise Green, "Painterly Thoughts and the Unconscious: Alex Katz: The Rage Is the Drive," *Art Press* (February 1994), p. E3. *Chapter 4: AVOIDING BOREDOM*

2. Alex Katz, in *Invented Symbols*, p. 113.

3. Alex Katz, in *Invented Symbols*, p. 87.

4. Heiss, "Faster than Thought," in *Alex Katz Under the Stars*, p. 28.

5. Hickey, "Those Cool American Blondes," p. 44.

6. Alex Katz, in Saltz, "Alex Katz: Cool School," p. 106.

7. Kuspit, *Alex Katz Night Paintings*, p. 60.

8. Gerrit Henry, "Alex Katz: From Theater to Poetry," *The Print Collector's Newsletter* (September–October 1992), p. 127.

9. Kuspit, *Alex Katz Night Paintings*, p. 60.

10. Ibid., pp. 60, 62.

11. Sanford Schwartz, "Alex Katz So Far," p. 58.

Chapter 5:
THE
DECLINE
AND RISE
OF
AMERICAN
REALISM

1. Sidney Tillim, "The Present Outlook on Figurative Painting," *Perspectives on the Arts (Arts Yearbook)*, 1961, p. 59.

2. Alfred H. Barr, Jr., *Recent Painting USA: The Figure*, exh. cat. (New York: The Museum of Modern Art, 1962).

3. Jack Kroll, introduction to *Figures*, exh. cat. (New York: Kornblee Gallery, 1962).

4. See Clement Greenberg, "Abstract and Representational," *Arts Digest* (November 1, 1954), p. 7.

5. Tillim, "The Present Outlook on Figurative Painting," pp. 44, 53–57.

6. Linda Nochlin, "The New Realists," in *Realism Now*, exh. cat. (Poughkeepsie, N.Y.: Vassar College Art Gallery, 1968), p. 8.

7. Sidney Tillim, "Figurative Art in 1969: Aspects and Prospect," in *Aspects of a New Realism*, exh. cat. (Milwaukee: Milwaukee Art Center, 1969), p. 4.

8. Sidney Tillim, "A Variety of Realisms," *Artforum* (summer 1969), p. 42.

9. Robert Hughes, "The Most Living Artist," *Time* (November 29, 1976), p. 54.

10. "Painters Reply," *Artforum* (September 1975), p. 26.

11. Max Kozloff, "Painting and Anti-Painting: A Family Quarrel," *Artforum* (September 1975), p. 41.

12. Hilton Kramer, "The Art Scene of the '80s," *New Art Examiner* (October 1985), pp. 24–25.

13. Kay Larson, "Art: Pressure Points," *New York* (June 28, 1982), p. 59.

14. Grace Glueck, "Alex Katz: Painting in the High Style," *New York Times Magazine*, March 2, 1986, pp. 38, 84.

15. Sanford Schwartz, *Alex Katz: Drawings 1944–1981*, exh. cat. (New York: Marlborough Gallery, 1982), p. 5.

16. Alex Katz, "Talk on Signs and Symbols," p. 26.

BIOGRAPHICAL OUTLINE

1927 Born July 24 in Sheepshead Bay, Brooklyn, the first of two children. Parents Isaac and Ella Katz emigrate to New York from eastern Europe in the early 1920s. Father is a coffee merchant in New York. Mother is an actress, with the stage name Ella Marion.

1928 Moves with parents to St. Albans, Queens.

1941–45 Attends Woodrow Wilson Vocational High School in Queens with the intention of becoming a commercial artist.

1944 Father killed in an automobile accident.

1945 Enlists in the United States Navy. Devotes free time to making drawings and watercolors of the men on the ship and the ports where the ship docks.

1946–49 Attends Cooper Union Art School, New York. At first majors in commercial art; then turns to fine art. Studies with Robert Gwathmey, Morris Kantor, Carol Harrison, and Peter Busa.

1949 Exhibits for the first time in New York in a group show at the Roko Gallery. Graduates from Cooper Union and is awarded a scholarship for summer study at the Skowhegan School of Painting and Sculpture, Skowhegan, Maine. Studies with Henry Varnum Poor.

1950 Receives a second scholarship for summer study at the Skowhegan School.

Marries Jean Cohen, a fellow student at Cooper Union and a painter. Lives on East 6th Street, New York.

Supports himself throughout most of the 1950s by carving frames, painting houses, and assisting muralists Vincent Maragliotti and Allen Cox. Spends summers in Maine painting outdoors.

1953 Moves to West 28th Street.

Exhibits in a two-person show at the Tanager Gallery with Lois Dodd.

1954 First one-person show at the Roko Gallery, New York.

Purchases a small house in Lincolnville, Maine, with Lois Dodd and Jean Cohen. From this point spends every summer in Maine. Becomes sole owner of the house in 1963.

1955 Begins creating small paper collages.

1955–60 Attends The Club and participates actively in the social, intellectual, and cultural activities of the New York School and its allies in the other arts.

1956 Becomes a member of the Tanager Gallery, the first and most prestigious of the artist cooperatives on East 10th Street. Remains a member until 1962.

Marriage to Jean Cohen ends.

1957 Begins to concentrate on specific portraiture.

Meets Ada Del Moro, a research biologist at the Sloan-Kettering Institute for Cancer Research, at a Tanager Gallery opening.

1958 Begins to enlarge size and scale of paintings.

Marries Ada Del Moro. They continue to live on West 28th Street.

1959 Makes first freestanding, painted, flat cutouts of figures that are initially of wood and later of metal.

1960 Designs first set and costumes for Paul Taylor.

Has a one-person exhibition at the Stable Gallery.

Birth of son Vincent.

1960–63 Visiting Critic, Yale University School of Art, New Haven, Connecticut.

1962 Appointed to the Board of Governors, Skowhegan School. Continues until 1979.

Begins to paint large-scale heads.

Moves to loft at 182 Fifth Avenue.

1962–65 Teaches painting at Pratt Institute, Brooklyn.

1964 Paintings are exhibited at Festival of Two Worlds, Spoleto, Italy.

First one-person exhibition at Fischbach Gallery.

1965 Starts serious printmaking career.

1968 Moves into loft at West Broadway and Prince Street in what is later known as SoHo.

1971 Retrospective of paintings, collages, and cutouts executed between 1958 and 1969, originating at the Utah Museum of Fine Arts, University of Utah, Salt Lake City. Show travels to The Art Gallery, University of California, San Diego; Minnesota Museum of Art, St. Paul; and the Wadsworth Atheneum, Hartford, Connecticut.

1972 Awarded John Simon Guggenheim Memorial Fellowship for painting.

1973 First one-person exhibition at the Marlborough Gallery, New York.

1974 Awarded Professional Achievement Citation by Cooper Union. *Alex Katz Prints*, a traveling exhibition, opens at the Whitney Museum of American Art, New York.

1976 Awarded National Endowment for the Arts grant to make sets and costumes for Paul Taylor's *Polaris*.

Delivers talk and participates in symposia for Congress for Creative America, Greater Philadelphia Cultural Alliance.

Delivers address entitled "Talk on Signs and Symbols" to the General Meeting of the American Philosophical Society, held in Philadelphia.

1978 Receives United States Government grant to participate in an educational and cultural exchange with USSR.

Paintings of the 1970s at the Rose Art Museum, Brandeis University, Waltham, Massachusetts.

First one-person exhibition of cutouts at Robert Miller Gallery, New York.

1980 Receives Skowhegan Medal of Achievement.

Receives St. Gaudens Medal for Professionalism in Art, Cooper Union.

1982 Receives Art Direction Magazine Award for *Time* magazine cover.

1984 Resident at the American Academy in Rome, Italy. Awarded Honorary Doctorate by Colby College, Waterville, Maine.

1986 *Alex Katz*, a traveling retrospective exhibition, opens at the Whitney Museum of American Art, New York.

Designs sets and cutouts for National Dance Institute's collaboration between the United States and the People's Republic of China.

1988 *Alex Katz: A Print Retrospective* opens at the Brooklyn Museum of Art.

Inducted into the American Academy and Institute of Arts and Letters.

1991 *Alex Katz: A Drawing Retrospective*, a traveling exhibition, opens at the Munson-Williams-Proctor Institute, Utica, New York.

1996 Colby College Museum of Art establishes a wing to house a permanent collection of Alex Katz's art.

1997 Pratt Institute confers the Mary Buckley Award for Achievement.

Queens Museum of Art confers its 1997 Award for Lifetime Achievement.

SELECTED
SOLO
EXHIBITIONS

1959 Tanager Gallery, New York. *Alex Katz.* January 16–February 6.

1960 Stable Gallery, New York. *Alex Katz.* March 15–April 2.

1961 Stable Gallery, New York. February 20–March 11.

1962 Tanager Gallery, New York. *Alex Katz: Flat Statues.* February 9–March 1.

Martha Jackson Gallery, New York. *Alex Katz: The Set for George Washington Crossing the Delaware, by Kenneth Koch.* June 5–30.

1964 Fischbach Gallery, New York. *Alex Katz.* January 28–February 22.

1965 Fischbach Gallery, New York. *Alex Katz: Cutouts 1955–65.* January 5–30.

Fischbach Gallery, New York. *Alex Katz: Paintings.* November 23–December 26.

1967 Fischbach Gallery, New York. *Alex Katz: Cutouts.* January 7–February 4.

Fischbach Gallery, New York. *Alex Katz.* December 2, 1967–January 5, 1968.

1969 Mont Chateau Lodge, West Virginia University, Morgantown. Presented by West Virginia University and West Virginia Arts and Humanities Council. *Alex Katz at Cheat Lake.* August 1–31.

1970 Fischbach Gallery, New York. *Alex Katz: New Paintings.* September 26–October 22.

1971 Utah Museum of Fine Arts, University of Utah, Salt Lake City. *Alex Katz.* January 7–February 7. Traveled to the Art Gallery, University of California, San Diego. February 22–April 14; Minnesota Museum of Art, St. Paul, July 16–October 3; Wadsworth Atheneum, Hartford, Conn., November 10–December 31.

Galerie Thelen, Cologne. *Alex Katz.*

Fischbach Gallery, New York. *Alex Katz: Cutouts.* October 22–November 11.

1972 Reed College Art Gallery, Portland, Ore. *Alex Katz.* April 5–28.

1973 Marlborough Gallery, New York. *Alex Katz.* December 8–29.

1974 Marlborough Godard Gallery, Toronto, Canada. *Alex Katz.* February 9–March 2.

The Picker Art Gallery, Charles A. Dana Creative Art Center, Colgate University, Hamilton, N.Y., *Alex Katz: Recent Works of Paul J. Schupf.* January 20–February 17.

Davison Art Center, Wesleyan University, Middletown, Conn. March 9–April 21.

Whitney Museum of American Art, New York. *Alex Katz Prints.* September 9–October 26. Traveled to Virginia Museum of Fine Arts, Richmond. January 10–February 9, 1975; Utah Museum of Fine Arts, Salt Lake City, February 17–March 31, 1975; The Santa Barbara Museum of Art, Calif., April 7–May 19, 1975; University Gallery, University of Minnesota, Minneapolis, July 20–August 24, 1975; Indianapolis Museum of Art, September 2–October 12, 1975.

1975 Marlborough Fine Art Ltd., London. *Alex Katz.* January 28–February 21.

1976 Marlborough Gallery, New York. *Alex Katz: Recent Works.* February 28–March 20.

Marlborough Godard Gallery, Toronto. *Alex Katz: Recent Works.* April 10–May 10.

1977 Fresno Arts Center and Museum, Calif. *Alex Katz: Recent Paintings.* September 7–October 9. Traveled to Art Galleries, California State University, Long Beach, October 17–November 6; Seattle Art Museum, November 17, 1977–January 8, 1978; Vancouver Art Gallery, British Columbia, Canada, February 4–March 5, 1978.

Galerie Roger d'Amecourt, Paris. *Alex Katz.* October 11–November 12.

Marlborough Galerie AG, Zurich, Switzerland. *Alex Katz.* December 1977–January 1978.

1978 Marlborough Gallery, New York. *Alex Katz: Recent Paintings.* February 4–March 25.

Rose Art Museum, Brandeis University, Waltham, Mass. *Alex Katz in the Seventies.* May 27–July 9.

1979 Weatherspoon Art Gallery, University of North Carolina, Greensboro. *Alex Katz: Prints.* January 14–February 4.

Robert Miller Gallery, New York. *Alex Katz: Cutouts.* February 21–March 17.

1980 Hartnell College Gallery, Salinas, Calif. *Alex Katz: RUSH—An Environmental Wall Piece.* February 11–March 14. Traveled to University Art Museum, University of California, Santa Barbara. November 12–December 14.

Marlborough Gallery, New York. *Alex Katz.* March 1–29.

The Queens Museum, Flushing, N.Y. *Alex Katz: Scale and Gesture.* March 8–April 27.

Fine Arts Gallery, State University of New York, Stony Brook. *Alex Katz: Ada.* April 14–May 10.

1981 Portland Center for the Arts, Oregon. *Alex Katz.* February 19–March 22.

Birmingham Museum of Art, Alabama. *Alex Katz.* May 14–June 21.

Contemporary Arts Center, Cincinnati. *Alex Katz: Paintings and Drawings 1959–79.* September 17–November 1.

Robert Miller Gallery, New York. *Alex Katz: 1957–59.*

1982 Marlborough Fine Art Ltd., London. *Alex Katz: Recent Paintings.* January 13–February 6.

Marlborough Gallery, New York. *Alex Katz: Drawings 1944–81.* March 3–27.

1984 The Picker Art Gallery, Charles A. Dana Creative Arts Center, Colgate University, Hamilton, N.Y. *Alex Katz—Process and Development: Small Paintings from the Collection of Paul J. Schupf '58.* September 10–November 4.

1985 Houghton Gallery, Cooper Union for the Advancement of Science and Art, N.Y. *Alex Katz Paints a Picture.* February 5–23.

Robert Miller Gallery, New York. *Alex Katz: An Exhibition of Recent Cutouts.* March 5–30.

Marlborough Fine Art Ltd., Tokyo. *Alex Katz.* April 13–May 25.

William A. Farnsworth Library and Art Museum, Rockland, Maine. *Alex Katz.* July 11–September 15.

Colby College Museum of Art. Waterville, Maine, and Bowdoin College Museum of Art, Brunswick, Maine. *Alex Katz: An Exhibition Featuring Works from the Collection of Paul J. Schupf.* July 18–October 6.

Mario Diacono Gallery, Boston, Mass. *Alex Katz: Twelve Hours.* November 8–30.

Edwin A. Ulrich Museum of Art, Wichita State University, Kansas. *Paintings by Alex Katz.* November 13, 1985–January 5, 1986.

1986 Whitney Museum of American Art, New York. March 13–June 15. Retrospective Exhibition. Traveled to Center for the Fine Arts, Miami, Fla. September 12–November 9.

Marlborough Gallery, New York. *Recent Paintings.* May 2–24.

1987 Robert Miller Gallery, New York. *Alex Katz from the Early 60s.* October 6–31.

1988 The Brooklyn Museum, New York. *Alex Katz: A Print Retrospective.* January 15–April 15.

Daniel Templon, Paris. *Alex Katz.* February 13–March 16.

Marlborough Gallery, New York. *Alex Katz: Dark Paintings.* March 31–April 23.

The Seibu Museum of Art, Tokyo. *Alex Katz.* May 13–June 7. Traveled to Parco Studio, Osaka. June 22–July 5.

The Cleveland Museum of Art, Ohio. *Alex Katz: Nocturnal Paintings.* May 31–August 21.

1989 Galeria Emilio Mazzoli, Modena, Italy.

Galerie Bernd Klüser, Munich. *Alex Katz.* July 11–September 30.

1990 Fandos Galeria de Arte Moderno, Valencia, Spain. *Alex Katz: Pinturas y Dibujos.* February–March.

Orlando Museum of Art, Florida. *Alex Katz: Paintings, Drawings, and Cutouts.* March 14–April 29.

North Carolina Museum of Art, Raleigh. *Making Faces: Self-Portraits by Alex Katz.* May 5–July 15. Traveled to Newark Museum of Art, N.J., August 11–September 22; J. B. Speed Art Museum, Louisville, Ky., November 1–December 16.

Institute of Contemporary Arts, London. *Alex Katz: Recent Paintings.* July 18–September 2.

Marlborough Fine Art Ltd, Tokyo. *Alex Katz.* November 27, 1990–January 26, 1991.

1991 Contemporary Museum of Honolulu, Hawaii. *Alex Katz: Small Paintings.* September–October.

Marlborough Gallery, New York. *Alex Katz.* October 2–November 2.

Museum of Art, Munson-Williams-Proctor Institute, Utica, N.Y. *Alex Katz: A Drawing Retrospective.* October 26, 1991–January 5, 1992. Traveled to Colby College Museum of Art, Waterville, Maine, March 1–April 15; The Arkansas Arts Center, Little Rock. May 14–July 12.

1992 Munson-Williams-Proctor Institute, Museum of Art, Utica, New York. *Alex Katz:* March–April.

Colby College Museum of Art, Waterville, Maine. *Alex Katz at Colby College.* July 8–September 20.

1993 Robert Miller Gallery, New York. *Alex Katz.* March 22–April 16.

Rubenstein/Diacono Gallery, New York. *Alex Katz.* April 17–May 12.

Marlborough Gallery, New York. *Alex Katz: Paintings.* November 10–December 4.

1994 Robert Miller Gallery, New York. *Alex Katz: Landscapes 1954–1956.* March.

Galeria Marlborough, Madrid, Spain. *Alex Katz.* October.

1995 Marlborough Gallery, New York. *Alex Katz: Small Drawings—Small Paintings.* March 8–April 1.

Staatliche Kunsthalle, Baden-Baden, Germany. *Alex Katz: American Landscape.* October 15–December 3.

1996 Peter Blum, New York. *Alex Katz: Dawn.* February.

Marlborough Gallery, New York. *Alex Katz: Recent Paintings.* April 7–May 11.

Robert Miller Gallery, New York. *Alex Katz: New Cutouts.* November 19, 1996–January 4, 1997.

Baltimore Museum of Art, Md. *Alex Katz Under the Stars: Landscapes. 1951–1995.* June 12–September 8. Traveled to Norton Museum of Art, West Palm Beach, Fla., March 15–May 3, 1997; Portland Museum of Art, Portland, Maine, July 18–September 14, 1997; Institute for Contemporary Art/P.S. 1 Museum, Long Island City, N.Y., spring, 1998.

Colby College Museum of Art, Waterville, Maine. First exhibition of the Colby College Permanent Collection of Alex Katz Art, donated by the artist, in celebration of the opening of the Paul J. Schupf Wing for the Art of Alex Katz. (inaugurated October 11, 1996).

IVAM Centre Julio Gonzalez, Valencia, Spain. *Alex Katz.* October 29–January 12, 1997.

1997 Fred Hoffman Fine Art, Santa Monica, Calif. *Alex Katz: Landscapes and Figures.* January 18–February 22.

SELECTED
COLLABO-
RATIONS:
DANCE,
THEATER,
BOOKS

1960

Sets and costumes for *Meridian* by Paul Taylor, performed at the Festival of Two Worlds, Spoleto, Italy.

1962

Sets and costumes for *Junction* by Paul Taylor, first performed at Hunter College Playhouse, New York; music by J. S. Bach.

Sets and costumes for *George Washington Crossing the Delaware* by Kenneth Koch, presented at the Maidman Theater, New York.

1963

Sets and costumes for *Scuderama* by Paul Taylor, first performed at Connecticut College, New London; music by Charles Jackson.

Sets and costumes for *Party Mix* by Paul Taylor, first performed at the Little Theater, New York; music by Alexei Haieff.

Sets and costumes for *Red Room* by Paul Taylor, first performed at the Festival of Two Worlds, Spoleto, Italy; music by Gunther Schuller.

1965

Sets and costumes for *Post Meridian* by Paul Taylor, first performed at the Ambassador Theater, New York; music by E. de Boeck.

Sets and costumes for *Shopping and Waiting (A Dramatic Pause)* by James Schuyler, first presented at the Poets Theater, New York.

1966

Sets and costumes for *Orbs* by Paul Taylor, first performed at the Hague Opera House, Holland Festival; music by Ludwig von Beethoven.

Cover of *Paris Review,* winter issue.

1967

Illustration for *In Memory of My Feelings: A Selection of Poems by Frank O'Hara,* edited by William Berkson, the Museum of Modern Art, New York.

1968

Sets for *Little Eyolf* by Henrik Ibsen, presented at the Artists Theater Festival, Southampton College, New York.

Cover for *Freely Espousing* by James Schuyler, Doubleday & Co., Paris Review Editions, New York.

1969

Sets and costumes for *Private Domain* by Paul Taylor, first performed at the New York City Center; music by Iannis Xenakis.

Cover for *Pleasures of Peace* by Kenneth Koch, Grove Press, New York.

Illustrations for *Fragment* by John Ashbery, Black Sparrow Press, Los Angeles. (First appeared in *Harper's Bazaar,* June 1968.)

Collaboration with Kenneth Koch for *Interlocking Lives,* Kulchur Press, New York.

1970

Sets for *Foreign Exchange* (first version) by Paul Taylor, first performed at the New York City Center; music by Morton Subotnick.

1971

Cover for *Motor Disturbance* by Kenward Elmslie, Columbia University Press, New York.

1972

Cover for *City Junket* by Kenward Elmslie, Boke Press, Adventures in Poetry, New York.

1976

Sets and costumes for *Polaris* by Paul Taylor, first performed at the American Dance Festival, Newport, Rhode Island; music by Donald York.

1977

Illustrations for *Selected Declarations of Dependence,* Z Press, Calais, Vermont.

Cover for ZZZZZZ, and cutouts of eight poets in same issue; Z Press, Calais, Vermont.

1977–78

Set for *Red Robins* by Kenneth Koch, presented at P.S. 1, Long Island City, and the Theater at St. Clemens, New York.

1978

Aquatint illustrations for *Face of the Poet,* with poems by fourteen poets, Brooke Alexander and Marlborough Gallery, New York.

1982

Set and costumes for *Lost Found Lost* by Paul Taylor, first performed at the New York City Center.

1983

Set and costumes for *Sunset* by Paul Taylor, first performed at the New York City Center; music by Edward Elgar and audio tape of loon calls.

Aquatint portrait iIllustrations for *Give Me Tomorrow* by Carter Ratcliff, Vehicle Editions, New York.

1984

Set and costumes for *The Eager Witness* by Yoshiko Chuma, first performed at Japan House, New York.

1985

Set and costumes for *Last Look* by Paul Taylor, first performed at the New York City Center; music by Donald York.

1986

Set and costumes for *Ab Ovo Usque Ad Mala (or From Soup to Nuts)* by Paul Taylor, first performed at the New York City Center; music by P. D. Q. Bach, edited by Professor Peter Schikele.

Original linocut illustrations for *A Tremor in the Morning* by Vincent Katz, Peter Blum Editions, New York.

1989

PARKETT Collaboration. Zurich, Switzerland: No. 21. Essays on Katz by John Russell, Brooks Adams, David Rimanelli, Richard Flood, Patrick Frey, Carl Stigliano, Bice Curiger, Glenn O'Brien; poem by Michael Kruger; and discussion between Francesco Clemente and Alex Katz.

Soft ground etchings of Ada for which Ron Padgett wrote *Light as Air,* Pace Editions, New York.

1990

Set and costumes for *Incandescence* by David Parsons, first performed at Jacob's Pillow, Lee, Massachusetts; music by Leslie Stuck.

1995

Set and costumes for *Mood Swing,* first performed at Kennedy Center, Washington, D.C.; music by Morton Gould.

1996

Drawings for set designs for *Ligeia—A Libretto* by Robert Creeley, Granary Books, New York.

1997

Aquatint illustrations for *Edges* by Robert Creeley, Blumarts, Inc., New York.

WRITINGS BY THE ARTIST

Statement in "Is There a New Academy? Part II." *Art News,* vol. 58 (September 1959), p. 39f.

"Brand-new and Terrific." *Scrap 5* (February 23, 1962).

"Rudolph Burckhardt: Multiple Fugitive." *Art News,* vol. 62 (December 1963), pp. 38–41.

"A Dialogue." Interview by Jane Freilicher. *Art and Literature,* no. 1 (March 1964).

Statement in "Sensibility of the Sixties." Edited by Barbara Rose and Irving Sandler. *Art in America,* vol. 55 (January–February 1967), p. 50.

Statement in "Jackson Pollock: An Artists' Symposium, Part 1." *Art News,* vol. 66 (April 1967), p. 32.

"Interview." *Realism Now.* Exh. cat. Poughkeepsie, N.Y.: Vassar College Art Gallery, 1968.

"Statement." *Art Now: New York,* vol. 2, no. 9, 1970.

Statement in "Ten Portraitists: Interviews/Statements." Edited by Gerrit Henry. *Art in America,* vol. 63 (January–February 1975), p. 36.

"New York Today: Some Artists Comment." Interviews by Donald B. Kuspit, Carter Ratcliff, and Joan Simon; statement by Vito Acconci. [Katz was interviewed by Ratcliff] *Art in America,* vol. 65 (September–October 1977), pp. 81–82.

"Talk on Signs and Symbols." *ZZZZZZ,* vol. 6. (1977).

"Interview with Alex Katz, New York, November 1990." By Constance Lewallen. *View,* vol. 7, no. 5 (fall 1991).

"A Painter Learns to See Through His Own Eyes." *New York Times,* October 17, 1993, p. 17.

Invented Symbols. Edited by Vincent Katz. Volume 2 of Positions in Contemporary Art by the Museum für Moderne Kunst, Frankfurt am Main, Germany. Series editor Rolf Lauter. Ostfildern-Ruit, Germany: Cantz Verlag, 1997. (Published in German and English.)

MONOGRAPHS AND CATALOGUES

Beattie, Ann. *Alex Katz by Ann Beattie.* New York: Harry N. Abrams, 1987.

Belting, Hans. *Alex Katz: Bilder und Zeichnungen.* Exh. cat. Munich: Galerie Bernd Klüser, 1990.

Bryant, Edward, and Paul J. Schupf. *Alex Katz: Recent Works from the Collection of Paul J. Schupf.* Exh. cat. Munich: Galerie Bernd Klüser, 1990.

Burton, Scott. *Alex Katz at Cheat Lake.* Exh. cat. Morgantown, W. Va.: West Virginia University, 1969.

Calvo Serraller, Francisco. *Alex Katz: Pinturas y Dibujos.* Exh. cat. Valencia, Spain: Fandos, Galeria de Arte Moderno, 1990.

Close, Chuck. *Alex Katz: Reduction Block.* Los Angeles: Lannan Foundation, 1985.

Coffey, John W., and Vincent Katz. *Making Faces: Self Portraits by Alex Katz.* Exh. cat. Raleigh, N.C.: North Carolina Museum of Art, 1990.

D'Amecourt, Roger. *Alex Katz.* Exh. cat. Paris: Galerie Roger d'Amecourt, 1977.

Damian, Carol. *American Art Today: Heads Only.* Exh. cat. Miami, Fla.: The Art Museum at Florida International University, 1994.

Diacono, Mario. *Alex Katz: Twelve Hours.* Exh. brochure. Boston: Mario Diacono Gallery, 1985.

———. *Alex Katz.* Exh. brochure. New York: Rubenstein/Diacono, 1993.

Field, Richard S. *Alex Katz.* Exh. cat. Middletown, Conn.: Davison Art Center, Wesleyan University, 1974.

Field, Richard S., and Elka M. Solomon. *Alex Katz Prints.* Exh. cat. New York: Whitney Museum of American Art, 1974.

Hinson, Thomas E. *Alex Katz.* Exh. cat. Cleveland: The Cleveland Museum of Art, 1988.

Hunter, Sam. *Alex Katz.* Exh. cat. New York: Rizzoli, 1992.

———. *Alex Katz: Landscapes and Figures.* Exh. cat. Santa Monica, Calif.: Fred Hoffman Fine Art, 1997.

Kuspit, Donald. *Alex Katz Night Paintings.* New York: Harry N. Abrams, 1991.

Levin, Gail. *Alex Katz—Process and Development: Small Paintings from the Collection of Paul J. Schupf.* Exh. cat. Preface by Dewey F. Mosby; introduction by Paul J. Schupf. Hamilton, N.Y.: Picker Art Gallery, Charles A. Dana Creative Arts Center, Colgate University, 1984.

Ligare, David. *Alex Katz:* Rush—*An Environmental Wall Piece.* Exh. cat. Salinas, Calif.: Hartnell College Gallery, 1980.

Maravell, Nicholas O. *Alex Katz: The Complete Prints.* Exh. cat. Interview by Carter Ratcliff. New York and London: Alpine Fine Arts, 1983.

Marshall, Richard. *Alex Katz.* Exh. cat. Essay by Robert Rosenblum. New York: Whitney Museum of American Art, in association with Rizzoli, 1986.

Murray, Richard N. *Alex Katz.* Exh. cat. Birmingham, Ala.: Birmingham Museum of Art, 1981.

Okada, Takahiko. *Alex Katz.* Exh. cat. Tokyo, Japan: Marlborough Fine Art Ltd., 1990.

———. *Alex Katz.* Exh. cat. Tokyo, Japan: Marlborough Fine Art Ltd., 1995.

Poetter, Jochen, ed. *Alex Katz: American Landscape.* Exh. cat. Baden-Baden: Staatliche Kunsthalle, 1995.

Ratcliff, Carter. *Alex Katz.* Exh. cat. New York: Marlborough Gallery, 1973.

———. *Alex Katz: Cutouts.* Exh. cat. New York: Robert Miller Gallery, 1979.

———. *Alex Katz: A Drawing Retrospective.* Exh. cat. Interview by Paul D. Sweitzer. Utica, N.Y.: Munson-Williams-Proctor, 1991.

Ricard, Rene. *Alex Katz Paints a Picture.* Exh. cat. New York: Houghton Gallery, Cooper Union for the Advancement of Science and Art, 1985.

Rosenblum, Robert. *Alex Katz: Recent Paintings.* Exh. cat. Fresno, Calif.: Fresno Arts Center and Museum, 1977.

Russell, John. *Alex Katz: Recent Paintings.* Exh. cat. London: Marlborough Fine Art Ltd., 1982.

———. *Alex Katz: The Cooper Union Collection.* Exh. cat. Introduction by John Jay Iselin. New York: Cooper Union for the Advancement of Science and Art, 1994.

———. *Alex Katz at Colby College.* Exh. cat. Waterville, Maine: Colby College Museum of Art, 1996.

Saarikivi, Sakari. *Alex Katz.* New York: Marlborough Gallery, 1973.

Sandler, Irving. *Alex Katz.* Exh. cat. New York: Tanager Gallery, 1959.

————. *Alex Katz*. New York: Harry N. Abrams, 1979.

————. *Alex Katz: 1957–1959*. Exh. cat. New York: Robert Miller Gallery, 1981.

Sandler, Irving, and William Berkson, eds. *Alex Katz*. Exh. cat. Essays by Lucy R. Lippard, Robert Rosenblum, David Antin, William Berkson, poems by Ron Padgett, selected writings on Alex Katz and preface by Irving Sandler. New York: Frederick A. Praeger, 1971.

Schneider, Janet. *Alex Katz: Scale and Gesture*. Exh. brochure. Flushing: The Queens Museum of Art, 1980.

Schwartz, Sanford. *Alex Katz: Drawings 1944–1981*. Exh. cat. New York: Marlborough Gallery, 1982.

Scholnick, Michael. *Alex Katz from the Early 60s*. Exh. cat. New York: Robert Miller Gallery, 1987.

Scott, Sue. *Alex Katz Paintings, Drawings, and Cutouts*. Exh. cat. Orlando, Fla.: Orlando Museum of Art, 1990.

Smith, Roberta. *Alex Katz in the Seventies*. Exh. cat. Waltham, Mass.: Rose Art Museum, Brandeis University, 1978.

Stang, Alanna, ed. *Alex Katz Under the Stars: American Landscape 1951–1995*. Exh. cat. Essays by Alanna Heiss, Dave Hickey, and Simon Schama. Long Island City, N.Y.: Institute for Contemporary Art/P.S. 1 Museum, 1996.

Sylvester, David. *Alex Katz: Twenty-Five Years of Painting from the Saatchi Collection*. Exh. cat. Introduction and interview by David Sylvester; commentaries by Merlin James. London: Saatchi Gallery, 1997.

Walker, Barry. *Alex Katz: A Print Retrospective*. Exh. cat. Brooklyn: The Brooklyn Museum, in association with Burton Skira, Inc., 1987.

ARTICLES AND REVIEWS

Adams, Brooks. "Alex Katz at Marlborough and Robert Miller." *Art in America* (July 1994), pp. 90–91.

"Alex Katz." *Arte y Parte*, no. 6 (December 1996–January 1997), pp. 10–32.

Alloway, Lawrence. "Alex Katz's Development." *Artforum*, vol. 14 (January 1976), pp. 45–51.

————. "The Constant Muse." *Art in America*, vol. 69 (January 1981), pp. 110–18.

Antin, David. "Alex Katz and the Tactics of Representation." *Art News*, vol. 70 (April 1971), pp. 44–47, 75–77.

Bass, Ruth. "Bland Power." *Art News* (April 1986), pp. 107–11.

"Bench Marker: Interview with Alex Katz." *Border Crossings* (winter 1993), pp. 26–29.

Berkson, William. "Alex Katz's Surprise Image." *Arts Magazine*, vol. 40 (December 1965), pp. 22–26.

————. "Alex Katz: First Painter of Character." *Art in America* (November 1986), pp. 152–59, 183, 185.

Bourdon, David. "Katz Advertises His Family." *The Village Voice* (March 15, 1976), pp. 131–32.

Brody, Jacqueline. "New Prints of Worth: A Question of Taste." Interview. *Print Collector's Newsletter*, no. 10 (September–October 1979), pp. 109–19.

Calas, Nicolas. "Alex Katz: Faces and Flowers." *Art International*, vol. 11 (November 20, 1967), pp. 25–26.

Cembalest, Robin. "Figuring a Way out of Abstract Expressionism: Alex Katz, Forerunner of Pop, Shows Signature Style at Marlborough." *Forward* (April 12, 1996), p. 9.

Denby, Edwin. "Katz: Collage, Cutout, Cut-Up." *Art News*, vol. 63 (January 1965), pp. 42–45.

Di Lauro, Stephen. "Alex Katz." *American Artist* (March 1986), pp. 30–75; reprinted in *Downtown* (July 7, 1987), pp. 21–23.

Disch, Thomas M. "The Katz Chronicle." *The Village Voice* (September 28, 1982), pp. 67–70.

Domingo, Willis. "Galleries: Alex Katz." *Arts Magazine*, vol. 45 (November 1970), pp. 61–64.

Esterow, Milton. "The Second Time Around." *Art News* (summer 1993), pp. 148–50.

Gardner, Paul. "What Artists Like About the Art They Like When They Don't Know Why." *Art News*, vol. 90, no. 8 (October 1991), p. 118.

Gefter, Philip. "Alex Katz." *Shift*, vol. 3, no. 1 (Spring 1989), pp. 36–43.

Glueck, Grace. "Alex Katz: Painting in the High Style." *New York Times Magazine*, March 2, 1986, pp. 37–86.

Green, Denise. "Painterly Thoughts and the Unconscious: Alex Katz: The Rage Is the Drive." *Art Press* (February 1994).

Hess, Thomas B. "Alex Katz's Sign of the Times." *New York*, October 3, 1977, pp. 68–70.

Hogrefe, Jeffrey. "Charles Saatchi Gets Real: Selling Sex at Sotheby's." *New York Observer*, March 17, 1997.

Horsfield, Kate, and Lyn Blumenthal. "On Art and Artists: Alex Katz," Interview. *Profile: Alex Katz*, vol. 2, no. 1 (January 1982), pp. 1–11.

Hughes, Robert. "The Rockwell of the Intelligentsia." *Time*, April 14, 1986, p. 96.

Kataoka, Mayumi. "Alex Katz and Ann Beattie." *Switch*, vol. 7, no. 5 (October 1989), pp. 79–88.

Katz, Ada. "Alex Katz." Interview. *Profile*, no. 2 (January 1982), pp. 12–21.

"Katz, Alex." *Current Biography*, vol. 36 (July 1975), pp. 214–16.

Katz, Vincent. "Plunk 'Em Down and Paint 'Em." *Inside Art*, no. 8 (1984).

————. "New Alex Katz." *Interview* (April 1990), p. 58.

————. "Alex Katz in Three Dimensions." *House & Garden*, October 1991, pp. 60, 62, 64.

————. "Alex Katz by Sam Hunter." *The Print Collector's Newsletter*, vol. 24, no. 4 (September–October 1993), pp. 154–56.

Kimmelman, Michael. "Art, Too, Finds a Summer Home Outside Manhattan." *New York Times*, August 24, 1990, section C, pp. 1, 21.

Kramer, Hilton. "The Sociable Art of Alex Katz." *New York Times*, December 24, 1967.

————. "The World of Alex Katz: 'Big Numbers,' Fast Moves." *New York Times*, December 16, 1973.

————. "Art: Zoom Lens Canvases of Alex Katz." *New York Times*, March 3, 1978, section C, p. 18.

————. "Art View: Two Illuminating Styles of the Late 1950s." *New York Times*, February 15, 1981, section D, pp. 29, 31.

————. "The Return of the Realists—And a New Battle Shaping Up." *New York Times*, October 25, 1981, section C, pp. 1, 35.

———. "At 68, Alex Katz Blossoms with Ambitious New Show." *New York Observer,* April 29, 1996, pp. 1, 27.

Kroll, Jack. "Domesticated Hipster." *Newsweek,* December 13, 1963, p. 88.

Kuspit, Donald B. Review. *Art in America,* vol. 76, no. 11 (November 1988), pp. 178–79.

Larson, Kay. "A Shock to the System." *New York,* vol. 24, no. 17 (April 29, 1991), pp. 86-87.

Lemos, Peter. "Coolest of the Katz." *Elle Decor,* October/November 1993, pp. 32–38.

Lippard, Lucy R. "Groups: Alex Katz." *Studio International,* vol. 179 (March 1970), pp. 93–99.

Mahoney, Robert. Review. "Alex Katz: From the Early 60s." *Arts Magazine,* vol. 62, no. 4 (December 1987), p. 107.

"The Maine Attraction Through the Eyes of Alex Katz." *Vis Vis,* American Airlines, May 1989, pp. 119–24.

McGee, Celia. "Portraiture Is Back, But My It's Changed." *New York Times,* January 1, 1995, section 2, pp. 1, 35.

———. "Maine Man." *Town & Country,* July 1997, pp. 88–93, 129.

McGill, Douglas C. "How Alex Katz Puts Power on Canvas." *New York Times,* March 24, 1985, section 2, pp. 1, 33.

Moritz, Charles, ed. "Alex Katz." *Current Biography,* vol. 36 (July 1975), pp. 17–20.

O'Brien, Glenn. "Studio Visit." *Mirabella,* June 1990, pp. 52–54.

O'Hara, Frank. "Alex Katz." *Art and Literature,* no. 9 (summer 1966), pp. 91–101. Reprinted in *Art Chronicles 1954–1966.* New York: George Braziller, 1975.

———. "Reviews and Previews: Alex Katz." *Art News,* vol. 53 (November 1954), p. 66.

Perl, Jed. "Making Faces." *Vogue,* March 1993, pp. 217–28.

Porter, Fairfield. "Art." *The Nation,* April 2, 1960.

———. "Art." *The Nation,* October 1, 1960, pp. 215–16.

———. "Art." *The Nation,* March 18, 1961.

Prince, Richard. "Alex Katz." *Journal of Contemporary Art,* vol. 4, no. 2 (fall/winter 1991), pp. 70–81.

Ratcliff, Carter. "Alex Katz: Style as a Social Contract." *Art International,* vol. 22 (February 19, 1978), pp. 26–28, 50–51.

———. "Alex Katz's Cutouts." *Arts Magazine,* vol. 53 (February 1979), pp. 96–97.

———. "American Nocturnes." *Elle,* January 1990, pp. 64, 66.

———. "Le portrait hobbesien d'Alex Katz." *Artstudio,* no. 21 (summer 1991), pp. 78–85.

———. "Artist's Dialogue: Alex Katz." *Architectural Digest,* September 1992, pp. 38–42.

Russell, John. "Alex Katz at Marlborough." *Art in America,* vol. 52 (March–April 1974), pp. 110–11.

———. "Katz Portraits Step Out of Their Frames." *New York Times,* March 2, 1979, section C, pp. 1, 17.

———. "Art People." *New York Times,* September 7, 1979, section C, p. 14.

———. "Art: Alex Katz's Works, Ever Nice, Never Empty." *New York Times,* March 11, 1983, section C, p. 22.

———. "Art View: When a Pastime Becomes the Stuff of Metaphor." *New York Times,* March 17, 1985, section 2, p. 31.

———. "Alex Katz and the Art That Conceals Its Art." *New York Times,* March 1986.

Saltz, Jerry. "Alex Katz: Cool School." *Flash Art,* vol. 24, no. 159 (summer 1991), pp. 106–10.

Sandler, Irving. "Alex Katz at Marlborough." *Art in America,* vol. 62 (March–April 1974), pp. 110–11.

———. "Alex Katz 1957–1959." *Arts Magazine,* vol. 55 (February 1981), pp. 98–99.

Schuyler, James. "Alex Katz Paints a Picture." *Art News,* vol. 60 (February 1962), pp. 38–41.

Schwartz, Sanford. "Alex Katz So Far." *Art International,* vol. 17 (December 1973), pp. 28–30f.

Smith, Roberta. "Reviews: Alex Katz," *Artforum* (March 1974).

———. "Art: Expression without the Ism." *The Village Voice,* March 29, 1983, p. 81.

———. "Art: Surface Effects." *The Village Voice,* January 31, 1984, pp. 82–83.

———. "Museum Madness." *House & Garden,* July 1988.

———. "Art in Review: Alex Katz." *New York Times,* October 18, 1991, section C, p. 28.

———. "Turning Back the World." *New York Times,* November 26, 1993, section C, p. 7.

Solomon, Deborah. "A Downtown Aesthetic: The Residence and Studio of Artist Jennifer Bartlett." *Architectural Digest,* November 1989, pp. 316–21, 346.

Steinbrink, Mark. "Why Artists Design for Paul Taylor." *New York Times,* April 3, 1983, section 2, pp. 1, 24.

Tillim, Sidney. "The Katz Cocktail: Grand and Cozy." *Art News,* vol. 64 (December 1965), pp. 46–49, 67–69.

Wallach, Amei. "In Katz's Art, Only Happy Endings." *Newsday,* March 16, 1980, section II, pp. 4–5.

Welish, Marjorie. "Contesting Leisure: Alex Katz and Eric Fischl." *Artscribe* (June/July 1986), pp. 45–47.

GENERAL BOOKS

Alloway, Lawrence. *American Pop Art.* New York: Collier Books, Macmillan, 1974.

Ashbery, John. *Reported Sightings: Art Chronicles 1957–87.* Edited by David Bergman. New York: Knopf, 1989.

Ashbery, John, and Alex Katz. *Fragment.* Los Angeles: Black Sparrow Press, 1966.

Battcock, Gregory, ed. *Minimal Art: A Critical Anthology.* New York: E. P. Dutton, 1968.

Calas, Nicolas, and Elena Calas. *Icons and Images of the Sixties.* New York: E. P. Dutton, 1971.

Danto, Arthur C. *Encounters & Reflections: Art in the Historical Present.* New York: Noonday Press, 1991.

The Figurative Fifties: New York Figurative Expressionism. Newport Beach, Calif.: Newport Harbor Art Museum, 1988.

Hunter, Sam. *American Art of the the 20th Century.* New York: Harry N. Abrams, 1972.

Koch, Kenneth, and Alex Katz. *Interlocking Lives.* New York: Kulchur Press, 1970.

Kultermann, Udo. *The New Painting.* New York: Frederick A. Praeger, 1969.

———. *New Realism.* Greenwich, Conn.: New York Graphic Society, 1972.

Lippard, Lucy. *Pop Art*. New York: Frederick A. Praeger, 1966.

Livingstone, Marco. *Pop Art: A Continuing History*. London: Thames & Hudson, 1990.

Marshall, Richard, and Robert Mapplethorpe. *50 New York Artists*. San Francisco: Chronicle Books, 1986.

Matthews, Harry, and Alex Katz. *Selected Declarations of Dependence*. Calais, Vt.: Z Press, 1977.

McDarrah, Fred W. *The Artist's World in Pictures*. New York: E. P. Dutton, 1961.

Mellon, Gertrud A., and Elizabeth F. Wilder, eds. *Maine and Its Role in American Art: 1740–1963*. New York: Viking Press, 1963.

O'Hara, Frank. *Art Chronicles 1954–1966*. New York: George Braziller, 1975.

——. *Standing Still and Walking in New York*. Edited by Don Allen. Bolinas, Calif.: Grey Fox Press, 1975.

Ratcliff, Carter, and Alex Katz. *Give Me Tomorrow*. New York: Vehicle Editions, 1985.

Rose, Barbara. *American Art Since 1900*. Revised and expanded edition. New York: Frederick A. Praeger, 1975.

Rosenblum, Robert. *The Dog in Art*. New York: Harry N. Abrams, 1988.

Sandler, Irving. *The New York School: Painters and Sculptors of the Fifties*. New York: Harper & Row, 1978.

——. *American Art of the 1960s*. New York: Harper & Row, 1988.

Skolnick, Arnold. *Paintings of Maine*. New York: Clarkson Potter, 1991.

Ward, John L. *American Realist Painting 1945–1980*. Ann Arbor, Mich.: UMI Research Press, 1989.

WORKS IN PUBLIC COLLECTIONS

U.S.A.

Athens, Ga., Georgia Museum of Art, University of Georgia

Atlanta, Ga., The High Museum of Art

Boston, Mass., Museum of Fine Arts, Boston

Brunswick, Maine, Bowdoin College Museum of Art

Cambridge, Mass., Fogg Art Museum, Harvard University
The Albert & Vera List Arts Center, M.I.T.

Chicago, Ill., The Art Institute of Chicago

Cincinnati, Ohio, Cincinnati Art Museum

Cleveland, Ohio, Cleveland Museum of Art

Denver, Colo., Denver Art Museum

Des Moines, Iowa, Des Moines Art Center

Detroit, Mich., Detroit Institute of Art

Fort Worth, Tex., Modern Art Museum of Fort Worth

Greensboro, N.C., Weatherspoon Gallery of Art, University of North Carolina

Hamilton, N.Y., The Picker Art Gallery, Colgate University

Hanover, N.H., Hood Museum of Art, Dartmouth College

Hartford, Conn., Wadsworth Atheneum

Honolulu, Hawaii, Honolulu Academy of Art

Houston, Tex., Rice Museum, Rice University

Iowa City, Iowa, University of Iowa Museum of Art

Kansas City, Mo., The Kemper Museum, La Jolla, Calif., Museum of Contemporary Art

Lawrence, Kans., Spencer Museum of Art, University of Kansas

Lewiston, Maine, Olin Art Center, Bates College

Little Rock, Ark., The Arkansas Art Center

Los Angeles, Calif., Los Angeles County Museum of Art

Madison, Wisc., Madison Art Center

Malibu, Calif., Frederick R. Weisman Museum of Art, Pepperdine University

Manitowok, Wisc., Rahr West Museum

Miami, Fla., Miami-Dade Community College
Miami Art Museum

Milwaukee, Wisc., Milwaukee Art Museum

New Orleans, La., New Orleans Museum of Art

New York, N.Y., The Brooklyn Museum
The Metropolitan Museum of Art
The Museum of Modern Art
The Grey Art Gallery, New York University Art Collection
The Whitney Museum of American Art

Oberlin, Ohio, Allen Memorial Art Museum, Oberlin College

Omaha, Nebr., Joslyn Art Museum

Philadelphia, Pa., The Pennsylvania Academy of Fine Arts
Philadelphia Museum of Art

Portland, Maine, Portland Museum of Art

Providence, R.I., Museum of Art, Rhode Island School of Design

Raleigh, N.C., North Carolina Museum of Art

Richmond, Va., Virginia Museum of Fine Art

Rochester, Mich., Meadow Brook Art Gallery, Oakland University

Salt Lake City, Utah, Utah Museum of Fine Arts

Scranton, Pa., Everhart Museum

Seattle, Wash., Virginia Wright Fund

Sioux City, Iowa, Sioux City Art Center

Syracuse, N.Y., Joe and Emily Loew Art Gallery, Syracuse University

Tampa, Fla., University of South Florida Art Galleries

Trenton, N.J., New Jersey State Museum

Waltham, Mass., Rose Art Museum, Brandeis University

Washington, D.C., Hirshhorn Museum and Sculpture Garden, Smithsonian Institution
National Collection of Fine Arts, Smithsonian Institution
National Gallery of Art
National Portrait Gallery, Smithsonian Institution

Waterville, Maine, Colby College Museum of Art

Wilmington, Del., Delaware Art Museum

Winston-Salem, N.C., Wake Forest University

Worcester, Mass., Worcester Art Museum

AUSTRIA
Vienna, Museum für Moderne Kunst

CANADA
Toronto, The Art Gallery of Ontario

FINLAND
Helsinki, Atenium Taidemuso

GERMANY
Aachen, Neue Galerie

Berlin, Staatliche Museen zu Berlin, Preussicher Kulturbesitz, Nationalgalerie

Munich, Bayerische Staatsbibliothek

GREAT BRITAIN
London, Tate Gallery

ISRAEL
Jerusalem, The Israel Museum

JAPAN
Iwaki, Iwaki City Art Museum

Hiroshima, Hiroshima City Museum

Tokyo, Metropolitan Museum of Art

KOREA
Kyonqiu-Shi, Sonje Museum of Contemporary Art

MEXICO
Mexico City, Museo Rufino Tamayo

PORTUGAL
Sintra, Berardo Collection

SPAIN
Madrid, Museo Nacional, Nacional Centro de Arte Reina Sofia

Valencia, IVAM Centre Julio Gonzalez

ACKNOWLEDGMENTS

I am very grateful to many artists, critics, curators, and other associates who have generously provided information about Alex Katz. Above all, I should like to thank the artist himself for his unstinting cooperation. Among those who were particularly helpful were his wife, Ada Katz, who tracked down innumerable details; Edwin Denby and Donald Droll, whose insights into Katz's painting have been invaluable to me over the years; Frank O'Hara; Bill Berkson; Roberta Smith; and Pierre Levai.

I also wish to acknowledge the contributions of Lawrence Alloway, John Ashbery, David Antin, Rudolph Burckhardt, Nicolas Calas, Jane Freilicher, Gerrit Henry, Thomas B. Hess, Henry Geldzahler, Al Held, Hilton Kramer, Jack Kroll, Lucy Lippard, Philip Pearlstein, Fairfield Porter, Carter Ratcliff, Robert Rosenblum, James Schuyler, Peter Schjeldahl, Sanford Schwartz, Sylvia Stone, and Robert Storr. Moreover, I want to express my appreciation to Robert Morton, Samuel N. Antupit, Catherine Ruello, Jennifer Bright, and Nola Butler of Harry N. Abrams, Inc., Publishers; The Archives of American Art; Joan McDermott-London, whose help in the preparation of the original manuscript was indispensable; and Tom Cugliani and Soheray Meier of the Marlborough Gallery.

Very special thanks are due to my wife Lucy for her constant encouragement.

I. S.

194

59 *Summer Game.* 1972. Oil on canvas, 72 × 144″. Private collection. MG

60 *Superb Lilies #2.* 1967. Oil on canvas, 72 × 144″. Private collection

61 (above) *View.* 1962. Oil on canvas, 30 × 40″. Collection Rudy Burckhardt and Yvonne Jacquette. MG

61 (below) *Eli.* 1963. Oil on canvas, 72 × 86″. Collection of Whitney Museum of American Art, New York. Gift of Mr. and Mrs. Herbert Fischbach 64.37

62 (above) *Here's to You.* 1961. Oil on canvas, 48 × 72″. Collection of the artist

62 (center) *Supper.* 1974. Acrylic on canvas, 72 × 96¼″. Hood Museum of Art, Dartmouth College, Hanover, New Hampshire. Gift of Joachim Jean Aberbach, P.975.70

62 (below) *Rockaway.* 1961. Oil on canvas, 83½ × 71¾″. Colby College Museum of Art, Waterville, Maine; gift of the artist. MG

63 *The Walk #2.* 1962. Oil on canvas, 59⅞ × 59⅞″. Rose Art Museum, Brandeis University, Waltham, Massachusetts. Gervirtz-Mnuchin Purchase Fund

64 *Jack and D. D. Ryan.* 1968. Cutout, oil on aluminum, 68 × 44 × 4½″. Private collection. Photograph by Rudolph Burckhardt, New York

65 (left) *Howie.* 1966. Cutout, oil on aluminum, height 13″. Private collection. Photograph by Rudolph Burckhardt, New York

65 (right) *Ada.* 1966. Cutout, oil on brass, height 11½″. Collection M. Fischbach. Photograph by Rudolph Burckhardt, New York

66 *Road #1.* 1962. Oil on canvas, 72½ × 48¾″. Collection Sandy Schwartz. Photograph by eeva-inkeri, RMG

67 *January #4.* 1962. Oil on canvas, 48½ × 41½″. Private collection. Photograph by Rudolph Burckhardt, New York

68 (above) *Vincent in Hood.* 1964. Oil on canvas, 54 × 66″. Private collection. Photograph by Rudolph Burckhardt, New York

68 (below) *LeRoi Jones.* 1963. 48½ × 71½″. Private collection. Photograph by Zindman/Freemont, RMG

69 (above) *Paul Taylor.* 1964. Oil on canvas, 60 × 60″. Collection Charles and Stephen Reinhart

69 (below) *Frank and Sheyla Lima.* 1964. Oil on canvas, 49⅞ × 57⅞″. Wichita Art Museum, Wichita, Kansas. Purchased through the National Endowment for the Arts. Photograph by Rudolph Burckhardt, New York

70–71 *One Flight Up,* details left, center right, and right sides. 1968. Cutouts, oil on metal, 67¾ × 180 × 47″. Collection of the artist. Photograph by Rudolph Burckhardt, New York

72 *Violet Daisies #2.* 1966. Oil on canvas, 108 × 76″. Colby College Museum of Art, Waterville, Maine; gift of the artist. MG

73 *Ada and Vincent.* 1967. Oil on canvas, 95 × 72″. Collection of the artist. MG

74–75 *John's Loft.* 1969. Wall piece, cutouts, oil on aluminum, 60 × 144″. Collection of the artist. Photograph by Rudolph Burckhardt, New York

76 *Self-Portrait with Sunglasses.* 1969. Oil on canvas, 96 × 68″. Virginia Museum of Fine Arts, Richmond. Gift of Sydney and Frances Lewis

79 *Green Jacket.* 1989. Oil on canvas, 72 × 48″. Private collection. MG

83 *The Cocktail Party.* 1965. Oil on canvas, 72 × 96″. Collection Paul Jacques Schupf, New York

84 (above) *Round Hill.* 1977. Oil on canvas, 72 × 96″. The Saatchi Collection, London. MG

84 (below) *The Place.* 1977. Oil on canvas, 108 × 144″. Collection of Whitney Museum of American Art, New York. Purchase, with funds from Frances and Sydney Lewis 78.23

85 *Rose Room.* 1981. Oil on canvas, 72 × 144″. Private collection. MG

90 *Trophy #3.* 1973. Cutout, oil on aluminum, 64 × 32″. Collection of the artist. MG

91 *Face of a Poet.* 1972. Oil on canvas, 114 × 210″. The Metropolitan Museum of Art, New York. Gift of Paul Jacques Schupf, 1986. (1986.363) Photograph © 1990 The Metropolitan Museum of Art

92 *The Black Jacket.* 1972. Oil on canvas, 72 × 144″. The Saatchi Collection, London. MG

93 *The Black Dress.* 1960. Oil on canvas, 72 × 94″. Collection of the artist. Photograph by Rudolph Burckhardt, New York

94–95 *Eleuthera.* 1984. Oil on canvas, four panels 120 × 264″. The Saatchi Collection, London. MG

96–97 *Pas de Deux.* 1983. Oil on canvas, five panels each 132 × 72″, overall 132 × 360″. Private collection. MG

98 *Walk.* 1970. Oil on canvas, 72 × 144″. Collection of the artist

99 *Sunny #4.* 1971. Oil on canvas, 96¼ × 72¼″. Milwaukee Art Museum, Wisconsin. Gift of Mrs. Harry Lynde Bradley

100–101 *Rush* (details). 1971. Environmental wall piece, cutouts, oil on aluminum, approx. height 16″. Collection of the artist. Photograph by Rudolph Burckhardt, New York

102 *Grey Day #2.* 1971. Oil on canvas, 72 × 86″. Private collection

103 (above) *Joan.* 1971. Oil on canvas, 55½ × 68½″. Private collection. Photograph courtesy Fischbach Gallery, New York

103 (below) *Mr. and Mrs. R. Padgett, Mr. and Mrs. D. Gallup.* 1971. Oil on canvas, 72 × 120″. Collection Commerce Bankshares, Inc.

104 *Edwin.* 1972. Oil on canvas, 96¼ × 72¼″. Private collection. MG

105 *Canoe.* 1974. Oil on canvas, 72 × 144″. Atlantic-Richfield Corporate Art Collection, Los Angeles

106 (above) *Good Afternoon #1.* 1974. Oil on canvas, 72 × 96″. Private collection, on extended loan to the Colby College Museum of Art, Waterville, Maine. MG

106 (below) *Dorothy and Netti.* 1974. Oil on canvas, 72 × 96″. Private collection

107 (above) *Vincent with Radio.* 1974. Oil on canvas, 72 × 96″. Private collection. MG

107 (below) *December.* 1974. Oil on canvas, 72 × 92″. Private collection. MG

108 (above) *Thursday Night II.* 1974. Oil on canvas, 72 × 144″. The Saatchi Collection, London. MG

108 (below) *Summer Picnic.* 1975. Oil on canvas, 78 × 144″. Private collection. MG

109 (above) *February 5:30 P.M.* 1972. Oil on canvas, 72 × 144″. The Saatchi Collection, London. MG

109 (below) *Sydney and Rex #2.* 1975. Oil on canvas, 72 × 96″. Collection of the artist. MG

110 (above) *Rex #2.* 1975. Oil on canvas, 78 × 90″. Private collection. MG

110 (below) *Moose Horn State Park.* 1975. Oil on canvas, 78 × 144″. The Saatchi Collection, London. MG

111 *Twilight.* 1975. Oil on canvas, 126 × 96″. Colby College Museum of Art, Waterville, Maine; gift of the artist. MG

112 (above) *Six Women.* 1975. Oil on canvas, 114 × 282″. North Carolina Museum of Art, Raleigh

112 (below left) *Vincent Facing Right.* 1974. Pencil on paper, 15¼ × 22¼″. Private collection

112 (below center) *Evy.* 1974. Pencil on paper, 14¾ × 21⅞″. Marlborough Fine Art, London. MG

112 (below right) *Susan.* 1974. Pencil on paper, 14½ × 22⅛″. The Metropolitan Museum of Art, New York. Purchase 1975, Mrs. Charlotte B. Kantz Gift, Mrs. Vera Kuhn Gift, and the Metropolitan Republican Club Gift. (1975.207) All Rights Reserved, The Metropolitan Museum of Art

113 (center left) *Boy with a Hat.* 1974. Pencil on paper, 16⅜ × 22⅜″. The Museum of Modern Art, New York. Acquired with matching funds from The Lily Auchincloss Foundation, Inc. and the National Endowment for the Arts Photograph ©1997 The Museum of Modern Art, New York

113 (below right) *Anne.* 1978. Pencil on paper, 22 × 15″. Private collection

114 *Blue Umbrella #2.* 1972. Oil on canvas, 96 × 144″. The Saatchi Collection, London. MG

115 (above) *Islesboro Ferryslip.* 1975. Oil on canvas, 78 × 84″. The Saatchi Collection, London.

115 (below) *Night.* 1976. Oil on canvas, 72 × 96″. Collection of the artist. MG

116–17 *Song, Laura Dean Dance Company.* 1977. Oil on canvas, 96 × 144″. Collection of the artist. MG

117 (below right) *Vincent, Ruth and Paul.* 1979. Oil on canvas, 72 × 96″. Private collection. MG

118 *Ada with Superb Lily.* 1967. Oil on canvas, 46½ × 52″. Rose Art Museum, Brandeis University, Waltham, Massachusetts. Herbert W. Plimpton Collection

121 (above) *His Behind the Back Pass.* 1979. Oil on canvas, 72 × 96″. Colby College Museum of Art, Waterville, Maine; gift of the artist. MG

121 (below) *Hiroshi and Marsha.* 1981. Oil on canvas, 72 × 96″. Tate Gallery, London. Gift of Paul Jacques Schupf. MG

123 (above) *The Black Dress.* 1989. Oil on canvas, 88 × 130″. Collection of the artist. MG

123 (below) *Chance.* 1990. Oil on canvas, 82 × 128″. Private collection. MG

124 *Anne.* 1988. Oil on canvas, 90 × 66½″. Private collection. MG

125 *Ada in Front of Black Brook.* 1988. Oil on canvas, 48 × 96″. Collection Galería Fandos, Valencia, Spain. MG

126–27 *Summer Triptych.* 1985. Oil on canvas, each panel 78 × 48″, overall 78 × 144″. The Saatchi Collection, London. MG

129 (above) *Woods.* 1991. Oil on canvas, 80 × 168″. The Saatchi Collection, London

129 (below) *Poplars.* 1994. Oil on canvas, 108 × 144″. Private collection. MG

130 *The Ryan Sisters.* 1981. Oil on canvas, 144 × 144″. Colby College Museum of Art, Waterville, Maine; gift of the artist. MG

131 *Tracy on the Raft at 7:30.* 1982. Oil on canvas, 120 × 72″. Colby College Museum of Art, Waterville, Maine; gift of the artist

132 (above) *Song.* 1980. Oil on canvas, 72 × 96″. Private collection. MG

132 (below) *Six Soldiers.* 1981. Oil on canvas, 72 × 96″. The Cooper Union Collection, New York. MG

133 *Three Cows.* 1981. Oil on canvas, 96 × 144″. Exxon Corporation, Irving, Texas. MG

134–35 (above) *Up in the Bleachers.* 1983. Oil on canvas, 120 × 264″. The Saatchi Collection, London. MG

134–35 (below) *Last Look.* 1986. Oil on canvas, 78 × 180″. Private collection. MG

134 (lower left) *Ada and Flowers.* 1980. Oil on canvas, 96 × 72″. Private collection. MG

136 *The Red Coat.* 1983. Silkscreen, edition of 73, 58 × 29″. Private collection. MG

137 *Lilies Against the Yellow House.* 1983. Oil on canvas, 84 × 48″. Collection of the artist. MG

138 *View.* 1987. Oil on canvas, 60½ × 84½″. Private collection. MG

139 *Sunset.* 1987. Oil on canvas, 126 × 96″. Private collection. MG

140 *Wet Evening.* 1986. Oil on canvas, 132 × 312″. Instituto Valenciano de Arte Moderno, Valencia, Spain. MG

141 *Purple Wind.* 1995. Oil on canvas, 126 × 96″. The Saatchi Collection, London. MG

142 (left) *Night II.* 1987. Oil on canvas, 138 × 48″. Private collection. MG

142 (right) *SoHo Morning.* 1987. Oil on canvas, 126 × 96″. Private collection. MG

143 (above) *Varick.* 1988. Oil on canvas, 60 × 144″. The Saatchi Collection, London. MG

143 (below) *Snow.* 1988. Oil on canvas, 98 × 72″. Staatliche Museen zu Berlin, Preussischer Kulturbesitz, Nationalgalerie, Berlin. MG

144 *Red Nude.* 1988. Oil on canvas, 90 × 120″. Collection of the artist. MG

145 (above) *Ada and Luisa.* 1987. Oil on canvas, 72 × 96″. Collection Guellermo Caballero de Lujan, Valencia, Spain. MG

145 (below) *Ada in Aqua.* 1988. Oil on canvas, 78 × 48″. MG

146 (above) *Apple Blossoms.* 1994. Oil on canvas, 96 × 120″. Collection of Whitney Museum of American Art, New York. Purchase, with funds from the Contemporary Painting and Sculpture Committee and additional funds 97.46. © 1997 Whitney Museum of American Art

146 (below) *Lake Light.* 1992. Oil on canvas, 66¼ × 78¼″. The Saatchi Collection, London. MG

147 *A Tree in Winter.* 1988. Oil on canvas, 126 × 120″. Private collection. MG

157 *Nell.* 1986. Oil on canvas, 96 × 72″. Private collection. MG

158 (above) *Rain.* 1989. Oil on canvas, 54 × 72″. Private collection. MG

158 (below) *Muna.* 1990. Oil on canvas, 40 × 130″. Private collection. MG

159 *Blue Coat.* 1990. Oil on canvas, 96 × 48″. Marlborough Fine Art, Ltd., Tokyo. MG

160 *Black Brook 10.* 1990. Oil on canvas, 126 × 96″. Colby College Museum of Art, Waterville, Maine; gift of the artist. MG

161 (above) *Beach.* 1990. Oil on canvas, 40 × 130″. Collection of the artist. MG

161 (below) *Black Brook 11.* 1990. Oil on canvas, 108 × 132½″. Private collection. MG

162 (above) *Rowboat I.* 1991. Oil on canvas, 60 × 70″. Private collection. MG

162 (below) *Grey Light #1.* 1992. Oil on canvas, 30 × 96″. Private collection. MG

163 *New Year's Eve.* 1990. Oil on canvas, 108 × 96″. Denver Art Museum. MG

164 *Thick Woods, Morning.* 1992. Oil on canvas, 126 × 96″. Private collection. MG

165 *Morning.* 1993. Oil on canvas, 126 × 96″. Private collection. MG

166 (above) *Seven People.* 1993. Oil on canvas, 90 × 138″. Private collection. MG

166 (below) *Vincent and Vivien.* 1994. Oil on canvas, 48 × 78″. Private collection. MG

167 (above left) *Massimo.* 1994. Cutout, oil on aluminum, 71½ × 30 × 29½″. Private collection. RMG

167 (above center) *David and Rainer.* 1991. Cutout, oil on aluminum, 71½ × 32½ × 11½″. Private collection. RMG

167 (above right) *Wedding Dress VI.* 1992. Oil on canvas, 90 × 96″. Private collection. MG

167 (below left) *Wedding Dress V.* 1992. Oil on canvas, 90 × 96″. Private collection. MG

167 (below right) *Wedding Dress IV.* 1992. Oil on canvas, 90 × 96″. Private collection. MG

168 (above left) *Kathryn Smiles.* 1994. Oil on canvas, 96 × 72″. Private collection. MG

168 (center right) *Ahn Smiles.* 1994. Oil on canvas, 96 × 72″. Private collection. MG

168 (below left) *Jessica Smiles.* 1994. Oil on canvas, 96 × 72″. Private collection. MG

169 (above) *Big Red Smile.* 1993. Oil on canvas, 96 × 120″. Museo Nacional Centro de Arte Reina Sofía, Madrid

169 (below) *Black Scarf.* 1996. Oil on canvas, 72 × 48″. Private collection. MG

170 (above left) *Grass I.* 1993. Oil on canvas, 34¼ × 48″. Collection of the artist. MG

170 (above right) *Gold and Black I.* 1993. Oil on canvas, 23 × 58″. Private collection. MG

170 (below) *Morning with Rocks.* 1994. Oil on canvas, 144 × 96″. Private collection. MG

171 (above) *10 A.M.* 1994. Oil on canvas, 72 × 96″. Private collection. MG

171 (below) *Winter Landscape.* 1993. Oil on canvas, 80 × 166″. The Saatchi Collection, London

172 *Dawn III.* 1995. Oil on canvas, 139 × 132″. Private collection. MG

173 *Vetch Number I.* 1996. Oil on canvas, 54 × 58½″. Private collection. MG

174 *Dark Reflection.* 1995. Oil on canvas, 118 × 96″. Private collection. MG

175 *Yellow Morning.* 1996. Oil on canvas, 96 × 120″. Private collection. MG

176 *January 7 P.M.* 1997. Oil on canvas, 96 × 126″. Private collection. MG

177 *Woman in Woods.* 1997. Oil on canvas, 92 × 72″. Private collection. MG

178–79 *Green Dusk.* 1996. Oil on canvas, 105 × 240″. Private collection. MG

180–81 *New Cutouts,* installation at Robert Miller Gallery, New York, November 19, 1996–January 4, 1997

180 (below left) *Jessica.* 1996. Oil on canvas, 72 × 48″. Private collection

180 (below center) *Man in White Shirt #5.* 1996. Oil on canvas, 72 × 34″. Private collection. MG

180 (below right) *Man in White Shirt #6.* 1996. Oil on canvas, 72 × 34″. Private collection. MG